The Photographer's Playbook

The Photographer's Playbook

307 Assignments and Ideas
Edited by Jason Fulford and Gregory Halpern
Photographs by Mike Slack

aperture

But it just happens, every so often, that something very ordinary seems beautiful to me and I'd like it to be eternal. I'd like this bistro, and that dusty light bulb, and that dog dreaming on the marble, and even this night—to be eternal. And their essential quality is precisely that they aren't.
—*Raymond Queneau,* Witch Grass

About This Book

Neither of us particularly liked being in school. But we've both been lucky enough, at some point, to connect with a photographer or teacher we admired. Someone who provided encouragement, advice, or criticism at the right moment. We were curious about other photographers' experiences of learning, and so we started asking around, and that's how this book was born.

This is a collection of assignments, though we define the word *assignment* loosely. An assignment can take the form of a lesson, a game, a starting point, or a challenge.

In making this book, we reached out to a range of practitioners. As Alex Klein says in her piece, there are many "photographies." Our contributors are artists, teachers, curators, journalists, commercial photographers, and even a park ranger, who have each dedicated a good part of their life to the medium. Their assignments range from the absurd to the practical, from the sarcastic to the heartfelt. You can learn a lot about a person, and how they think, based on the type of assignment they choose to give, and how they write it.

In our experience, a great teacher knows when to be an inspiration and when to be a vexation. Also, when to be tough and when to be fun. You'll find assignments here that contradict one another. You can adopt one into your own practice, and reject the other. Or you can read both, and position yourself somewhere in between.

We imagine this book can be used as an inspiration for the student; an exercise manual for the working photographer; a reference book for the teacher; a document of the contemporary photographic scene for the future historian; or just for a laugh.

One of the great things about books is that they stick around. If this one ends up on your shelf, we hope you will take it down, off and on, over the years. There may be things in here that don't quite resonate now, but will down the road.

—Jason Fulford and Gregory Halpern

Contents

The Polaroid pictures that appear throughout the book were shot by Mike Slack in response to Susan Meiselas's assignment from 1975, Alphabetography.

Dan Abbe
Forgetting the Game

I encourage you to read this book with the lightness suggested by its title. A "playbook" is not at all dogmatic; it's more like a map. In some sense, then, it completes its purpose when it is discarded or forgotten. Of course, simply "forgetting this book" would be a meaningless goal—that's easily accomplished! A map could be forgotten because of carelessness, or because you know your way. The following "play" might result in the latter kind of forgetting:

1. Figure out what game you are playing. This is probably harder to do than it sounds. (It is not easy to define things.)

2. Teach yourself about that game. This takes time, but I think it is easier than it sounds. (Books are still everywhere.) Don't rush.

3. If things go well, thoughts of "winning" the game (and perhaps even the game itself) will fade away. Franz Kafka—who is, by the way, a very photographic writer—provides a useful image in his story "The Wish to Be a Red Indian."

> *If one were only an Indian, instantly alert, and on a racing horse, leaning against the wind, kept on quivering jerkily over the quivering ground, until one shed one's spurs, for there needed no spurs, threw away the reins, for there needed no reins, and hardly saw that the land before one was smoothly shorn heath when horse's neck and head would be already gone.*

See also De Rita, Murphy

Kim Abeles
Watching the Moon

This exercise is best done with a group, though it can be done solo.

Photograph the moon every night, at a particular time, from wherever you are in the world at that time. Take note of your location and any extenuating circumstances. Do this over several weeks or months. At the end of the duration, bring together the images and notes of this collective watching, and consider together what is seen and recorded.

Questions that might come to mind:
Are the photographs about the object or about the environment around it? What is your relationship to that environment and why does it matter? Are any poetic images or notes evoked by the moon's romantic associations? Conversely, does a cynical side emerge in reaction to these associations? Are there any political and environmental issues that arise? Does the notion of time or change or mortality come up during the exercise? What is the most impactful way to arrange and present the resulting photographs and notations? Is the process more important than an outcome?

See also Jacobson, Sanguinetti

Shelby Lee Adams
Find Your Reflection

If you're having difficulty finding a natural or intuitive expression in a portrait session or having trouble identifying with the person you're photographing, look into their eyes carefully and see if you can find your own reflection there. Discover yourself looking at you. Then, ask your subject to look into your camera lens and find their own reflection, and be prepared to make the portrait. In that singular moment, people are less focused on projecting an image of themselves for the camera and are more looking to find themselves.

See also Johnston, Weber

Christopher Anderson
Parameters

The greatest freedom is to have no choice. Confining yourself to certain parameters can actually lead to discovery of a universe of subject matter that is hard to find when you (if you are like me) tend to wander endlessly.

Make a set of parameters within which you will work. This could be a geographic parameter (one city block for instance), or a psychological, thematic, or technical one. The point is to create a method of working where you make some very strict and precise choices about how you will *not* work. The stricter the better. Set a time constraint (one week, month, whatever) during which you will work only this way. After the time period is finished, repeat the assignment by creating an entirely different list of parameters.

See also R. Bell, Chaplin

Amy Arbus
Not Necessarily to Be Taken Literally

Photograph:

someone in water
someone intimidating
someone irritating
your biggest fear
your favorite possession
your biggest loss
your best friend
your favorite place
your dark side
your dreams
something you covet
something you dread
something you don't understand
something timely
something timeless
somewhere you've never been
a celebration
a nightmare
a mundane moment
a fleeting moment
a secret
and what you can't see.

See also Hamada, L. Hewitt

Bill Armstrong
Auras

Some people believe that every individual emanates an "aura"—
a distinct atmosphere or quality that seems to surround them,
often described as a color. Whether this is literally true or not,
it's an intriguing idea metaphorically. If we could capture a
person's aura in a photographic portrait it could add a psycho-
logical element to the picture.

Put on a neutral shirt, blouse, or dress (white, gray, beige,
etc.). Stand in front of walls painted different colors and take
self-portraits. You can try to do this with a camera phone, but a
camera with a timer on a tripod is much better.

Decide which portrait best captures what you feel is your
aura. Ask a friend, colleague, or even a stranger their opinion.
Try to capture their aura through the same process.

If you're having trouble finding enough different-colored
walls to work with, try it with different-colored shirts, blouses,
or dresses instead.

See also Pfahl, Terry

Michael Ashkin
Revealing an Enigma

One role of art is to reveal untruths in accepted correspondences or, conversely, to reveal truths in unlikely correspondences.

My assignment is thus to assemble an installation that includes one photograph, one object, and one text in such a way as to produce or reveal an enigma (i.e., an artwork). All three components should be ready-mades or assisted ready-mades (pulled from the real world with or without some modification on your part).

You might start with a found photograph, since this is ostensibly a photography assignment. This photo should have meaning to you, or perhaps some sense of mystery (though, of course, all photographs are mysterious). Now consider how you will choose the accompanying object and text. Will this choice be based on chance, association, metaphor, or absurdity? At what point does the connection between them become too didactic or too nonsensical? This really is a question of poetics. Be aware of the difficulties of using the logic of the world to undermine that same logic.

Finally, consider how the three components will be physically installed and how they will be displayed in a space (not necessarily a white cube gallery). Is the divide between these components and the space they occupy absolute, indistinct, or complicit, and how do you, as the artist, signal this to us, the viewers?

See also Fisher, Jude

Jane Evelyn Atwood
Storytelling With Pictures

Telling a story with pictures is just like writing with words. Something is seen, or thought of, or imagined.

I would like you to tell a story with images that you make and put together, one after another, to recount something—be it abstract, conceptual, documentary, or journalistic.

You can follow one person, a group, a place. Inside or out. It can be vast or very small. It can be realistic or abstract. It can be something real, an idea, a fantasy, an emotion.

You should use no more than eight photos, no fewer than five. Each image must add something that hasn't yet been seen in the images that precede it. The selection should be coherent.

See also Johnson, C. Reas

Theo Baart
My Uncle

When I was ten years old, I went to a kind of family reunion. This was my first encounter with many family members. I remember one gentleman introducing himself: "I am your Uncle Tom." He was so full of himself (and alcohol) that he introduced himself every fifteen minutes. When I grew older, my mother told me stories about how World War II had brought all kinds of trauma to the family: imprisonment and resistance; radical political beliefs; postwar colonial fighting; and more banal things such as adultery and fraud. The bottle did the rest. This normal, Dutch, petit bourgeois family fell apart. The weather and the traffic were the only safe topics during family gatherings. Some family members excelled at keeping up appearances, especially Uncle Tom, who was a "doctor" in Paris when he died—without any qualifications whatsoever, except a white coat. Of course, the family albums show nothing of this, neither the truth nor the appearances.

There are all kinds of personal events that are traumatic and overwhelming, and photographers may want to make work about it. You should start by asking yourself, "Will the subject and my approach to it be interesting to others, or is it just therapy for me?" Both are valid, but my experience is that personal projects are often too narrow to be universal or seem insightful to an outside viewer.

I've often thought—acknowledging the wish to make personal work on personal matters—that it could be a good idea, as an exercise, to make a reconstructed family album. Retell your family history. Combine family pictures with newly made material. Use the stories that have remained untold as a basis, and fictionalize others. This is art, not science. Try to place the project in a broader context. Edit the images and the stories so that an audience will be intrigued. I think I should make an album myself. I already have the title.

See also Badger, Heiferman

Gerry Badger

What Cannot Be Seen

As photography has gotten more and more personal, more and more photographers have become interested in issues such as identity, memory, and relationships. For example, I met one student who was photographing how difficult it was to "come out" in his endemically homophobic country. Another, a female student this time, was photographing issues related to child abuse.

The gay student presented portraits of young men, the child abuse photographer portraits of young women. My first question was, "How do I know these young men are gay?" "How do I know that these young women were sexually abused in childhood?" In other words, you're telling me, but the photographs aren't.

So many young photographers are trying to deal with the essentially unphotographable. Feelings, memories, and relationships are inside one's head, not out there and visible to all, especially to the camera. You can't photograph them directly. In order to get your point of view across, you must photograph them indirectly.

For instance, you can use words to amplify the imagery. Both students had elicited testimonies from their subjects, but, as sensitive human beings, were reticent about using them. "Fair enough," I said, "so make them up, invent them." As John Gossage has said, "It's all fiction anyway." But fiction in search of truth is a powerful weapon.

The student exploring child abuse had made several moody, semi-abstract photographs to go with the portraits. They were in fact more interesting and original than the portraits. So here was a way forward, to utilize poetry as well as fact. If we go back to Walker Evans (and we can almost endlessly go back to Walker Evans), he said that photography was about structure and coherence, but also symbol and metaphor, and "paradox and play and oxymoron."

Metaphor, symbolism, paradox, play, oxymoron. Here are the tools, along with text, for the photographer photographing what cannot be seen.

Of course, it's not easy to photograph the invisible and make a coherent piece of work with it. But that is no reason not to try. Quite the opposite. If you attempt something difficult, you may fail to some degree, but if you succeed, then you have really done something.

See also Kelsey, Ou

John Baldessari

Assignment 96

Using photography, prove a point as in a science fair diorama, display, tableau, such as: "How quickly does bread mold under certain conditions?", "Is plant growth hampered by use of conditioned water?", "What is the effect of colored lights on plants?", "Is untreated seaweed useful as fertilizer?", "What effect do ultrasonic vibrations have on plants?", "What is the effect of aspirin on potato plants?", "Why is a rainbow round?", "Do race, color, texture affect the strength of hair?", and etc.

See also Lazarus, Rudensky

Roger Ballen
Inside Out

Turn your eyeballs around toward the inside of your head ...
photograph what you see.

See also Ess, July **15**

Tim Barber
Findings

Find someone else to take your photographs for you. Tell them what you're looking for, and then see if you can find it in the photos they take.

 See also Blalock, Lampert

Richard Barnes
Collaborating Across Disciplines

In my class "Subverting the Document," we examine the nineteenth century not only through technology, in which the invention of photography was a major development, but also through the social sciences (anthropology, psychology, evolution, criminology, and eugenics). We discuss the interaction between photographers, criminologists, social scientists, etc. The nineteenth and early twentieth centuries are full of these collaborations. Charles Darwin, for example, collaborated with the photographer Oscar Rejlander on his book *The Expression of the Emotions in Man and Animals*, and Nadar's brother, Adrien, also a photographer, worked with the noted neurologist, Guillaume Duchenne de Boulogne on his book *The Mechanism of Human Physiognomy*.

Photography played a crucial role, not only in documenting new ideas in the social sciences of the nineteenth century, but also in developing and furthering the disciplines mentioned above.

Your assignment is to find a collaborator—for example, a forensic scientist, or someone else working in a field that is foreign to you—and offer your services as a photographer. Write about your interaction even if it leads to rejection. When you do find someone to work with, create a portfolio of images based on the experience.

See also Calisch, Fletcher **17**

Tina Barney
Slow Down

I've always felt that students tend to rush out searching for something to photograph in order to complete an assignment, without spending time really thinking about what they plan to photograph beforehand.

I have suggested that they put away their cameras (my dream is to do this for a whole semester) and write down their thoughts in any form they choose, such as a list of subject matter, conceptual thoughts, narrative plots, places to photograph, etc.

One of the best things about using a view camera, as I do, is that it slows down the whole process of picture-taking. This can be frustrating as hell much of the time, but this year I finally started using a handheld digital camera to see what it was like, and the speed and flexibility of digital just baffles me.

I feel that photography, as a medium, has a point-and-shoot quality to it no matter what kind of camera you use, especially if you compare it to painting. If the process is slowed down, then your mind can dissect what you're seeing, analyze its contents, and inspect every inch of the situation that interests you, so that you can design it with all the infinitesimal possibilities that exist. It just isn't an automatic activity, no matter how fluent you are as a photographer.

So think more and shoot less is the best advice I can give.

See also Parlato, Sultan

Douglas Beasley

Excerpts from Vision Quest Assignment Cards

Number 10: Go for a walk without your camera. Go back and make one photo of something you noticed along the way.

Number 14: Use negative space with "wild and reckless abandon," making your main subject a very small part of the composition.

Number 20: Walk an area you would normally drive past. Bring your camera and make photos of what you might normally overlook.

Number 28: Make a scenic photograph. Eliminate one element and retake the photo. Repeat until there's nothing left to take out. See how many steps you can make.

See also Benning, Young

Ute Behrend
The Coal Thieves

At the age of seventeen, I shared a flat with two guys that was heated with coal. The winter was long and cold. It was snowing all the time, and we had no money to buy coal. So one night, we drove to a coal merchant, broke in, threw sacks of coal over the fence, and dragged them to the car. On our trip back we were stopped by a police patrol. After the suspicious policeman had checked our papers, he asked us to open the trunk. "What do you have in there?" he asked, and pointed to the sacks. "Coal," we replied. "Oh, okay," said the policeman, and let us go.

His intuition was right, but what he saw didn't trigger anything in him. He had asked too few questions, and gave up too soon. No doubt he asked himself later that evening what he had probably overlooked.

Trust your intuition, and if you still can't see anything, ask questions!

See also A. Brown, Finke

Adam Bell
Failing to Succeed

At the heart of art is failure. Fail often and fail hard. The time and the space to fail are both precious commodities, especially for artists trapped within the indentured servitude of art school debt or recovering from its wake. With so little time and so much money on the line, this may seem like an impossibly tall order. But you may just have to give yourself permission and ignore your instincts.

Take a picture you think, or know, won't work. Try a genre or subject you dislike or that scares you. Turn your photo into a painting, a performance, or a sculpture, or vice versa. Take a picture you don't recognize. After all, what you think might work might not for long. Maybe it never did.

See also DuBois, Kippenberger

Roberley Bell
Points of Intersection

The importance of place in the creative process is often over-looked. In fact, where we are at any given time influences and alters our way of thinking and making. Even the subtle and quiet aspects of place matter. The intent of this assignment is to learn to see a specific locale through the senses, moving beyond our dependency on sight alone to understand place as a series of sensory experiences.

Seek out points of intersection that exist both as a physical space and as a metaphor, and that reveal an expression of contrast with your city. The goal is to reinforce your observational skill by focusing attention on contrast. Return to the same locale multiple times, not necessarily following the same path each time. Each time, return with a new and more focused intent, as you are seeking something specific. This is not necessarily a simple matter of contrast; to consider intersections requires developing the concept of something shared, something seen in reflection, something that unfolds through the process of observation. An intersection, for example, may represent a point of separation, but may also represent a point of connection. The points of intersection can be enormous contradictions or small nodes. What are the nuances of place and the discrete characteristics that distinguish one place from another? And by turning the corner, what is revealed?

In order for the city to unfold, reveal itself, and present possibilities of intersection requires that you visit the locale multiple times over the course of several weeks. This is necessary because what you experience at 2 p.m. on Sunday is not what you will experience at 2 p.m. on Friday or 3 a.m. on Tuesday. This assignment plays on what we think we know of place, and what we uncover over time.

See also Jacobson, McPhee

James Benning
An Assignment

Go for a walk. Before leaving your home, look at the clock.
Cover your ears and only look. When you see something
interesting, sit down and keep looking for at least an hour. Then
close your eyes and just listen. Keep listening until you have
heard enough. Then go home and see what time it is.

See also Perkis, Records

Dawoud Bey
Open Mind

Whatever ideas you have in advance about the subject you want
to photograph are just that—ideas. They are not the work itself,
but rather the things that lead you to the work. They give you a
reason to show up. Usually once you start working, other things
happen, you see something else, or you might even find some-
thing quite different from what you set out to find.

If you allow your preconceived ideas to be a ball and chain
around your ankle, so to speak, the results can often be nothing
more than a lifeless illustration of an idea. The ability to impro-
vise and respond in the face of the unexpected is what will
make your work interesting, what will make it more resonant
and meaningful for you, and probably for the viewer as well.

See also Hido, Steacy

Lucas Blalock
Audience

Make a picture for your friend. Look for something that he or
she would find beautiful, or tell him/her a joke, or remake an
existing picture with whatever objects or situations are at hand.
Try it again or move onto a new picture—this time for your
sister, or for Jan Groover, or for David Hammons.

See also Calisch, Deveney

Melanie Bonajo
Perspective

1. What do you see that others see?

2. What do others see that you don't see?

3. What do you know that nobody knows?

4. What does nobody know?

See also Feininger, Pratt

Chris Boot
A Test

In 1986, I signed up for the part-time photography degree course at the Polytechnic of London. I was already working as an editor, but I wanted to learn more about the medium, practically and theoretically, while fancying the possibility that I might transition to become a working photographer. The practical course for my first term at college was taught by Peter Goldfield, a charismatic figure of the British photography scene, who started the first photography workshop program in the UK in the mid-1970s. The "basics of black-and-white photography" course he taught blended rigorous lessons in technical perfectionism with spiritual guidance in the religion of photography. He was a true believer. He set his students an assignment each week, to be completed by the following week and presented to the group. Many were technically demanding— for instance, taking photographs of a white object on a white background, using the zone system—but the one that floored me was all about human interaction. We were asked to take fifty portraits in the street. I don't think he really cared about the portraits; the point was to be in the world, engaging people, lots of people, with a camera.

I went to Hyde Park that Saturday, for a mass rally organized by the Campaign for Nuclear Disarmament. I was working for the Photo Co-op at the time, and we'd been asked to produce a campaign leaflet for the local CND branch, and I thought the leaflet might work with a mass of portraits reflecting the diversity of campaign supporters. I didn't find it easy. I wasn't comfortable asking people, and I didn't really know what I wanted people to do for me. I didn't enjoy it. I nervously asked demonstrators if I could take their picture. Usually they agreed, sometimes after a short discussion of what the picture was to be used for. I concentrated on people's faces. Being a dutiful student, I didn't stop until I had at least fifty.

When I processed the film, and made contact sheets, I could see immediately just how bad I was at this. Everyone I photographed looked anxious and uncomfortable. Clearly I had no ability to put anyone at ease while making a picture of them. Discomfort showed in every face. This was exacerbated by my having taken no account of my height, relative to others. I am tall, and most of my subjects were shorter, so I somewhat towered above them. In each case they looked up at me, as if cowering. They all looked worried.

I have since learnt that some people gain confidence when they engage with the world using a camera. While others, like me, who aren't particularly shy, find that a camera complicates and interferes with everyday human relationships. I never resolved my issues with the camera, but Peter Goldfield's brilliant exercise became a key moment in recognizing a very useful bit of information: I wasn't cut out to be a photographer.

See also Visser, Weber

Yannick Bouillis and Colette Olof
Rejection Letter

1. Write down a list of your two all-time favorite artists (or publishers, writers, graphic designers, photographers, etc.). Artists you like so much that you are unable to say which one you prefer. Who you like so much that you would be irritated if someone asked you to choose between the two (like you were, when, as a child, someone asked, "Who do you like better, your mother or your father?").

2. Now choose one.

3. Write a gentle, friendly, and honest e-mail to the one you rejected, explaining in detail why he or she didn't make number one.

See also Brandt, Carter

Frish Brandt
Step Out of Your Shoes

In the first many years of my art life, I was largely drawn to finding the work of artists who spoke to me—artists who were asking similar questions to my own; artists who used the colors or the lines or the subject that I found resonant.

In time, however, I have found that the artists that most inspire me are the ones I am not "friendly" with. And the exhibitions that I learn the most from are the ones of artists I don't really fancy—artists whose work I haven't sought out or read about. Those are the ones I want you to think about.

In fact, if you can, go to a museum, or a library, and find your way to work that is unfamiliar, that you don't really like very much, that doesn't "sing in your key." That's where I want you to be, and just be with it.

Don't think too much. Just get close to it. Breathe for a while. Stop the monkey mind of "I don't like this. Never liked this. I remember hearing *blah blah blah* about the artist," and just look. Because you know what? Your current favorite artist is someone else's least favorite artist.

After you've spent a long time with this artist, go out and try to make something in the way that artist might have.

We spend a lot of time trying to perfect our own aesthetic high-wire walk, but there is much to be said for trying someone else's. It is in that that you can find your true balance, your true creative gait.

See also Fleming, Homma

Deborah Bright
Practical Advice

I offer the following eclectic bits of advice for today's young artists from the perspective of forty years in the U.S. art world:

1. Don't cede control of your ideas and work to others, ever.

2. Don't just react. Analyze.

3. Step back and enlarge your frame of reference to include all the domains of visual culture today, not just a particular medium or its culture.

4. Dwell in another culture/country long enough to perceive your own culture through others' eyes.

5. Take at least one anthropology class.

6. Develop good networking skills. You never know where opportunities will come from.

7. Regard the art market as you would any of the media/fashion/entertainment industries. In finance capitalism, these are winner-take-all enterprises that depend on a star system to create wealth for investors (international collectors).

8. Accept the hard truths that life is not fair and that investment markets like the global art market are neither benevolent nor meritocratic systems.

9. Find a community of peers that cares about and supports your creative work, even if it's a virtual community and/or only has one member other than yourself.

10. Assume you will need income-generating work other than your art and find the solution that won't deplete your art-making energy.

11. Especially if you're a woman, insist on the seriousness and centrality of your art practice to your life. Don't sacrifice it to please others or gain their approval.

12. Remember that artists don't exhibit their outtakes! We all produce duds sometimes.

13. Think about how your work will be preserved after you're gone. Talk to an art librarian or archivist about best practices.

14. Find a tax accountant who is used to dealing with artists.

15. Never stop thinking about what a privilege it is to be an artist. We are the luckiest people. Think about this every day.

16. Be true to yourself, to your work, and to those near and dear to you. They're all that matters, in the end.

See also Killip, Thomas

Adam Broomberg and Oliver Chanarin
Alias: An Exercise for Five Students or More

1. Invent the name and biography of a fictional photographer. He or she can be from the past, present, or future. Write a synopsis of the photographer's life and practice on a single sheet of paper.

2. Sit together as a group and introduce your fictional character as if it were you.

3. Then pass your written description to the person two places to your left.

4. Read the text you have received and make a series of photographs as if you were the fictional person described on the page. Imagine that you are inhabiting that persona. Enjoy not being yourself for a while and be careful not to slip into the habits of your usual practice. This work should not resemble anything you have made before because it is not your work!

5. Exhibit, publish, and promote the series of photographs under the name of the fictional character, not your own.

6. Never reveal who the real author is, not even to your mother.

See also Kessels, McFarland

Jeff Brouws
Our Relationship to the Windshield

While I don't find myself in a classroom situation often, when I do I like to give students a few exercises to help alter their spatial and cultural perceptions.

To wit: for road photographers, the windshield is an extra framing device we contend with as we drive in search of material. To see how that windshield shapes perception and formal issues, I ask my students to slowly drive down any small-town main street. Drive its span noticing what you notice; then turn around and drive in the opposite direction. See how the "look of things" has changed with this geographic reorientation. If you are with a companion, drive down the street again—but as a passenger this time, not the driver—and gauge yet again how your attention and perceptions shift.

Now park the car at the far end of the street. Get out and walk the same route you just drove. Again, monitor how your spatial perceptions change. Notice how the car and the windshield not only act as a framing mechanism, but perhaps a distancing mechanism as well, something that insulates you from the world, or maybe normalizes your vision and perception in such a way that it becomes routine. As a pedestrian, with the feel of the sidewalk beneath your feet, do your thoughts change about what might be important to photograph?

See also Kelly, Schneider

Able Brown
Rockaway Beach

It was the first week of March and I was on duty as a park ranger, walking the beach, checking to see if any piping plovers or American oystercatchers had made their annual pilgrimage north to Rockaway Beach in New York City in an attempt to lay eggs and raise young in a city of eight million awful people.

My partner decided to stay in the truck and listen to some NHL shit relating to the New York Islanders. I respected his wanting to root for such a sad sports team, but really had difficulty caring about a sport the white man stole from the Indians and capitalized on.

I wanted to get out and walk on a cold, empty beach.

A large requirement of my job was that I get out and walk. Check out animals. Learn to identify the flora, clean and maintain shit, look for possible poaching. (I have caught two different people hunting cottontail rabbits using a bow and arrow in Prospect Park, then selling the rabbit out of their food cart. It was actually tasty meat.)

I wore a ranger uniform: a Stetson and a belt loaded with a baton, pepper spray, a dog leash, handcuffs, and a small 35 mm camera. I have only taken three things out of this belt during my seven years. I took out the baton to break into my partner's locker (at his request), the dog leash once because that was how my supervisor liked her sex, and the 35 mm to photograph the beautiful, wondrous, hideous, and hilarious things and people that exist on this sphere spinning eight hundred miles an hour.

I had seen two gannets, three cormorants, and a bunch of gulls, but no plovers or oystercatchers. It was cold, a nice swell from the north with the wind from the northeast, creating pleasure paths for riding surfcrafts, if you can brave the balmy 44 degree water.

As I am walking I see a man, the only other person out here, approaching, wearing a long white beard, a ragged peacoat, a

sailor cap, scraggly Levi's, barefoot, using a cane: A Rockaway Beach Production.

He is taking long pulls from his pipe and gesticulating to himself as if solving large-scale environmental and economic issues.

I need his photograph. I don't know exactly why, but it has something to do with wanting to share this moment with others. I have never sought out a subject or place to photograph. I allow photography to happen as if I'm scribbling notes of goodness on a bar napkin.

Sometimes I ask permission to take a person's photograph, but my favorite photos have always been taken on the sly, without you or the subject knowing exactly what you're getting. Sometimes asking permission leads to all kinds of interesting things about people. Soon they are telling you that they are dying of bladder cancer, or just shaped their own wave rider, or just grew their own basil, or that they really enjoy the buttocks of Colombian women.

"Hey man, beautiful day."

"It's a crock of shit any way you twist it," he said back.

"Not too bad out here, away from people, the City."

"I've lived in Rockaway Beach for sixty-one years and have yet to visit the City."

"Wow. That's…"

"Shut up kid, it doesn't mean I haven't been to Morocco or Bora Bora. It just means I haven't been to that goddamn place people refer to as the City. I have been to Queens. Too many Slovenians."

"Good food though."

"If you like dried rabbit intestines, it's great! Who do you work for? The feds?"

"No, I am with the City. I am a City Park Ranger."

"That's stupid."

"We are all entitled to our opinions, sir."

I pulled out my camera. He stepped closer to me. He was about three feet away now.

"Mind if I take a photo of you? You got a good look. With the captain hat, the pipe, the sea, and all."

"Feds are hiring queers for everything now! Queer cops, queer Navy men, queer UPS drivers, queer rangers." As he said this, he swung his cane at me, with the ferocity of a darted black bear. I ducked. He swung again. I ducked. He was nowhere near hitting me, but he meant every swing he took with a "fuck the government" shout out between swings. I moved away from him. He was winded.

"Sir, you need to relax. I just wanted a photo of you. I thought the situation warranted it."

"Are you crazy, boy? That's a weird thing to do to a stranger."

"You are right. I am going to go my way now."

"The government is always in my business. You better go your way, boy."

"I will."

"Up ahead you will see a turkey wearing a bow tie. Help that thing out would ya?"

I couldn't believe I wasn't going to get a photograph of this guy. I walked on. I walked the shoreline, watching sanderlings dance their dance and talked aloud to some gulls. It's a habit that forms when you work on desolate beaches and communicate with four humans all day. My nose and lips were beginning to get cold. The wind changed from northeast to southwest, bringing serious coldness off the sea. I was about to turn around and head back to the truck, where one Vincent Piccallo was most likely blaring the heat, eating French fries, and listening to Islanders talk radio, when I see something big and white on the shoreline. It is not a gull, egret, gannet, or anything else so white and large that I can recognize. I get a little closer and take a look through the binoculars.

It is a domestic turkey wearing a red bow tie.

I call my partner on the radio. "Queens 70 to Queens 81?"

"Proceed," he says, and I can tell he just swallowed down that last bite of a chicken Parmesan sandwich.

"Can you give me a 71 at beach 64. Bring gloves and a carrier. We got an animal condition."

"10-4."

I am watching this turkey in a red bow tie walking the shoreline of Rockaway Beach. I see Piccalo pull up on the boardwalk, then make his way down to the shoreline. He stands next to me. "What the fuck is that, Brown?"

I give him the binoculars. He takes a peek.

He gives the binoculars back to me, gives me a look, the same look he gave me when he jumped into Prospect Lake to "dispose of" a six-foot alligator on a call two years ago. He charges at the turkey, and being weakened by stress and hunger, it becomes as still as a horseshoe crab shell.

Piccalo grabs the turkey and holds it in his arms and walks back my way. The turkey looks like a card dealer on her/his fourteenth hour. Piccalo holds it gently in his arms and looks off into the distance. I take a photo.

"Asshole, can't you just fucking let a moment be a moment!?" Piccalo says.

See also Terpstra, Ventura

Michael Christopher Brown
The Last Seven Pictures

For much of my career, photography was more of a way to make money than a compulsion. I spent a lot of time communicating ideas that were not my own. Two years ago, during the Libyan Revolution, I began taking a more honest path with regards to photography. It had to do with finding a voice. An interesting exercise that anyone can do is to take one photograph per day for a week. The idea is to be focused enough to only photograph what is absolutely necessary. What are the seven pictures that not only define the week, but yourself? What if you were to die next week and these were to be the last seven pictures of your life? This exercise can be an important analysis of the self in relation to life and photography.

See also Anderson, Harbutt **39**

Peter Bunnell

Assignment Two from Twentieth-Century Photography Seminar

> *If you want to draw a bird, you must become a bird.*
> —*Katsushika Hokusai*

Think about this notion expressed by the Japanese artist Hokusai in terms of photography: what is the fusion between the photographer and his or her world? Consider the images by a particular photographer who has worked within the last thirty years and comment on how you believe this photographer functioned in terms of direct experience on the one hand, and the translation of fact and idea into pictorial form on the other. How do you believe such an image may be interpreted by you, the viewer?

Select a specific photograph by this photographer and analyze it in answer to the above queries.

Do some research about what the photographer has said about his or her work in general, and/or what others have said about it.

See also McCall, Phelps

Owen Butler

Two Approaches

The Blind Photographer

This assignment goes back to the 1950s. Students paired up, and one student was blindfolded and given a ten-foot pole as a guide. Led by the other student, s/he would stumble about until they tapped something and, for whatever reason, would then take a photograph that they could not see. With careful editing, a finished print was made, framed, and brought to Minor White's class, where it was gushed over as if it were the third coming of Alfred Stieglitz.

The Nude Photographer

This assignment tries to alter the physical way in which we work. We are prone to habits that yield predictable results. I ask students to create a photograph of their best friend and also to make a second photo of their best friend while they, as the photographer, are nude. The outcomes between the two pictures will be very different, but it does not matter which they do first.

See also Carroll, Johnston **41**

Nolan Calisch
Offer Your Services

Arrange a visit with three different people who are confined to three different institutions (hospital, prison, school, cubicle job, etc.). Offer your services as a photographer. Tell them you will photograph anything they would like you to photograph and promise them copies of the prints when you are done. Complete the assignments you are given. Make a small book that contains all the photographs and give a copy of the book to all three people.

The people who participate in this exercise are also, in turn, the intended audience. In my experience, working with a specific audience, as opposed to an ambiguous one, tends to make the artistic process more meaningful.

See also Barnes, Onorato & Krebs **43**

Reid Callanan
Cameras Don't Take Pictures

Of all the workshops that I've taught, my favorite is called "Cameras Don't Take Pictures." In this class, we examine where our images come from, because they certainly don't come from our cameras. What we find out very quickly is that our photographs come from our imaginations, our curiosity, our questions, our hearts, our memories, our dreams, and from all of the different things that make us human. A few assignments I give to help speed this process along are:

1. The camera is blind and it doesn't understand mood. Make an image with your camera of a mood.

2. Make a portrait of something you love. Now make a portrait of something you hate.

3. Recreate a dream in a sequence of ten images.

4. Create an image you don't understand and create an image that asks a question.

5. Make images where the subject is on the edge of the frame and then make images where the subject is outside the frame.

See also Fink, Kander

David Campany
What to Photograph?

I recall the very first project I gave to my students on my very first day as a photography tutor. If they learned a tenth as much about photography as I did from it, I'd consider it a success.

I had a group of thirty-six students and it went something like this: each student thought of an "instruction," an object, place, or scenario to be photographed. The thirty-six instructions were compiled and given to all thirty-six students. Each was given a roll of color film (thirty-six exposures) with which to make one attempt at each instruction. They processed their film at a local lab and brought their 6-by-4-inch prints to the class.

We laid them out in a huge grid, so that vertically you could see thirty-six different responses to the same instruction, while horizontally you might be able to discern each student's approach or style.

I still have the list of instructions they gave each other:

> A red ball
> A tree and a dog
> An ugly photograph
> A political argument
> A kiss
> A shallow-focus image of a bar of soap
> A random photograph
> An unambiguous photograph
> Grass and concrete
> An old-fashioned photograph
> A futuristic photograph
> A blue car and a white car
> Nigeria
> Timeless beauty
> Flowing water

A woman dressed as a man
An empty room
Consumerism
A person crying
A really bad smell
Bright clothing lit by flash
A dangerous place
Dawn
Justice
A cheese and tomato omelette
A boy shoplifting
A plate in the air
A modern landscape
A parking lot at night
Things in a pile
Things in a long line
A fake photograph
A celebrity
Someone asleep
A classic still life
A smile

This is a list compiled by nineteen-year-olds thinking they might want to take photography seriously, and I think it is remarkable in that light. It tells you something about their "world" and how photography might fit into it or express it. It also seems uncannily like an inventory of all the major trends in "art photography" from the 1960s to the 2000s!

We didn't really know what we were doing, but the results proved to be so fascinating for the group that we put the grid up on the studio wall and it stayed there all year. I wish I'd kept the pictures—all 1,296 of them.

See also Muellner, Whitaker

Asger Carlsen
Photography as Sculpture

Take a photograph of your own body (i.e. your leg, arm or chest). The photograph needs to have a feel of abstractness. Then make an object from it using a non-photographic material (i.e., clay or metal).

See also Ezawa, Klein

J Carrier
Five Obstructions

During my MFA class, Doug DuBois showed the beginning of
Lars von Trier's film *The Five Obstructions* to inspire us to work
outside our comfort zone.

Placing limits or obstructions on oneself can be liberating,
removing the demands of decisions and the dilemma of choice.
Constraints allow one to focus, hone in on process. Realizing
one's limitations, and learning how to work within them, is
essential to any artistic process. This assignment is aimed at
allowing you to explore the area outside your comfort zone, to
work against your tendencies, and ultimately help you focus on
improving your process.

Obstructions can be gifts. Before reading further, pick one
of your favorite photographs (yours or another photographer's),
what von Trier would call "a little gem that we are going to
ruin."

You are going to reproduce this photograph.

1. You have twelve frames.
2. You have four hours and must work alone.
3. You must shoot on film.
4. You cannot travel further than five miles.
5. There must be a cat in the photo.

See also DuBois, Slota

Eric William Carroll

Chicken

Choose a person, preferably a stranger, to make a portrait of.
After securing their permission, begin photographing them.
Ask them to try a few poses, move the camera around, suggest
a different location. Never stop photographing. If/when the
subject becomes visibly irritated, snap the shutter at an even
faster pace. Fake technical problems to prolong the session for
as long as possible. The only rule is that you cannot choose to
stop photographing—the subject must tell you that they no
longer wish to have any more pictures made. Bonus points for
those who get a model release signed post-shoot.

(Inspired by Jim Goldberg)

See also Ivis, Lampert

Keith Carter
Garden of Earthly Delights

Whether a teacher or student, you will have your share of disappointments along with the pleasures of making art. How you deal with them is the key to an engaging career. My favorite way of dealing with those disappointments comes from a funny and insightful friend. "Every time I sent slides to a gallery or entered a competitive exhibition and got back a form letter that mostly indicated nobody even bothered to look, I would go buy a shrub and plant it. I called it my 'Garden of Small Disappointments.' I have a climbing rose for X gallery, a hibiscus for Y, and a flowering wild azalea for those dumb sons of bitches at the Z museum. I'm thinking of renaming it my Garden of Earthly Delights."

See also Bouillis & Olof, McCaw

Henri Cartier-Bresson

From the Images of Man Audiovisual Series, The Decisive Moment: Henri Cartier-Bresson, *1973*

The most difficult thing for me is a portrait. It's a question mark you put on somebody. Trying to say, "Who is it? What does it amount to? What is the significance of that face?" The difference between a portrait and a snapshot is that in the portrait, the person has agreed to be photographed.

I like to take pictures of people in their environment—the animal in its habitat. It is fascinating coming into people's homes, looking at them. But you have to be like a cat. Not disturb. On tiptoes, always on tiptoes. It's like a biologist and his microscope. When you study the thing, it doesn't react the same way as when it is not being studied. And you have to try and put your camera between the skin of a person and his shirt, which is not an easy thing.

See also Lambrou, Leiter **51**

Elinor Carucci

A Thousand Pictures

Simcha Shirman was one of my professors at the Bezalel Academy of Arts and Design in Jerusalem. What he taught me changed the way I saw photography.

When I was in my freshman year in art school, I felt that I should be doing "important" work and was unable to muster the intuitiveness and flexibility I had possessed when I was fifteen and would play with my father's camera. One time in class Simcha asked me, "Are these the images you want to leave behind after you are dead?" The importance he attached to the pictures shocked me.

Before the spring/Passover break (which is three-and-a-half weeks-long in Israel because of the Jewish holiday), he gave us an assignment that I found very annoying at the time. He said, "Use up one roll of film every day, no matter what. You must take thirty-six pictures every day for almost a month." I asked, "And what if there is nothing interesting to photograph that day?" He replied, "Take thirty-six pictures anyway, of whatever is before and around you."

"Making art is not about quantity," I muttered, annoyed. Simcha did not seem bothered by my skepticism. "I want to see about a thousand photos when I am back."

I was left with no choice. I took so many pictures, every day, of things that I had never thought of shooting before, pointing the camera at everything, thinking less, making more, letting go of preconceived ideas about what art should or should not be, about what is "important" enough to be in a photograph. It all had to go.

Indeed, I did take some boring pictures, but to my surprise, there was so much that appeared in the work, so much that was opened up. I learned the importance of working intensively and the delicate balance between doing and letting go. I learned how to let things happen, but to capture them as they do.

See also Abeles, Bey

Ricardo Cases
Spanish Recipe

Ingredients
Four cups of coffee
A camera
Comfortable shoes
A place in a foreign country (outside Spain)
A music device with headphones and the complete works of
 Manuel de Falla
Eight hours
A sunny day

Directions
Step into your shoes. Place the headphones on your head. Take
the first coffee. Once in the street, turn on the audio device and
start walking without any direction and with no interruption
except for those strictly necessary for the proper performance
of the exercise—meaning, the second, third, and fourth cof-
fee. Take pictures of everything that suggests to you the term
"Spanish." Do not talk to anyone, do not stop walking, do not
look at the time (set the alarm on your phone to alert you that
the exercise is over). At the end of the day select ten photos.

(Based on the original recipe of Mario Rey's series Ameri-
can Insider and on the José Ortega y Gasset quote, "Only the
imaginary can be exact" that appears in the book *An Imaginary
Spaniard* by Cristóbal Hara.)

See also Maddock, Powell

Melissa Catanese
The Arrangement Game

> *Art begins the moment the creaking of a boot on the sound-track occurs against a different visual shot and thus gives rise to corresponding associations.* —*Sergei Eisenstein*

Editing your work can be a daunting process. How we interpret the meaning of a photograph can greatly change based on where it is placed within a sequence. In this exercise, we experiment with different ways of organizing photographs, teasing out many possible readings and strengthening our ability to edit our work.

Start with a large stack of photographs. Begin the exercise by separating groups of ten to fifteen images, seeking out simple visual clues. Consider the following ideas as starting points for making a group: a particular color palette; similarities and differences in shapes; groups based on type (portraits, objects, landscapes, etc.).

Move a single photograph in and out of each group, exploring the different ways it can be activated. Spend time looking. Question your instincts. Play around with making obvious pairings as well as disparate ones. Think about the associations that are made when placing one image next to another and how they change when more images are added.

Lay your groups out in a line, or if you're feeling funky, try a pyramid. If you feel stuck at any point, flip the beginning and the end or start in the middle working outward towards each end. Once you're happy with an arrangement, photograph it with a digital camera, shuffle the stack, and start over. You may not end up using any of these sequences, but separating them into these groups will help you better understand the potential themes and patterns that exist in your work and provide structure for tapping into them.

 See also Martin, Schles

Bruno Ceschel
Shooting Happiness

Take five photographs of things that make you happy. Just do it instinctively.

For example:
1. Spend time with people you like to hang out with.
2. Take the train/bike/car to visit that place you always wanted to see.
3. Use the assignment as an excuse to photograph that stranger you have been fancying for a while.
4. Go back to the secret clubhouse you had when you were a kid.
5. Lock yourself in the bedroom with your lover(s).
6. Organize a party for grandma.

Photography is the most powerful tool with which to record and relive pleasure. Use it.

See also Frelin, Gearon

Lewis Chaplin
Lessons Learned from a Failed Attempt

1. Find the camera that you have owned the longest (your first ever, preferably). Put a roll of film in it.

2. Tape your watch to the camera and walk out of the house.

3. Head north.

4. Every time the second hand of your watch reaches the top, take a photograph.

5. Do not put the camera up to your eye.

6. Walk for thirty-six minutes (or twenty-four).

See also Cases, Mater

John Chiara
Taking Stock

Every five years reorganize your collection of photographs. Take several days to look through all of your photographs—those that are personal, collected, or vernacular, along with those you consider your photographic work.

Think of which photographs you respond to most and which no longer make sense for you to keep in your photography collection. Think carefully about how to reorganize and categorize your photographs as a whole and singular collection. Focus on any relationships within the photographic collection and organize them accordingly. What kind of collection of photographs do you have?

Write an essay defining your photographic collection along with any new insights you have discovered about what has quietly emerged as your collection of photographs over the years. Take some time to visualize the collection of photographs you eventually want to make.

See also Keegan, Nakadate

Jörg Colberg
Letters to Yourself

Get out of the house and take one picture, spending not more than ten minutes to do so.

Don't look at the picture (assuming you used a digital camera). Go back home. Write a short text (half a page) about why you took that picture. Put it into envelope A. Write another short text (half a page) about what you remember the picture to look like in your viewfinder. Put it into another envelope, B. Once done, store everything and wait four weeks, not looking at either the picture or what you wrote.

If you use film, get it developed, but don't look at the picture; just get a cheap print made somewhere.

After a month, open envelope B, read about your picture, and look at it. Then write more about your picture, about what it shows and what it doesn't. Base your writing only on what is in the picture. Put the pages into envelope, C. Once done, store everything and wait another four weeks, not looking at either the picture or what you wrote.

After another month, open envelope C, read about your picture, and then go about recreating it, based on what you wrote. Don't look at the original picture.

Once you're done recreating the picture, put the original and the recreation next to each other, and look at them. Are they different? Why? How?

Also, read what you wrote in envelope A and see whether you can find any of it in your new picture.

Lastly, compare what you wrote in envelopes B and C.

See also Abeles, Chiara

Lois Conner

Rules for Students in Introduction to Photography

1. Don't drop your camera.

2. Make sure the film winds.

3. Avoid graveyards, campus arches, the Manhattan skyline from New Jersey.

4. Don't put the "subject" in the middle of the frame every time.

5. Remember to look through the camera. Consider what it includes and eliminates, how the frame informs the picture from the edges to the center.

6. Photograph something you love, hate, are intrigued by, that infuriates you . . . and watch how light illuminates and transforms it.

7. Don't photograph everything from eye level. Move your feet, bend your knees, climb up on things, lie on the ground, walk in closer and observe.

8. Circle your subject while looking through the camera; watch how the background and light change.

9. Photograph at different times of the day and night—not only in your room, house, or dorm, but also in places that are unfamiliar to you.

10. Read John Szarkowski's *The Photographer's Eye*.

See also Goldberg, Keegan

Linda Connor
Visual Source Binder

Create a visual source binder. Each week, find the work of five photographers or artists who interest you. Books are best, but your sources can include exhibitions, websites, etc. Print at least one key image from each source (this could be a photocopy, an ink-jet print, or even a show announcement you saved). Adding a copy of the cover or title page of the books can also be a good reference. For each entry, write in (by hand) the artist, title, and a brief response to the work. Both the personal response and the physical act of writing will help you remember the work better than if you were just to type it.

Keep all these entries in a three-ring binder. This type of notebook is essential because you can reorganize and resequence it as your collection grows. By the end of the semester, you will have over one hundred different entries in your binder and you will find your knowledge and retention of photographic artists has grown by leaps and bounds.

This exercise works for all students, from beginners to graduate students. This notebook will prove a very useful personal resource as well because all the references are self-selected. Each student's binder will be its own unique reflection of their interests and development, a valuable guide as their art practice evolves.

See also Davis, Kurland

Matthew Connors
A Short List of Remedies for Photographer's Block

Hello to You
Choose a street corner with moderate pedestrian traffic and stand there for a predetermined hour. Say hello to every person that passes by. Take portraits of the people who stop to talk to you. Return to the same corner the following week at the same time and hand out copies of the pictures.

Perimeter Delimiter
Identify the boundaries of your neighborhood or town and draw them out on a printed map. Walk them to the best of your abilities and take pictures along the way. Stand as close as you can to the border when taking each picture.

Neighbor Labor
Introduce yourself to your closest neighbor. Tell them you are a student working on an assignment and ask permission to accompany them to their job tomorrow. Spend at least an hour with them at work and make pictures there. Additional permissions may be required. Repeat with other neighbors.

Physical Laws
Using household items, construct devices that will illustrate one or more of the following laws of physics: Snell's law (the refraction law) the Tyndall effect, Lambert's third law, Archimedes's principle, or Newton's laws of motion. Photograph them. These are illustrations and need not be viable experiments.

Sticks and Stones at Home
Contact a former bully and ask them if they would be willing to meet up with you. Make a portrait of them in their childhood bedroom.

In the Family

Make a series of pictures of the decorative objects, art, and photographs found in the houses of your relatives. Consider photographing as if you were making images for an archaeological study or exhibition catalogue.

Terms of Estrangement

Contact a former partner that you haven't spoken to in a long time. Arrange to meet and take their picture. Make a distinct portrait for each year that you were together.

Frank Cost

Drones

One of the results of major government and military invest-
ment in drone technology has been an overflow of related com-
mercial products. These tiny, helicopter-like devices are now
available to the general public and are remarkably affordable.

Your assignment is to purchase one of these "drones." If it
does not come with a lightweight camera, purchase one (also
an affordable drone-related product) and attach it to the drone
using velcro or tape. It can be a remote-controlled still camera
or a small video camera.

Choose a location (no bigger than a city block) and spend a
few hours photographing that location on the ground with your
digital SLR. On another day, return with your drone camera
and photograph the same location from the air. Make five
prints from each set of images.

Since we have grown accustomed to seeing photographs
taken at eye level, how does the change in height alter the
work? Did people notice or react to the camera? If so, how?
How did you feel when flying the camera? How does the new
perspective alter your perception of the place and your relation-
ship to it? If people are present in your location, did the new
viewpoint seem to alter your relationship to the people? When
looking at the two bodies of work, how do they each make you
feel?

See also Kinsman, Paglen

Charlotte Cotton
How to Make Ideas Better

This is a workshop exercise that I learned from Mark Allen, founder of Machine Project in Los Angeles. What I like about it is that it is an effective way to create a real conversation in a group about the nature of having ideas—it is easiest to generate ideas when you are in a relaxed and generous state of mind. It's even better if you use a group meditation session beforehand to calm and focus everyone.

The How to Make Ideas Better exercise is a quick process of individually having ideas and then making them even better through discussion. Each participant is given two sheets of paper, which are taped to the walls of the meeting place at their writing height. Ask the participants to write the numbers one to ten down both sheets. Tell the participants that they have twenty minutes to write down twenty ideas for projects they want to realize; these can be ideas that they have been thinking about for a while or things that have occurred to them during the workshop.

The ten ideas that they write down on the left-hand sheet of paper can be anything from a subject they want to investigate through making photographs to an event that they feel would be timely to stage, or even an initiative that would enhance the experiences and progress of the group/program they are part of. The ten ideas that they write down on the right-hand sheet of paper can be equally diverse but have to be presented through the eyes of a character or single interest group that you allocate to each participant. My personal favorites are: a nudist, a marauding Viking, a turtle, a pack of hungry wolves, Elvis Presley, and Mahatma Gandhi.

While the twenty minutes progress, walk around and answer any questions participants have. Be encouraging. Enjoy and share with the group the humor that participants are injecting into the ideas (i.e., set the tone so everyone feels

comfortable enough to write down lighthearted and half-formed ideas). Let them know when their time is up and orchestrate it so that each participant quickly presents their ideas to the group. Occasionally, a participant won't feel able to get their head round writing twenty ideas in twenty minutes. Talk it through as a group—about different participants' needs for a situation in order to let ideas flow. You can end the exercise with a group discussion about what the exercise illustrated. Likely issues that will arise include how we self-censor; the importance of humor and creativity in responding to real problems; and the range of ways that ideas can start, from the juxtaposition of two words to releasing our alter egos.

A further ending to the exercise could be to pick a couple of the ideas generated that piqued the group's interest and spend ten minutes collectively making a list of what modifications and developments would make the idea even better. Then make a list of what would make the idea and its outcome so much worse. This can be a pretty useful checklist for the participants and the development of their ideas in the future.

See also Muellner, Shank

Eileen Cowin
Beautiful

1. Photograph something beautiful.

2. Make a beautiful photograph.

See also Defibaugh, Diederix

Reuben Cox

A Dozen to Gnaw On

1. Camera out of the bag! Lens cap off! Crucial first steps.

2. Each morning, Shirley Temple would do a single push-up, look into the mirror, and recite the Pledge of Allegiance. Why not? Anything to give you an advantage.

3. Consult the *I Ching*. If you do not like what you get, it is perfectly acceptable to toss those coins again with the hope of a better outcome.

4. Garry Winogrand hung a lucky rabbit's foot on his enlarger, saying, "It can't hurt."

5. Avoid zoom lenses at all cost. Very few great photographs have been taken with telephoto lenses. Moving your body closer to, or further away from, the thing you are photographing is always best.

6. Perhaps an antiquated notion, but you are probably not working as hard as you need to be working to achieve a satisfactory result.

7. "Focus, and see what develops." —Gregory Crewdson, 1991

8. Dissatisfied with the way a shoot at a Pennsylvania VFW lodge was proceeding, I once saw/heard Judith Joy Ross violently cuss herself out under the semi-privacy of her focusing cloth. Then the master got to work.

9. Cold-call artists you admire and try to invade their living/ working spaces. This can be very educational and enlightening, is tuition-free, and often involves dinner and drink.

10. Some of your teachers care very deeply about your education, but not all of them!

11. It is good to have a plan before you leave the house or enter the studio.

12. Unlike painting or poetry, photography requires the artist to be in situ. You will need to bring a camera to the thing you are photographing. Often this means putting yourself in uncomfortable situations. This is your sink-or-swim moment as a photographer.

See also diCorcia, Gilden

Barbara Crane

Some of My Beliefs About Photography and Teaching

1. I believe that the best you can do, as a teacher, is to support a student's efforts even though you may not like the student's imagery. They need to know that someone believes in them and respects them for what they do, and that their efforts in some way are of great worth.

2. I also believe that a "mistake" picture is a usable entity to be pursued.

3. The way I see photography is, "It's all about light." Be conscious of the quality of light at all times.

4. From my experience, no matter what kind of camera you use—analog or digital—contact prints and proof sheets are essential to improving your vision for the next picture-taking session.

5. It's also all about practice. I used to tell students, "If you're a tennis player, how many hundreds of thousands of times do you have to practice your tennis serve?"

6. Finally, self-discipline of the mind is of the essence.

See also Kurland, Shore

Yolanda Cuomo
Sister Corita's Rules

Many students overthink things to the point of being unable to create. They are afraid of making mistakes, afraid of not being brilliant. It is all too much pressure. When I found this list of rules by Sister Corita Kent, it struck a chord.

My aim is to create a place for them to experiment, so I give them a handout of these rules in the hope that they will put them on their refrigerator.

Rule One: Find a place you trust, and then try trusting it for a while.

Rule Two: General duties of a student: pull everything out of your teacher; pull everything out of your fellow students.

Rule Three: General duties of a teacher: pull everything out of your students.

Rule Four: Consider everything an experiment.

Rule Five: Be self-disciplined—this means finding someone wise or smart and choosing to follow them. To be disciplined is to follow in a good way. To be self-disciplined is to follow in a better way.

Rule Six: Nothing is a mistake. There's no win and no fail, there's only make.

Rule Seven: The only rule is work. If you work it will lead to something. It's the people who do all of the work all of the time who eventually catch on to things.

Rule Eight: Don't try to create and analyze at the same time.

They're different processes.

Rule Nine: Be happy whenever you can manage it. Enjoy yourself. It's lighter than you think.

Rule Ten: "We're breaking all the rules. Even our own rules. And how do we do that? By leaving plenty of room for X quantities." (John Cage)

Helpful Hints: Always be around. Come or go to everything. Always go to classes. Read anything you can get your hands on. Look at movies carefully, often. Save everything—it might come in handy later.

See also Bright, Parlato

Sara Cwynar
Object Lesson

Look for five to ten objects that are somehow related—it could be by color, type of object, quality of surface, even a theme like "tropical," or from the same place, like "stuff from Mom's basement." You don't necessarily have to go far in your search, but it can also be fun to make a trip to a junk store or some other place to find discarded objects. See what your chosen objects look like photographically and how they relate when they are placed together in one image. Narratives will develop between the objects.

Shoot a roll of film of your objects placed in different arrangements. Take some out, put new ones in, move them around.

If you want to challenge yourself further, look at what you've made with the objects and go out into the world to try to find real outside things that relate—a sign that relates to one of your objects, a color that mimics something you found, or a person who reminds you of your photograph.

See also Engman, Palmer

John Cyr
Limitation, Routine, and Repetition

Limit yourself to one subject; it may be narrow or broad. The content of this work isn't the main focus of the assignment and shouldn't be labored over for too long.

Determine a time in the day that you are routinely available to take a photograph of your chosen subject.

Repeat the process of photographing your subject at the decided time for an arbitrary, but preplanned, sequence of days.

The typological results will highlight the similarities and differences inherent within all subjects over the course of time.

The purpose and motivation of this exercise is for students to revisit the first steps of project creation and production while stressing the importance of diligence and consistency in their photographic practice. Although it may take repeated experimentation, it is common that this exercise will stimulate creativity for students and serve as a starting point in the development of a cohesive and unique project.

See also Anderson, Schiek **73**

Tim Davis
Don't Do Anything Subversive

Whatever you do, don't do anything subversive this week. Please do not elude authority, defy expectations, outrage anyone, or use photography in ways it isn't ready for. Whatever you do, do not waste any of your time looking at Marcel Duchamp, John Heartfield, Walker Evans's subway portraits, Guerrilla Girls, late Diane Arbus, Piero Manzoni, Andres Serrano, Janine Antoni, Merry Alpern, Leigh Ledare, Billboard Liberation Front, or Justin Lieberman.

Make sure you have the usual amount of work, eight finished prints, all the same size, on a recognizable documentary or personal subject. Don't dream of stealing anyone else's work or creating a disturbance or outlandish performance. This is a classroom, not a protest rally, stage, or psychologist's office. Just take pictures; that's all we expect.

See also Goldberg, Shore

Denis Defibaugh
Beautiful from Nothing

Make thirty-six unique, beautiful photographs of one piece of white bond paper. Your goal is to make something beautiful from nothing.

Consider the following:
Equivalents
Abstraction
Expressionism
Line, Space, Shape, Form
Chiaroscuro

You may not cut or tear the paper, but you can fold it, roll it, or crumple it. Shoot on a white background in a studio with spotlights and soft light. Use color filters on the spotlights, if you desire. There should be nothing else in the photographs but one piece of bond paper. Explore lighting and change the lighting for each photograph.

(This assignment is a variation of the Paper Assignment by Charles Arnold.)

See also Perkis, Slota

Sam de Groot
Devil's Advocate

The group is split into pairs. Each pair receives a different photograph. One person in the pair is assigned to criticize the photo as being somehow "bad"; the other, to defend it. Everyone gets some time to prepare their case, and then each photo is debated in several rounds. The teacher can act as moderator, provoking better arguments from either side.

Elisabeth Klement, Laura Pappa, and I organized this exercise in several different contexts. You can set it up anywhere, anytime, without any preparation, and it's a great way of getting people to critically reconsider quality criteria, without being bogged down by personal taste.

See also Dow, Ulrich

Janet Delaney
The Self-Portrait

The self-portrait is an essential assignment because it brings together so many of the complex notions of a photograph. Students attempt to photograph ideas, feelings, the unknown, the past, or the future. Though the self-portrait assignment usually comes at the beginning of a class, as a way of introduction, I prefer to situate it deeper into the course once students have begun to build trust with one another. Even with omnipresent cell-phone documentation, the act of sharing an honest image of oneself in a classroom setting is challenging. Beyond the technical struggles, it asks the students to be risk-takers, to look inside, and to be fully vulnerable to their subject, to themselves.

1. Write ten nouns that best describe you.
2. Now write ten adjectives.
3. Add ten verbs to the list.

Each word should be a direct reflection of how you feel about yourself at this specific moment. The last few words at the end of each list might become fairly abstract. You may find yourself reaching past the initial ideas and into words that are more fanciful, more honest, and perhaps more problematic. Use this list of words as a way to enter into the making of a photograph, which is quite different from taking a photograph. Remember, be alone with your camera. No one else can click the shutter for you.

I polled former students about their response to this assignment. Here was one answer that bears repeating:

"I had been in an awful, long-term relationship with an emotionally controlling, manipulating son of a bitch. I was not able to find the strength to realize how miserable I was; I was stuck. Your assignment was to make a self-portrait. I grabbed my spool of vintage sewing thread, the one I had always loved for its thick, coarse, yellow density, and made my way to the

studio. Once there, I bound myself in thread, embarrassed, but determined. I tried to express in those photos something that went between being trapped, being helpless, being knowing, powerful, stuck, tangled, engaged.

Later, he called me everything but a whore for showing bare skin to a room full of strangers, berated me for my 'illusion of nudity.' For the first time, I stood up to him and told him that he had no right to control my creativity, my expression, my art. And that broke the spell. I saw what he was and what I had become before him. And then I left him. That assignment, those photos, gave me a hard look at myself, and I haven't been the same since."

See also Saville, Thomas

Cristina De Middel

The De Middel Three-Step Guide to Photographic Storytelling

1. Watch your favorite movie again. Without leaving your city, try to tell the same story in twenty images. Sci-fi and old classics are welcome, whereas romantic comedies are not really recommended (even if it is your secret favorite).

2. Read your favorite book again. Without leaving your neighborhood try to tell the same story in twenty images. You can try to work with what you remember of the book if you don't want to read it again (but would it really be your favorite book then?)

3. Listen to your favorite song again (if you're not listening to it now). Without leaving your house try to tell the same story in twenty images. I personally find it a bit difficult to work with hard-core metal songs in this exercise, but any music style is welcome. If you want to go pro, try "Bohemian Rhapsody" from Queen.

In the first step, you will be making a translation from one language to another with the help of a visual reference, as well as an emotional link to a story you are familiar with. The second step eliminates the visual reference and forces you to create your own, still keeping the story structure and the description of places and characters which you might find helpful. The last step forces you to decode a story (if any) and interpret it with just acoustic information or stimulus . . . don't forget the chorus!

Needless to say, you are free to use your own archive of images and the infinite resource on the Internet to tell your stories, but I strongly encourage you to go out and shoot. It is way more fun! You will have passed the test if you can show the series to your mother or friend and they can guess which movie, book, or song you are picturing.

See also Cases, WassinkLundgren

Lorenzo De Rita
Alphabet of Assignments

a. Do one, or two, or more, or even all of the following assignments.

b. Look for something that doesn't exist. And find it.

c. Make the involuntary happen.

d. Give a present to yourself without spoiling the surprise.

e. Establish the exact width of your personal space.

f. Disassemble a thought for the pure sake of it.

g. Pour a generic quantity of invisibility into a visible thing.

h. Start a collection of question marks.

i. Demonstrate the validity of this emotional mathematics equation: $11 + 22 = 8$.

j. Take a picture that embodies this definition of beauty by Charles Simic: "Beauty is about the improbable coming true suddenly."

k. Find a way to open a door that opens outwards by pulling it.

l. Take a second and split it in two parts. You now have two seconds. Split them into two parts. You now have four seconds. Split them again, being careful to not break them, into two parts. Keep splitting the seconds until you have a life-lasting second. Give it to someone.

m. Identify, within a reasonable approximation, the instant in which "much" becomes "too much."

n. Do everything you can to do nothing.

o. Transform a kilogram into a kilowatt.

p. Reassemble assignment f for the pure sake of it.

q. Quiz: Better to fail as a poet or to succeed as an engineer?

r. Go to the limit of a lie just before it becomes truth again.

s. Write an essay on "senselessnesses" without using the letter "s."

t. Have a malapropistic day.

u. Write a non-CV about your non-life (based on all the things you wished you'd done).

v. Draw on a map the best ways for your loved one to go from her/his house to yours: the most interesting way, the fastest way, the one with less noises, the less banal one, and so on.

w. Extrapolate a fact from your day. Even the most banal fact of the bunch will do. Stare at it and wonder: "Why is this so?" Go deeper and deeper, until you get to a place in your mind where answers have not been invented yet. You must get to that point before you can go back to your day.

y. Assignment x is not in the list. Wonder why this is so.

z. Create your own alphabet of assignments.

See also Nelson, Scheeren

KayLynn Deveney
A Guide to the Neighborhood

For this assignment, you will meet someone new. You may find
them through a referral from a church, a community center, or
a social club. Or you might meet them when walking in their
neighborhood. You will interview the person about the place
where he or she lives and make notes about his or her impres-
sions. You might ask questions they would expect, regarding
how long they have lived there, what they know about the
history of the place, and whether they see themselves staying
there for a long or short time. But you might also ask them
questions about the feel and experience of the neighborhood.
For instance, what is the most beautiful spot in the neighbor-
hood? Are there places of tension? What is the noisiest thing
that happens in the neighborhood? What is it like at night—is
it dark enough to see stars? If this person had to go somewhere
several blocks away, would he or she walk or take the car, and
why? In which season or weather is the neighborhood the
calmest? Which neighbors are outdoors the most? Who is their
closest friend in the neighborhood? What neighbor is the least
known to them? What is the most beautiful time of day on
their block? What do they see out their windows? You will then
take this information and use it as a guide to make a piece of
work that is rooted in someone else's vision of a place. However,
you will not photograph the person you interviewed. You are
photographing what they see, not how they look. Finally, you
will take the images back to your "guide" for captioning and
discussion.
 By taking on a coauthor for this project, you will engage
with a more pointedly collaborative model for making subjec-
tive documentary work, one that can perhaps present people in
more inclusive, complex, and empowering ways.

See also Soth, Verene **83**

Philip-Lorca diCorcia
Something Real

Make any kind of work just as long as it involves sex. Exhibit it at some rundown gallery on the Lower East Side, or better yet in Bushwick. Invite Jerry Saltz and hopefully his wife will come along. Get a review in the *New York Times* or *New York* magazine. Sell all of your work for nothing. Start over again with something real.

See also Davis, Kippenberger

Elspeth Diederix
Extract the Magic

Choose an object that you normally wouldn't give a second glance. Something that you see all the time, but don't find very special.

Study it carefully and discover a quality that you like about it. Maybe its shape or color, or even the way it moves or feels.

Think of a way to photograph it that will show the beauty in this commonplace object. Most often, if you just document the object as it is, its particular beauty remains invisible. You might need to alter something to make the viewer see what you see. Take the object out of its normal surroundings, or change its color, or make it look like something else. All it might need is some special lighting. You must provide the extra element that will extract the magic from the ordinary and make it visible.

See also Hurn, Ogden

Dru Donovan
Sound Photographs

Use an audio-recording device to record a minimum of ten disparate sounds. Record both observed sounds and constructed sounds. Ask another photographer to record sounds and then swap sounds. Listen to the sounds and imagine what they would look like as photographs—electronics humming, silverware cutting food on a plate, the wind passing through a crack in the window, overheard conversation, someone jumping, etc.

Take photographs in response to the sounds and think about the following: how might your photograph illustrate the tone of the sound? How might contrast, for example, be used to describe the tension contained within the sound? Or perhaps blurriness corresponds to a muffled sound, while sharpness corresponds to one that is distinct?

Try not to make photographs that point at sounds; rather, try to make viewers feel as though they are listening when looking at the photographs.

See also Sutton, Willing

Jim Dow
Blind Jury

In legal terms, a blind jury is a group that looks at a case without any additional information or context beyond the evidence presented. When applied to the visual arts this may seem like an oxymoron, but it is, in fact, how most grant, admissions, and search committees cull at least the first round of candidates. With this in mind, I recreate the blind-jury process through the following assignment as a way of evaluating contemporary work that the students are interested in.

Each class member selects ten images of a photographer's work for presentation. The student "sponsor" sequences his or her nominee's pictures and submits the files to me, along with a five-hundred-word researched rationale for their choice.

I then prepare a PDF of the entire selection, organized by artist, which will be projected in class for the judging. Each image is projected for approximately ten seconds, so an individual artist's work is in front of the group for about a minute and a half, after which the students mark their ballots as follows: 1) they want to see the work again, 2) they are indifferent, or 3) they don't like the work.

After the voting, I tabulate the results and prepare a second presentation of the work, presenting the artist who was least popular first followed by the artist who was most popular, and then alternate between high and low until we reach those in the middle of the ratings. The work of each artist is presented by the student who chose him or her. In this round, nominators have time to discuss the images, the individual photographer, the context for the work, and, of course, the process itself.

I find that students have not considered the myriad subtleties that context provides to their work and often have little idea about the jurying process prior to participating in this assignment, even though a great many of the decisions important to their lives were, and will be, arrived at in similar fashion.

See also de Groot, Källström & Fäldt

Doug DuBois
Fits and Starts

Every so often, I start my graduate seminar with a celebration of false starts, dead ends, and wrong turns. The assignment calls for students to display a failed project. For inspiration, we all read Courtney Eldridge's wonderful letter to the editors of *McSweeney's*, which begins:

> *Dear* McSweeney's,
> *No, I'm afraid I don't have anything to submit to your upcoming issue. So instead of sending a complete work, because I don't see that happening anytime soon, I thought I might submit a working list of stories which I have recently or not so recently quit, abandoned, or forsaken, complete with short summaries of each failed effort, in order to give you some idea why they've been sent down. Besides, I like listing. It cheers me up.*

Maybe the strongest glue that binds artists together is failure. Celebrating this kinship, getting it out in the open, helps to avoid the delusion of self-pity and the scorn of schadenfreude. There is, of course, no critique of the work presented for this assignment, but the inevitable stories and laughter help us maintain the conceit, so critical to art and life, that things will get better.

See also Carter, Scheinbaum

Schuyler Duffy
Exercises in Photography

1. Photograph an object that is quintessentially one or two colors—a clear sky, a dollar bill, a bull's-eye, bananas, or some blueberries. Photograph this object through a filter of the complimentary color, placing the filter between the lens and the object, leaving the edges of the frame rendered in natural color. Make a print of your photograph. Color-correct the object back to its natural color, throwing the rest of the frame into extremely unnatural color. For example, photograph a yellow banana through a purple filter; color-correct the print back to "banana yellow."

2. Shoot a dangerous subject, like a beehive or wildfire.

3. Make a picture in which the subject is light itself, as in celestial light emerging from a gap in rain clouds, or light caught in the steam from a cup of hot soup.

4. Make a photograph with a six-month shutter speed.

5. Fill a suitcase full of prints. Fly somewhere. Put on a show. Fly home.

6. Make a photograph or series based on a dream you remember, mining the dream as source material. Work representationally, abstractly, conceptually, literally, formally, or narratively.

See also De Rita, Kinsman **89**

Shannon Ebner
Seeing More Flatly

1. Go outside and read the Georges Perec text "Practical Exercises" in *Species of Spaces and Other Pieces* twice.

2. Extract ten directives from Perec and add ten new ones that you write. Examples from Perec include:

> *Observe the street, from time to time, with some concern for system perhaps . . . Note down what you can see. . . . Force yourself to see more flatly . . . Decipher a bit of the town . . . Try to classify the people . . . Carry on/ Until the scene becomes improbable . . . Make torrential rain fall . . .*

3. Write observations based on your list of twenty directives.

4. Reassemble your material so that the original sequence of time comes undone and a new pattern is formed.

See also Mater, McPhee

Amy Elkins
Two Challenges

I was given these assignments early on in my studies and they still resonate, but at the time they either terrified me or nearly drove me to the edge of madness:

Assignment 1 (assigned by Silvio Wolf)

> *Art becomes "artless," shooting becomes not-shooting . . . the teacher becomes a pupil again, the Master a beginner, the end a beginning, and the beginning perfection.*
> —*Eugen Herrigel in* Zen in the Art of Archery

Take a photograph of nothing.

Assignment 2 (assigned by William Hendricks)

Go to an area that has a decent amount of foot traffic. After finding what you want to be your fixed backdrop within that area, set up your tripod and camera. You will not move until you have completed this assignment. Once set up, ask a minimum of twelve strangers to "sit" for the camera. Keep in mind that you must edit and print a minimum of ten solid portraits to present in class.

See also Gordon, Ou

Lisa Elmaleh

Cyanotype and the Blue World

> *The world is blue at its edges and in its depths. . . For many*
> *years, I have been moved by the blue at the far edge of what*
> *can be seen, that color of horizons, of remote mountain*
> *ranges, of anything far away. The color of that distance is*
> *the color of an emotion, the color of solitude and of desire, the*
> *color of there seen from here, the color of where you are not.*
> *And the color of where you can never go. For the blue is not*
> *in the place those miles away at the horizon . . . Blue is the*
> *color of longing for the distances you never arrive in, for the*
> *blue world.*
> *—Rebecca Solnit from* A Field Guide to Getting Lost

I often assign an easy cyanotype exercise to students. I ask them
to read the first chapter, "The Blue of Distance," in Rebecca
Solnit's *A Field Guide to Getting Lost.* We then create cyano-
type prints based on that idea, thinking of blue (and thus also
the cyanotype) not only as a color, but also as a metaphor for
distance. Distance could be a person or a place that you miss or
desire, or something from the past, a memory—something far
away, but that resonates. I have students bring in and work with
photographs of loved ones or meaningful places—or objects
that represent them—and we create cyanotype prints from
them. The students will need to create and print-out a negative
version of those photographs from Photoshop in advance to
contact-print them onto the cyanotype paper.

The cyanotype process is simple. You can buy the paper
pre-coated or can make the solution and coat your own paper.
Contact prints or photograms are then made by placing the
objects on the coated-paper in the sun or under UV light.
Experiment with exposure times to see the range of results.
The prints are developed under running water in a darkened
room (it doesn't even need to be totally dark).

Cyanotypes originally depicted botanical specimens, so from the beginning, they were used to document and preserve things from the past. Another variation of this assignment that requires no advanced preparation from students is to go out with them and collect leaves, pine needles, and detritus from outside that you will use to create cyanotype-photograms. You could also bring in a grab bag of items and have them work with that as well.

See also Ezawa, Kinsman

Charlie Engman
Practicing Fashion Photography

In its essence, a fashion image is an image that proposes a social or emotional approach to the world as communicated through the manipulation or adornment ("styling") of the body. This preoccupation with the body is what distinguishes fashion imagery from other kinds of imagery.

However, as with any type of photographic image, what is depicted within a fashion image serves only as a signifier: a certain code of dress or a certain posture describes a life lived or a feeling felt beyond the description; a certain confluence of shapes, volumes, and textures speaks to a greater material or tactile obsession.

Though the body is an essential consideration for every fashion image, the body, too, can be proposed in an oblique or referential manner. It is therefore possible to create a successful fashion image without the actual depiction of a physical body or articles of dress.

With this in mind, a potentially helpful exercise:
Take a set of nonhuman, non-clothing elements and using only these elements create several images, each time "styling" the elements in a different way to express a different social or emotional reference point of your choosing. Always keep the fundamental idea of the body in mind, though it will not be represented. Its presence must be felt.

Possible sets of elements might include: a chair and a block of cheese. The color orange, a lightbulb, and a car interior. Window light, printer paper, markers, and Photoshop. Bendy straws and the ocean. Plastic bags and karate. Skittles.

Possible reference points might include: punk, China, the elderly, contemporary art, hygiene, the future, the middle class, introverts, aggression, Harry Potter, motherhood, the itchiness of wool.

The next step is to try the exercise in reverse: attempt to remove the social/emotional reference from any given set of elements. Can Barbie shed her Barbie-ness?

Once you feel comfortable practicing this exercise on your own, take it a step further by collaborating with other people. For example, ask a makeup artist to reference anxiety with tofu.

See also Harris, Imboden

Barbara Ess
Tell Us Something About Yourself

a. Use the photograph as a window
b. Use the photograph as a mirror
c. Use the photograph as a mask
d. Use the photograph as a substitute
e. Use the photograph as a stand-in
f. Use the photograph as a copy
g. Use the photograph as a weapon
h. Use the photograph as a language
i. Use the photograph as a hiding place
j. Use the photograph as a therapist
k. Use the photograph to bring us closer
l. Use the photograph as your mother
m. Use the photograph as your lover
n. Use the photograph to keep us away
o. Use the photograph as a replica
p. Use the photograph as progeny
q. Use the photograph as art
r. Use the photograph to make your mark
s. Use the photograph to remember yourself
t. Use the photograph to forget
u. Use the photograph to clothe yourself
v. Use the photograph to feed yourself
w. Use the photograph as your sensorium
x. Use the photograph to protect yourself
y. Use the photograph as a witness
z. Use the photograph to see yourself

See also Callanan, Schles

James Estrin

The Basics

I believe that being in the moment and having something to say are the most important factors in good photography. But you must learn technique and visual language first. So I emphasize photography as a way of being, but I also focus on the practical kinds of decisions that documentarians and photojournalists use to organize photos.

Start with thinking of the viewfinder as a blank canvas. Control the frame. Remember that composition is a series of decisions. You decide where to go and where to stand once you get there. Perhaps the most powerful compositional tools that you have are your feet and the ability to move—left to right, floor to ceiling, forward and backward.

Look for the light and for color. Usually, if you find the light you can find a photo.

Consider motion, focus, depth of field, and exposure.

Think about how you use the frame—perhaps layering, rule of thirds, or spaces within spaces. Or something simple and clean.

Is there a decisive moment to be had?

Think about what you have to say and what is the best way to convey it.

After many thousands of assignments, I can walk into a room and visually dissect it within a few seconds. But that is because I have made these kinds of decisions for forty years.

 See also Haviv, Hurn

Wendy Ewald
Assignment: Dreams

Some years ago, while staring out the window of my workspace in Kentucky, trying to plan my second year of teaching photography to children there, I noticed a neighbor child lying down outside, flat on his stomach. His older brother was hogtying him, roping him wrists-to-ankles in imitation of a pig about to be slaughtered, a common event at the farms nearby.

The children of Kentucky often enacted such scenes. For them, the whole natural world was a playground, as in dreams, their play easily crossed borders between life and death. I wondered how photography could tap into that world. What would it mean for students to be able to write about and picture their dreams and fantasies? If vantage point is understood in a literal way—as the spot where the camera is placed in relation to the subject—is there also a sense in which the photographer's imagination can shift in stance? If the camera can change reality by looking at the world from different positions, can the camera also capture what it's like for the mind to change reality when it's dreaming?

Of course it can. Paradoxically, photography's tendency to be literal-minded, to render extraordinary things matter-of-factly, plays right into the fantastical. Young students instinctively grasp how everyday objects can become magical totems. A heating oil tank can become an airplane; a dish towel, a wedding veil; an armchair, a spaceship . . .

I asked my new class in Kentucky to talk about what dreams were, where they came from, and to narrate some of the more memorable ones. . . . I then asked the children to photograph those dreams.

(From *I Wanna Take Me a Picture: Teaching Photography and Writing to Children*, 2001)

See also July, A. Nolan **99**

Kota Ezawa
Make a Photograph

Using any technique you like, construct an object or image that carries the essence or aura of a photograph without being a photograph. When you are done with it, don't take a picture of it.

See also Carlsen, Gottlund

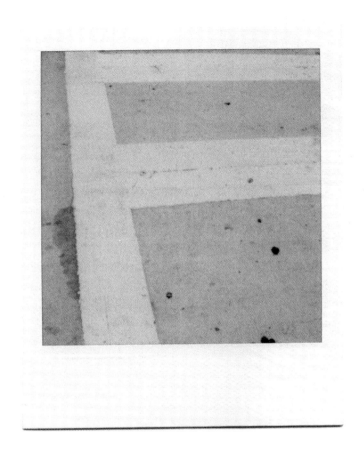

Thobias Fäldt and Klara Källström
Now in Relation to the Past

We are particularly interested in what history can bring to the contemporary photograph, and in how our time always stands in relation to the past.

Go out and take a picture of anything you find interesting. Afterward, do a little research of the place where you took the photograph. What happened there before you came? Write down a few sentences. The amount of time elapsed can be four billion years or one day; it doesn't matter.

Put the information you have found together with the image. How does the information about the past affect your image of today? What are your reflections on the combinations of the now in relation to the past? Can the image tell something more about the world, maybe even about tomorrow?

See also Menjivar, Southam

Sam Falls
Death

Sometimes when I think about death, I'm overcome with sadness and anxiety. Other times, I'm placid and happy with my present place, and the thought of death is an almost enjoyable abstraction. Either way I can never form a lasting sentiment on my relationship to death. Moreover, I'm never able to picture what death is in life. Can you?

See also Malašauskas, Nakadate

Andreas Feininger
The Real Nature of Space

Ask a photographer what space is and how it can be shown in a photograph, and he will probably answer that space is three-dimensionality and the means for rendering it is perspective—rectilinear perspective. Ask a physicist and he will define space as a thing much more complicated: a four-dimensional, negatively curved, space-time continuum. Study the different forms of graphic space rendition in art, from the ancient Egyptians to Picasso, and you will find that in different epochs different ideas of how to symbolize three-dimensionality in a two-dimensional plane existed.

The more we learn about the real nature of space, the more we realize how little we actually know and how much of what we see of the Universe and heretofore had accepted as real is actually an illusion produced by the inadequacy of our senses. But even though we might not be able to explain space and perhaps never will, because we can never approach it objectively since we are part of it, we can still get a more definite feeling for space. Artists try to interpret their impressions of space, which can never be illustrated directly, by means of symbolization and abstraction. And by thus transmitting their visions of space to canvas or sensitized paper, they help to give others who are open-minded and sensitive a better understanding of space, and, indirectly, of themselves.

(From *The Creative Photographer* by Andreas Feininger, 1955)

See also Reinfurt, Steacy

Ann Fessler
Mock Proposal

The assignment outlined below is one I generated for a seminar course I periodically teach at Rhode Island School of Design called Content/Context. The course is open to undergrads and grads.

The class revolves around a semester-long project that asks students to create a proposal for a thematic group exhibition. The exhibition must include the work of at least four artists, as well as their own.

The proposal must include accompanying public lectures, events, and educational and/or community outreach in addition to the exhibition. Students must identify a specific site for the exhibition and consider local organizations that may be interested in collaborating.

During the semester I invite curators and professionals in charge of educational outreach and special programs at nearby museums, contemporary art centers, and artist-run spaces to talk to the class and provide feedback on their proposals-in-progress.

Each student's proposal must be presented as a PowerPoint slide show. Students may create a physical model of the exhibition site. The students are divided into two groups, and half present their proposals, individually, to the other half of the class, which serves as a peer-review funding panel. The panel must judge the proposals using a list of criteria typically used for evaluating grants for exhibitions and artists' projects.

After each presentation the panel asks questions of the presenter. The members individually rank each proposal according to the established criteria and meet privately as a group to deliberate. Ultimately, they must award a hypothetical grant to the most thoughtful and deserving proposal. They may award the grant to one person or split it between two people. I do not participate in this discussion, but I observe the deliberations. In my experience, the discussion is always on par with, or exceeds,

that of grant panels I have served on over the last thirty years.

After the deliberations, the panel announces the award, and members provide feedback on each proposal and explain their decision. The following week the roles are reversed.

It's a surreptitious way to get students to research their area of interest. As a result, many feel more connected to the world of ideas outside of art school, and they are better prepared to write thesis papers where they are required to identify contemporary and historical artists whose ideas intersect with their own. It also demystifies the grant-submission process that many of them will encounter in the coming years. A few students have been so smitten with curating that they subsequently curated student exhibitions in our department gallery, and some have applied for internships at the RISD Museum or other local arts organizations.

See also Hornstra, Mandel

Larry Fink
Photographing Atmosphere

There's a difference between atmosphere and space within a picture. Atmosphere is a kind of charged space. Can you photograph heat in a way that conveys its hotness? Can you photograph water and make the picture feel wet, rather than just look like a picture of water?

See also Ou, Willing

Brian Finke
Trust the Gut

The need to make photographs should come from oneself; there is nothing I can or should tell you to go and photograph. My advice is to channel your feelings into your work, whether you are feeling joyful or bored or beaten down. Whatever it might be, try to feel it fully and to trust that it will show up in your photographs.

See also Gilden, Roma

J. W. Fisher
Visualizing Poetry

"Puke on the page!" exclaimed my former poetry professor, Charles Simic, during a reading he gave of his poems paired with paintings by Philip Guston. Puking on the page as well as embracing one's failures have always been in the forefront of Visualizing Poetry, an assignment given to my intermediate photography students at Lewis and Clark College.

We begin with assigned response and in-class discussion of Louise Glück's texts, "The Education of the Poet" and "Against Sincerity," in which we focus on themes of yearning, achievement, helplessness, rules (of art-making), the gap between truth and actuality, and development of one's voice. Reading aloud to each other, we pass around a pile of poems. Words shuffle around the room until every student has chosen one to read, reread, reread again, and live with until breaks, rhythms, form, poet intent, etc., are unshakeable.

Once students unfold their own deepened understanding of the words before them, they are directed to put the poem away. In their journals, students quickly respond to the call by writing out twenty descriptive words that come to mind when visualizing their chosen poet's verse. Some words may come directly from the poem, but an inclusion of interpreted mood, tone, meaning, voice, feeling, and narrative are encouraged. From the syntax employed, the twenty words, and whatever else is remembered, the students then write out ten picture ideas.

From the picture ideas, students work through various revisions until resolving ten final photographs that are in support of one another and represent a clear voice. This small body of work isn't meant to illustrate the poem, but rather, draw inspiration from disparate languages. After an initial critique of the work, the students exchange the poem, the twenty words, the picture ideas, and their work with another student in the class and make another ten photographs based on the exchange.

See also Harris, Lancaster **109**

Steve Fitch

Feedback Loop

One of the most difficult aspects of teaching photography is helping students learn to be "self-taught" and to find their own subject matter and voice. This basically involves learning to engage the "feedback loop." An analogy to science is, I think, useful. A common misconception about science is that it is a collection of facts or a set of theories that explain the world. But science is really a methodology—a way of asking a question, proposing an answer, and then devising a way to test whether the answer is correct or not. In art we also have a methodology. You start with an idea or an inspiration and then you act on it, you make some photographs. You look at the result and then engage what I call the feedback loop: you talk to the pictures and you let them talk to you; you look at them over and over; you evaluate them in terms of your intentions; and then you make some more photographs (or drawings, or paintings, or whatever). Then you live with those pictures. You think about them all the time, even dream about them. Your work evolves. What you create may be lousy or it may end up being superb. Nothing is guaranteed. What is important is to engage the process.

See also Catanese, Martin

Linda Fleming
Ventriloquism

This assignment explores collaboration, as well as ideas of identity and artistic persona.

Two students team up for the purpose of creating, between them, a third artist and his/her work. The artist and the work that students create together is a way for them to explore attitudes, ideas, and media that may be quite foreign to them. The brief duration of the project requires that students work intensely, take risks, and hopefully challenge assumptions held in their own work.

This is a chance for the two team members to "enter into" a persona outside of themselves. What are his/her doubts, pleasures, and peculiarities? To facilitate this process it might be helpful to consider the following:

What is the gender of your artist?
What is in his/her past and how has it shaped him/her?
What medium or mediums does he/she work in?
Who are his/her influences?
What culture or social strata is the artist working within?
What is the psychology of the artist?
What are his/her goals?

See also Broomberg & Chanarin, Lipper

Harrell Fletcher
Through a Child's Eyes

Take a young child, around the age of five, to a natural history museum. Give the child a digital camera with a lot of memory space on it. Ask the child to document everything in the museum that she or he finds interesting. Use an online book publisher to create a book version of the photos. In the book, present all of the photos that the child took in chronological order. Also include an interview with the child about her or his thoughts on subjects such as natural history, museums, the value of documentation, and photography. Give a copy of the finished book to the child. Also consider finding out if the natural history museum's bookstore would like to carry the book and if local libraries and schools would like a copy for their collections. A similar version of the project could be done in other types of museums, public gardens, etc.

See also Gremmen, Saville

Lucas Foglia
Make It Seem . . .

1. Make a photograph of something that is supposed to be happy, like a person laughing, and make it seem sad.

2. Make a photograph of something that is supposed to be sad, like a person crying, and make it seem beautiful.

3. Make a photograph of something that is normal, like a cup of coffee, and make it seem shocking.

4. Make a photograph of something that you want the world to know about and make it seem urgent.

See also Duffy, Halpern

Anna Fox
Staging the Real

This workshop was given in India at the Srishti School of Art, Design and Technology to undergraduate students in experimental fine art.

The workshop started with a discussion around dress in public space. The students were familiar with working in public environments and had been doing a documentary project in the local flower market.

I asked the students to tell me if there was anything they would find difficult to wear in public. We had some very interesting answers. I then asked them to come up with a series of drawings that showed what might be the fashion of the future. We called them "fusion costumes," and the idea was that they would challenge the conventions of the dress codes of their generation and blend fashion sensibilities from both East and West.

I gave a talk called "Staging the Real and Impacts on Identity." The lecture looked at portraiture and staged photography, and the various approaches that a photographer can take to forge new meaning and lend power to both groups and individuals.

The next day, the students arrived with their own made-up costumes—some handmade, some borrowed, a mix of East and West, some objects as well as clothing and wigs. We were a motley crew when we arrived at the flower market: girls dressed as boys and vice versa, punks, and people who had changed their religion. I brought my 4-by-5 camera, and students had digital cameras. It was an extraordinary event because the students were already acquainted with all the flower-market workers. Everyone wanted to take part in the fun. Clothing was swapped, wigs were tried on, and truth and fiction blended in the marketplace. The students were encouraged to shoot from

different perspectives and distances. They also included themselves in the pictures, acting as if they were members of the public.

When I returned home to the UK, looking back at the pictures, they all looked believable—even the oddest shots like a baby wearing a blue curly wig, with his mother holding him and selling flowers at the same time.

See also Kelly, Rome

Allen Frame
La Dolce Vita

One of my favorite assignments, which I give during the first term of my classes at the International Center of Photography (ICP), is to have the students divide into small groups of five or six and have a party together at someone's home. I ask them to videotape it in any way they like and show a short edit to the class. There needs to be someone who can shoot and edit in each group; sometimes there are multiple camera operators or the camera gets passed around, but usually there's just one in each group with the skills to edit.

The results are always fun—sometimes hilarious, sometimes mysterious, but always unexpected. The most recent one depicted each student in silent-comedy, time-lapse mode throughout the evening; another one took cues from horror movies. Once, they set up a kind of confessional in the bedroom and each guest revealed something private to the camera.

The purpose of this exercise is to promote social bonding; the better the students know each other, the more free-flowing and uninhibited the critiques will be. At ICP, in the intensive nine-month General Studies program, there are many international students who have just moved to New York and can be socially isolated, having to adjust to a new location and make new friends while dealing with the pressures of an accelerated program. This exercise gives them a chance to let their hair down with each other and begin to feel connected.

The video also underlines how subjective a given point of view may be. There are always at least two groups in a class, if not three, and the contrast between them underlines how significantly style and approach can affect the depiction of a generic experience. Everyone gets to compare their own experience of the party with what is captured and portrayed, underlining how many subjective choices occur in the fulfillment of any assignment.

See also Campany, Taylor

LaToya Ruby Frazier
Metaphor and Meaning

Readings from the book *Singular Images: Essays on Remarkable Photographs*: "Bill Brandt: A Snicket, Halifax, 1937" by Nigel Warburton, "Martin Parr: Jubilee Street Party, Elland, Yorkshire, 1977" by Val Williams

With the readings and photographers in mind, create six of your own photographs that contain a metaphor implying an inner vision of the external world. Absolutely no literal, derivative, or cliché photographs. Think deeply about what vexes you and compels you in our culture and society.

See also Ballen, L. Hewitt

Adam Frelin
The Excuse

Art is a very accepting discipline that allows its participants to incorporate activities from other fields into varying creative outcomes. Equally, art can be used as an excuse to do things, go places, meet people, or learn skills that you can use in your own art projects. For instance, artist Janine Antoni wanted to learn how to tightrope-walk so she created a piece that required her to learn this skill. Members of the Austrian art collective Gelitin wanted an excuse to dig enormous holes in the sand at the beach, so they made it into a project. And photographer Taryn Simon wanted a reason to travel to restricted areas throughout the country, so she created An American Index of the Hidden and Unfamiliar, a series of photographs that compile an inventory of what lies hidden and out-of-view within the borders of the United States.

This is a two-part project. The first part is to come up with a list of places, people, and activities that you would like to have the opportunity to somehow be involved with. The second part is to find a way to creatively frame your experience for a viewing audience, directing it toward the most applicable creative outcome.

See also Ceschel, Gossage

Tierney Gearon

How to Take a Perfectly Fantastic Shot in Less than Five Minutes (or a Masterpiece in a Couple of Hours)

This works every time, guaranteed. Have a party!

Set up a situation. Find a contained cool space, like an interesting backyard, or an amazing open space like a field. Make it look visually stunning, or maybe it already does. For example, sometimes a student apartment looks fantastic empty.

Create a party/picnic/intimate group of people—this could be anywhere from five people to one hundred or more. The point is to have fun, enjoy yourself. And then just document the whole event.

Instead of being a person, become a camera. Let the camera mingle with the guests. Just sit back and observe. The best moments may be the quiet moments. When I do most of my personal projects, I just create what I call "calculated chaos" and then wait for something interesting to happen. And, if I wait long enough, something always does. The most important point to remember is that you need to be inside the image. You are no longer a person hanging out with the group. You are an unnoticed observer.

See also Ceschel, Frelin

George Georgiou
Stop and Return

With the world becoming more homogenous through glo-
balization and places becoming similar in appearance, I am
constantly having to remind myself of the significance in the
ordinary and familiar that is right in front of my nose. I give
myself a small assignment that helps me to slowly understand a
little of what is in front of me.

I find a public place or space—a street corner, an office, a
laundry, a car park, a bus stop—and go back to it day after day,
allowing myself to see what I didn't value the previous day.

Slowly I get excited as I start to see the social and cultural
nuances of that space and the interaction and rhythms between
the private and public. Layers of meaning unfold, and suddenly
ideas open up.

See also R. Bell, Sanguinetti

Melinda Gibson
Lose an Eye

> *One has to lose the use of an eye for a substantial period to find how life is altered in its absence. —Oliver Sacks*

Left or right? Which eye is the most dominant (the one that you use when looking through the viewfinder)? Now cover this eye with a patch, tape, or stickers—anything that ensures complete coverage. Not with your hand, since you can peek through your fingers! Venture out with your forced disability and start photographing. Sitting here, writing this with my right eye covered, I understand the difficulty of this task. Everything I see, I have to really look at. My balance is off, and I move more closely toward objects to make sense of their shapes. Words and sentences take longer to read and there is a slight blur, a softness around the edges. But what is incredible is how "losing an eye" fundamentally alters the way we perceive and understand the environment around us and how much more we see when we are really forced to look.

Remove your patch after an extended period of time and then start photographing with both eyes again. See just how much brighter, more balanced, and focused this view is, but how quickly we revert to the "old way" of looking.

See also Butler, Letinsky

Bruce Gilden

Photograph who you are.

See also Ballen, Delaney

Jim Goldberg

Conversation with Gregory Halpern

Jim: Greg, can you remember any advice that I gave you as a student? I know I told you to make lists all the time—lists of anything, the things you ate that day, the photos that you missed taking, or all the girls that you lusted after—but also to relax and never censor your thoughts or ideas.

What about archive assignments? Were you my teaching assistant when I held class in an Ikea showroom, where each student bought the same multi-drawer box, and I made them figure out a way to create an archive with it? What else?

Gregory: The archive assignment was great. I remember you telling me to make a list of a hundred things I would do if I had no budget, time, or creative constraints. And that when I really didn't want to go out and shoot, to go out and shoot (that one still haunts me). And that when I start getting bored, this is the exact time I should stay in that place, because it's when I will start getting creative.

And to make a book or create a collection every day. You taught me how to make a book dummy, a physical one (not on the computer), using removable and artist's tape, so that I could play and move pictures around.

And to take a picture of my mom and take a picture of my dentist (still haven't photographed my dentist, but I like the idea). Should we go with that for your "assignment?"

124 *See also Davis, Gremmen*

Daniel Gordon
Three Assignments and a Thought

These assignments were used by Garry Winogrand with his students and were passed down from teacher to teacher, eventually making their way into my syllabus as follows:

1. Photograph someone doing something to someone else.
2. Make a photograph with more than three people in the frame.
3. Approach and photograph a complete stranger.

As an inexperienced teacher, I started with these prompts, and then began experimenting with new assignments inspired by students' ideas from class. The results were mostly positive.

I keep thinking, though, about my own experiences as a student, and I find myself wondering where and when the most meaningful learning took place. It often happened when a teacher was willing to be personal with me, and I could get a glimpse of what it might be like to be an artist. It was in these moments, far away from the structure of assignments, where I was able to take small steps, through a kind of osmosis, toward a greater understanding and appreciation of photography.

See also Crane, Cuomo

John Gossage

Assignment to Be Completed Before Commencing to Photograph

THE RULES

1. Fall in love with something.

2. For three and a half months, starting now, you will look at no other photographers' work, with the exception of Eugène Atget, Diane Arbus, William Eggleston, and Jeff Wall.

3. You will learn to dress in two ways: first, so that people will notice you and second, so that they won't.

4. Take a photograph that you like very much. Delete it before saving it. Remember that picture.

5. If you have faculty reviews, make bingo cards out of the most overused phrases of your teachers. Distribute these cards to your fellow students. Award twenty dollars to the student who gets enough of these phrases in their review to yell bingo in class (Kate's rule).

6. If gender and preference are correct, attempt to get a date with the bingo winner.

7. Never explain your work if asked to do so, but volunteer things to those who don't ask.

8. Make pictures to annoy people.

9. Take personal consolation in the fact that there are five really lousy pictures in *The Americans*, and it doesn't matter.

10. Stop trying to surf as well as Roe Ethridge.

11. Learn to tell at least one good joke.

12. Read everything Lewis Baltz has written about photography ("Junk Food of the Art World," etc.) and for extra credit read *The World Viewed* by Stanley Cavell.

13. Question your own cleverness. Remember that it is never enough to save anything.

14. Always see the real world, in spite of its terrors, as a source of wonder, fascination, and value—no less precious for being irrational (John's rule).

15. If you're going to make something or stage something and then photograph it, remember the above.

QUESTIONNAIRE

1. Are you sure you are really interested in the preservation of your artwork once you and all the people you know are no longer alive?

2. State briefly why.

3. Whom would you rather never have known?

4. Would you like to have a perfect memory or would you rather have the power to decide what you remember and what you do not?

5. To what age do you wish to live?

6. Would you rather have lived in a different time? If so, when? Past or future?

7. If you had the power to put into effect things you consider right, would you do so against the wishes of the majority? (Yes or no.)

8. Why not, if you think those things are right?

9. When did you stop believing that believing changes things— or do you still believe? If things have changed for you, at what age?

10. Are you more convinced by your own criticism or that of others?

11. When you think of somebody now dead, would you like him to speak to you or would you rather say something to him?

12. Let us assume you love another human being. How do you know and do they?

13. Let us assume that you never killed another human being. How do you account for that?

14. When you say you know someone's work, what do you think you know?

15. Which would you rather do: die as a human or live on as a healthy animal? Which animal?

(Questionnaire from Romance Industry, *with thanks to M. Frisch.)*

See also Kurland, Schmid

Nicholas Gottlund
Inside Out

I came to know the darkroom not through the front door of photography, but through the back door—printmaking. I remember taking my first introductory class in the techniques of photo-based screen printing on the second floor of what was called the Dolphin building.

The make-ready, setup, preparatory dance for printing became a time that I treasured. In fact, the elegance and grace found in those gestures were so powerful that my attention to them exceeded my interest in what was being printed.

The first time I coated a screen with light-sensitive emulsion, I was intrigued by the consistency and the way it filled in the mesh. The application was a smooth motion which required an even hand and a slight bend of the wrist at the end. Feeling proud of my first attempt, I wanted to see the evenness of the coating and its exact color. Walking the screen outside and into daylight, I admired its beautiful flat surface—now rendered perfectly useless.

Save that screen. Live with that screen. Spend time with it each day. Wash out a new screen and start over.

See also Maloney, Slota

Katy Grannan
Discomfort

Get comfortable with discomfort. There are so many ways to do this—it doesn't even have to involve making a photograph. When I was in graduate school, after our weekly critiques, a bunch of us would go out and get drunk and do karaoke together, visiting artists included. We all looked and sounded like asses, but most important, it reminded us to have fun and be stupid and have a life outside of making art. School can be an incredibly intimidating place. I'd never "studied" art until I went to graduate school, and I spent two years terrified of the potential for humiliation. My work mattered more than anything I'd ever done. But you have to make mistakes—sometimes you need to make terrible work to really get somewhere. Failure can make you brave.

The good work will come over time, and, of course, you'll still feel terrified because, hopefully, you're always risking something. Otherwise, why bother? That's when you need a sense of humor and humility, because in the end, we're all beggars here.

See also Mulligan, Vitali

Eliza Gregory
Find a Space, Make a Show

When I first got to Phoenix in 2007, I found it hard to meet people because things are so spread out. One of the best things I ever did for myself was join a small, cooperative gallery in Phoenix called the eye lounge. The first Friday of every month, people lined the street in front of the eye lounge. Lots of people touched the work on the walls and behaved as though they had never been in an art space before.

At first I didn't know how to react. I had come out of a photography education that emphasized craftsmanship and had pictured getting my work into the New York City galleries in Chelsea one day. I wasn't sure if showing my work in this context was somehow bad for me. It also raised questions. Some people have never been in an art space before! Why? Why doesn't everyone have access to art? Do I want to make things only some people can see? What is the purpose of doing this work?

This audience noticed things about my work that were new. I started to realize that there was a lot of context missing from my presentation—people were looking at the pictures, but the pictures didn't mean much on their own. The viewers wanted some way to make sense of what they were seeing. I had three shows over the three years. Each time, I learned more about context and engagement with my audience, and the ethics of making pictures and showing them.

If you make a picture and don't show it to anyone, the ethics surrounding it mean very little. When you make a picture and then make it publicly accessible, the ethics surrounding the picture—how it reads, how you made it, and where it is being shown—rise to the surface and become prominent. Engaging with the process of placing your work into a public context will teach you things. It will challenge you.

Find a space. Make a show that is relevant to that space. Listen to the people who come to see it.

See also Calisch, Fletcher **131**

Hans Gremmen

Based on a conversation which took place in Amsterdam in September 2012 between a student and his former teacher.

Teacher: Looking back on your time at the academy, were there assignments you found especially worthwhile?

Student: Hard to say. Everything that happens during the making process is chewed over and reconsidered, and chewed over again. Many of those things go on in your head and eventually all the different thoughts, the process, and the accompanying conversations merge into a single mass. And then it doesn't much matter how you actually got there or why you decided to make something in the first place.

T: I understand that, but in formal terms surely you can say that an assignment is a starting point for a step in a new direction?

S: When you're a student, you're mainly focused on your own development. An assignment is a random passerby you have to respond to. At least in my case, the response came from the direction I wanted to head in. Some things go on in the gray area of the making process and aren't influenced by outside factors.

T: Do you mean you could have managed perfectly well without teachers and assignments while you were at the academy?

S: Not all the things that matter to your development are contained in an assignment. But one important aspect of an assignment is that it restricts your options. So the parameters are very important and a teacher is someone who lays down the parameters. During your first lesson we watched Lars von Trier's and Jørgen Leth's film *The Five Obstructions*, which deals

with that. At one point in the documentary—in which von Trier challenges Leth to produce five remakes of his film *The Perfect Human* with restrictions imposed by von Trier—Leth is "punished" by von Trier. The punishment is having to manage without any instructions or restrictions at all. And Leth can't handle it. He does make a film, but it's by far the least interesting of the five.

T: Is the assignment von Trier gives Leth a good one?

S: Von Trier's assignments throw Leth off balance, forcing him to explore the limits of his own work and the ethical issues it raises. So the assignment's good—but so too is the "student." An assignment is a two-way dialogue.

T: Doesn't a good question lead to lots of new questions, even more so than a good answer does?

S: A good question leads to debate, and the debate can lead to new questions. It's an endless cycle.

S and *T*: [*silence*]

T: I read somewhere that an artist took a group of children to a museum and asked them to think up titles for all the "untitled" works. Now that's an assignment.

See also Fletcher, Siskind **133**

Gregory Halpern

Truth or Dare

Make a short series of purely objective photographs. This may
not be possible, but try. We know photographs can "lie." Is it
possible for them to tell the truth?

See also Jude, Pickering

Kyoko Hamada
Grocery List

Write down all the things you like, as if making a grocery list.
For example: snow, chicken face, strawberry, thunder, U.S.
legal-size paper, yellow pencil, well-made wig, wooden shoe,
walking cane, white mug, droopy pudding, big beauty mark, etc.
Keep going until it takes you more than ten seconds to think
of the next one on the list. The list should be personal and, yes,
fun. Try not to take it too seriously. Visualize the words as if
the objects they represent are scattered on the paper like pieces
of a jigsaw puzzle. A certain image might jump out, or a word
might take on new meaning because of its placement next to
other words. Select a few of them from the list and see if any
ideas for photographs emerge. If not, try arranging the words
in a different way and see if the new order inspires anything. If
nothing happens—as is often the case—go make yourself a nice
cup of tea and take a nap.

See also Harvey, Northrup

Léonie Hampton

Being There

Try photographing a subject that is close to you, or to your
family or friends. Look for something that might be easier
not to look at. Be sure to photograph long enough to create a
body of work, developing it to the point where you show it in
public. Doing so will teach you about what it means to be truly
accountable to your subject. Mothers/brothers/best friends
won't let you get away with anything less.

See also Deveney, Hau

Charles Harbutt
The Spaceship

Twenty-four hours from when you start this assignment, you
will board a spaceship headed toward a point in the solar sys-
tem from which it's unlikely you'll return. No one is going with
you—at least no critics or art buyers, no editors or savants. Cer-
tainly no teachers. There is nothing on the walls of the space-
ship, no mirrors or paintings. The food comes in tubes with bar
codes for labels. There is no radio or hi-fi, no TV or movies, no
games or books. No dope or alcohol either. But you can dream.

All you can take with you as art or entertainment, as puzzle,
pastime, or memento of life on Earth are the photographs you
make in the twenty-four-hour period before blast-off. Take the
day off, at least from all that strain to make "good photographs."
You can take any pictures you want, any way you wish. Maybe
you'll make a "bad" photograph in a new and original way.

Bon voyage!

See also M. C. Brown, Rogan

Sharon Harper
The Body as a Site of Perception

Pick a photograph you respond to viscerally. You may be inspired or confounded by the photograph. Make a photograph in response to your chosen photograph using a phenomenological approach. Keep in mind Maurice Merleau-Ponty's view that the body is the site of perception, and that perception precedes consciousness. Engage your senses and locate the subject of your photograph in the perceptual realm. Make a piece that defies rational logic. Pay attention and trust the responses of your body. Use your camera as an extension of your perceptions.

See also Behrend, Ebner **139**

Melissa Harris
Exquisite Corpse

In his book *Dada and Surrealist Art*, William S. Rubin describes the Surrealist technique of "exploiting the mystique of accident [as] a kind of collective collage." Exquisite corpse (*cadavre exquis*) began in 1925. It was "based on an old parlor game [and] played by several people, each of whom would write a phrase on a sheet of paper, fold the paper to conceal part of it, and pass it onto the next player for a contribution [. . .] The game was adapted to the possibilities of drawing, and collage, by assigning a section of a body to each player."

Divide up into teams of four. By chance means, each person selects one out of four possible quarters of the body: highest quarter; upper mid-quarter; lower mid-quarter; lowest quarter.

Beginning with the person who chooses the top quarter and working down, in order, create a photograph of your quarter of a body, in whatever way you wish to define and express it; e-mail a JPEG of the bottom third of your photograph to the next person in line, and so on. Once the last person has created his/her image, everyone please reveal your entire image, and collectively come up with a way to connect your individual parts, creating your tangible "exquisite corpse."

See also Imboden, Turyn

Cig Harvey
Ideas Into Pictures: A Two-Part Assignment

Grab some paper and write for twenty-five minutes nonstop. This is a free-write, a way of getting out what's inside, so try not to direct it at all. This is not a to-do list.

What to write? If you have an idea, then start there. If your brain is empty, or if you're feeling tired or blocked, then start with, "I am sitting in this room and . . ." It's better to start with an empty mind and see where the creative writing takes you. Write with the understanding that no one will read what you have written. No one. You need to be honest and open. Burn it if necessary later. Write fast and don't worry about grammar or spelling. If you get stuck, keep going. If you feel emotional, keep going.

After the free-write, take five minutes to distill the essential themes of what you have written into one word. Where you end up in your writing is often more interesting than where you began. Try to be as specific as possible when selecting your word. If you hate your word then pick its antonym.

Write your chosen word in the center of the page, circle it, and then start a twenty-minute session of free association. I like to work on a large piece of paper and avoid being too linear or symmetrical. No sentences, just words that you associate with your chosen word. Write nouns, verbs, adjectives, and pronouns, making sure you cover each of these categories: metaphors, symbols, gestures, weather, animals, landscapes, emotions, light, depth of field, palette, frame, format, and motion.

At the end of your session you will have an unconventional shooting map—a place to begin if you are a constructor of pictures, or a heightened-awareness list of what to be searching for if you are a finder of pictures.

A few points of direction: try to have at least sixty words on the page, and make sure a lot of them are nouns and verbs. The verbs tell us what to do with the nouns. Try to avoid clichéd metaphors: no gravestones, crosses, roses, love hearts, or lobster traps.

See also Cotton, Hamada **141**

Jacqueline Hassink

Depicting Consumption

There has been a shift from the traditional notion of artwork to the idea of art project. The art project could be understood as a concept structured in a constellation of different but independent elements, in which the author is able to master not only the implicit creative aspects but also a certain social dimension.

I would like you to make a series of photographs that deal with the growing consumption economy in a major city. For years all over the world, people have been consuming more than they can afford. How do you experience economic growth in the city you have chosen? You could wonder, where are the products that you consume made? Is there anything that you see in the department stores, on the street, or in the subways that is a reflection of this economic growth? How has it changed your own life and that of your family?

You could start by looking at your own life from a bird's-eye view—as if you are an alien visiting your city for the first time and wonder about these questions.

　　　　　　　　　　　See also Menjivar, Opton

Sebastian Hau

Important People

Ask yourself who is really important to you and photograph that person. Ask the person to name two people who are really important to them, and photograph these people too.

See also Butler, Verene

Ron Haviv

Some Thoughts About Making Images in the Chaos of Conflict

Access

Often, the best work one does is without the camera. Trust must be garnered, sometimes in a matter of moments. To work in reportage is to involve yourself in the lives of others. Sometimes it is only for a moment, other times it can last for months or years. Learn to read and bond with people through identifying common traits that cross cultures. Learn as many languages as possible. Use your natural endearing qualities to build relationships. Listen more than you speak and always be respectful whether you agree or not.

Danger

No image is worth dying for. We must live another day to photograph tomorrow. Constantly minimize your risk and act accordingly.

Emotion

There is a fine line between being overwhelmed with what you are witnessing and being able to photograph difficult situations. Your images must create an emotional reaction that comes from you to the viewer. If you are too clinical, the images might not have the impact you desire.

Exploitation

When a photographer is photographed at work, especially in private moments or times of crisis or grief, we look like vultures. It is the nature of what we do. But when people look at the photographs that were taken, they react to the emotion of the image, often forgetting that there was a photographer.

Fear

Find the balance between being too scared to work and too

brave not to be careful. Use your fear to your advantage.

Intervention
One of the most common questions people often ask photographers who work in challenging situations is, "How come you just took the photograph and didn't help the people?" Every photographer has to know his or her answer to this question. It is extremely personal and it's unfair for those who weren't there to question a photographer's motivation. The answers vary from person to person. For some the answer is that I am a human being first, and where I can intervene, I will, but for others the answer is that I am a photographer and I am in this place to do my job.

Privacy
When I started as a photographer, especially in times of grief such as a funeral, I would stand far away or would not even take a photograph. But very early on, I realized I was making a mistake. Often I would be told by grieving relatives to photograph their loved one. "Please, show the world what has happened." I understood that one of my roles as a witness was to be responsible for showing the world what I was seeing.

See also Kashi, Steinmetz **145**

Marvin Heiferman
Family Trees

Create an illustrated family tree, not of your actual family, but of the family of images (photographic and otherwise) that have, over the course of your life, shaped your interests, experience, perspectives, and current practice.

Given the visual world we live in, these images can be, but should not be restricted to, "art" images. Think broadly. They can be of any kind and come from any source: snapshots, TV, cartoons, porn, advertising, movies, packaging, magazines, posters, records, book covers, ephemera, etc.

Start as far back in time and in your visual memory as you like. The goal is to acknowledge the content, form, and impact of images you've been drawn to—from the past to the present—and to explore how they've influenced the ways you see, make, and use images yourself.

This presentation can take any form you like. Make a flow chart, a scroll, a slide show, a video, whatever, as long as it can be presented in about fifteen minutes.

See also Baart, McFarland

Corin Hewitt
The Replica and Its Mutation

1. Make a highly detailed replica of an object from a photograph. The object should be no smaller than a penny and no bigger than a volleyball. Use any materials you would like. Take a new photograph of that object.

2. Bring a printed image of the replica, but not the original replica. Pass the printed image on to another classmate and receive an image from them. Then do your best to make an object that replicates what is in their image. Take a picture of the new object and e-mail it to a different classmate. You'll receive a JPEG in an e-mail from another classmate.

3. Make an object replicating the image in the new JPEG that you have received.

4. Bring in all images and replicas and set them up in a series.

Note: Don't show the objects to anyone until the final day.

See also Osterman, WassinkLundgren

Leslie Hewitt

Image Construction

Respond to the following:
Give in to the fact that you have inherent biases that are part of your geographic, cultural, and sociopolitical position. In place of photographing any subject in particular, create a series of lists consisting of single words or set phrases to begin the process of mapping your subjective desires and discomforts as an image constructor. Perhaps this act of creating lists could for a short while replace the impulse to record/document with a camera what is outside of oneself, as a site that reflects a set of conditions that are often rendered invisible.

See also Frazier, Thomas

Todd Hido
Expose Yourself

Expose yourself to a different environment. Go on an over-night trip, preferably two nights, to somewhere that you don't normally go. Obviously the whole goal is to photograph there, and you should take as many pictures as you can. Notice how much more you're responding to, and the details you're seeing that you walk by every day in your normal daily life. Notice that it's like somebody opened your eyes. This is the most tried and true method of finding things that you like to photograph. It's worked for photographers for years and years. My favorite and most effective thing to do in my work process is to get an airplane ticket to a city that I've not yet visited, rent a car, and drive around for two days to shoot—with no hotel reservation, no plan to meet anybody, nothing set in stone. Everything is left to spontaneity, except for my return ticket home.

See also Cases, McPhee

Nicole Jean Hill

Scavenger Hunt

On the first day of my beginning darkroom class, we look at the photographs of Walker Evans, Dorothea Lange, Robert Frank, and Alec Soth. I recite the lists the photographers made of the subject matter they were seeking. We discuss how these lists reflect the artists' previsualization of the cultures they were photographing. I then ask everyone to fill out an index card of possible subjects that could serve as a template for photographing their own current time and place. I collect the anonymous index cards and, after class, I choose one unexpected or absurd item from each card and create a scavenger hunt for the students' first assignment. The cards help me gauge the students' concept of the range of photograph-worthy subject matter.

"The beach," "wrinkled hands," and "graffiti" populate many index cards every semester. Often times, they might just be hungry ("tacos," "donuts") or looking at the girl across the room ("hairy armpits," "dreadlocks"). I try to imagine the photograph the person who writes "hot chicks" or "my roommate sleeping" envisions in his or her mind. What does the student who writes "empty space," "gas station bathroom," or "broken branches" visualize? Eventually, each student photographs subject matter they wouldn't necessarily consider and also sees something they wrote transformed into another's photographic interpretation.

See also Campany, Connor

Darius Himes

Sequencing and Bookmaking

Editing a body of work and then sequencing those photographs is one of the most sophisticated acts of bookmaking. Most photographers get it wrong. They are usually too close to their own photographs to be dispassionate editors or too involved with the story of making the work to see more nuanced and powerful ways of sequencing.

An exercise that will help you toward your final book is the following: Find two or three significantly different-sized books, which you appreciate and enjoy holding in your hands. One should be the size that you think you want for your own book of photographs. Another should be quite small. If your ideal book is horizontal, find a vertical-formatted book or vice versa. Next, print out your edited photographs so that they roughly fit the size of the pages. These should be cheap work prints. Color photocopies will suffice. Work up a sequence by laying them out on the floor or on the table—wherever you see fit. Physically tape the photographs loosely into these books in such a way that you'll be able to easily move them around and change the sequence.

Fill the two or three books with your photographs and live with them for some months. Keep fiddling with the edit and sequence. Print out new images and paste those in. Move things around. Start with something totally different. Gauge your reaction to the different sizes. Listen to your inner voice and attempt to avoid having a set, pre-figured format. Work hard at this. Identify the inelegant shifts between images and keep tweaking it until it's better. Ask other artists, curators, and friends their advice.

The best format book for your work may be the one that you least expected. Like practicing a piece of music, you won't get it right on the first try.

See also Catanese, Lyons **151**

Takashi Homma
The Boundaries of Imitation

Pick a photograph by one of your favorite photographers and try and shoot an exact copy of it. Take the setup seriously and consider aspects like composition and point of view.

Producing a total copy of something is actually quite difficult. It requires you to genuinely see the work and to think it through deeply. There's a huge difference between understanding something and attempting to recreate it.

When you recreate a work of art, you enhance your understanding of its greatness. You'll find that what you intended as a total copy soon outgrows the boundaries of imitation, thus revealing the individuality of each photographer/creator.

See also Brandt, Bunnell

Rob Hornstra
The Best "Whatever"

Imagine you are able to erase all of your ideas about how to present a photo or photo story. So you've never heard about prints, frames, photobooks, or essays in newspapers and magazines. It's as if you are an alien from space coming to Earth without any knowledge, but with a brilliant photo (or photo story) in your jetpack. And you want this photo story to be seen. So you will need to find a way to communicate this to a chosen audience. Would you still choose the media all photographers are using nowadays?

First ask yourself which audience you want to reach—for example, your hometown or another country or your family or whomever. Think about the most effective and innovative way to distribute your photo story to that audience.

A few things are not allowed: you are not allowed to make photo prints (you are allowed to print your photo on "something," but not just a traditional photo print). You are not allowed to make a publication, album, book, or to publish it in existing media (newspapers and magazines). And you can definitely not publish your photo online. Try to find the best "whatever" to distribute your work. Everything else is allowed, from peanut butter jars to license plates.

See also Mayes, Opton

David Hurn
Giving the Mundane Its Beautiful Due

I tend to be very tenacious and finish what I start. I am at
an age where giving myself a long-term assignment means I
must hang around. I started a ten-year project about my vil-
lage sparked by a John Updike quote: "Giving the mundane its
beautiful due."

"Giving the mundane its beautiful due" seems a good
assignment/project for others too. Though "mundane" means
"run-of-the-mill," for me, the uninteresting sometimes becomes
the interesting when closely investigated.

Investigation starts with research, knowledge, involvement.
It's then a matter of utilizing the only two real controls we have
in photography: where you stand and when you press the shutter.

See also Diederix, Sanguinetti

Connie Imboden
Photographing the Human Form

The nude has been one of the most popular and commonly used subjects throughout the history of art. Often, our interpretation and judgment of the human form is filtered through this magnitude of previous expressions. And it can be easy to base our approach to the body as a subject within a framework in which we already understand it. But working with nudes can challenge our notions and expectations of what a nude "should" or "shouldn't" look like.

The body is a magnificent subject and can be seen in one instance as alluring, graceful, and beautiful, while in another as disturbing, alarming, or unsettling. Working with such a complex subject, we are able to explore our assumptions of beauty, our understanding of self and humanity, and the mysterious dynamics between body and spirit, body and mind. But in order to do so, we must free ourselves from the predetermined notions we have established when interpreting the human form.

While the human form may be the most widely used subject, it is not what you photograph, but how you photograph that is of value. This assignment is designed to see the nude in unique and personal ways and to encourage students to explore new ways of seeing the body.

Look at and explore lines in the body.

When you can see the body as form, you're not thinking about your subject but instead visually responding to it. In that moment, the cultural filters begin to disappear. Look at wrinkles as lines, folds as lines, edges as lines, etc. Then explore that line through camera angle to make it long, short, graceful, awkward, etc.

Rules
1. No faces. It is very hard to see pure form when you are conscious of the individual.

2. No tripods. The emphasis in this exercise is exploration, and a tripod will limit your investigation.

3. Use a 50 mm lens or shorter. You don't want to get too far away from the subject.

Again, the emphasis is on exploration—getting in close encourages you to see the body graphically, in terms of line and shape. You'll also see significant changes in these visual elements when you photograph close up and change camera angle.

See also Engman, Harris

Jessica Ingram
Roll a Day

One of my all-time favorite assignments is Roll a Day. It was
given to me by my teacher Tom Drysdale when I moved from
Tennessee to New York at age eighteen. I was particularly stuck
at the time. I had no trouble walking around making images,
but I didn't know how to connect my intuitive way of making
images to ideas, and I was starting to overthink. He told me to
shoot a roll a day and come back in a couple of weeks. I took
tons and tons of pictures, thinking less, intuiting more, and
looking at everything. I took my contact sheets to his office,
and said, "Now what?" He said, "Now look at your work and
see what is important to you. Then follow that." I still use this
in my practice when I'm stuck or transitioning, and trying once
again to understand what is important to me. And I give this
assignment to my students all the time.

See also Cyr, La Spina

Natalie Ivis
Twenty-Four Hours

Spend twenty-four hours with someone whom you've just met and photograph them during that time.

This assignment was given to me while attending the Salt Institute for Documentary Studies. It was intimidating, but ultimately I ended up asking a man that I had met the week before, Randy. I had gone on a long drive in a rural part of Maine and stopped to take a photograph, when a man in his pajamas approached me. He talked to me about his town and invited me in for coffee to continue the conversation. I eventually left with handpicked vegetables from his garden. When I called a week later to ask if I could spend twenty-four hours with him, I was welcomed back.

I didn't photograph constantly. Instead, we talked a lot and learned about each other, and I photographed occasionally. By giving the camera a rest and simply being with Randy, it fostered an intimacy that came through in the photographs.

See also van Manen, Weber

Jeff Jacobson
Where Do You Stand?

In creating my workshop, I have blatantly borrowed from other photographers. But I pride myself in only borrowing from the best: Charles Harbutt, David Hurn, and Phil Perkis.

The Welsh photographer Hurn has written that there are only two questions in photography: "Where do you stand?" and "When do you press the shutter?" I think it is a bit more complicated than that, but his questions provide an excellent teaching framework. The question of when you press the shutter seems simpler, a question of timing: you either press it at the right moment or you don't. But where you stand has deeper ramifications.

What makes photography unique, what it can do that no other medium does, is to render a still image from a specific moment in time and space. The question of where you stand, while physical and spatial in nature, also has political, professional, and emotional ramifications. Where do you stand politically in your work? How do you use photography to make money? What emotions are being expressed in your pictures?

With the question of stance in mind, here are two assignments: the first, concentrating on the physical aspects of the question, I borrow freely from Perkis. It is designed to help students move around rather than choosing a spot and remaining frozen in space. The second, focusing on the emotional and political aspects of the question, is a variation of Harbutt's famous spaceship assignment, which I did as his student in 1974. It's designed to help students understand how they occupy, photographically, their own individual and personal sliver of time and space.

Assignment 1
Choose a definable space, such as a square block area, or Grand Central Station, and spend a day walking all around it photo-

graphing. The next day return, but take one step closer to your subject, to what has most caught your attention. The third day, do the same thing but keep moving closer until you are right up on the subject. Then, drop to your knees and take another picture. On the fourth day, repeat the steps and then turn around, and take a picture of whatever is behind you. If that interests you, move closer.

Assignment 2
You are leaving on a spaceship and the only thing you can take with you to describe life on earth is your photographs. They must describe what life feels like to you (not just what it looks like) in order to give a sense of this to anyone you might encounter in space using only the photographs you make for the assignment, no words.

See also Hurn, Perkis

Margarete Jakschik
Follow Your Heart

When I studied photography in Thomas Ruff's class in Düsseldorf, there were always assignments given, such as, "shoot train stations, bus stops, or industrial sites." Then groups of students trotted off. I found this way of working did not suit me. There was something too concrete about it. I preferred a more abstract assignment, and instead I followed a path in which I embraced a certain degree of arbitrariness; motifs would come along, and as they did, I juxtaposed them into a kind of narration.

Therefore, my assignment would be to "follow your heart" —in all seriousness and with all its trappings. This way, you can be aware of situations that others might easily miss or things others are oblivious to—it could be a certain quality of light, the blow of the wind when driving . . .

Let your work evolve like a visual song. When you hear a song, try to transport the feeling of it into your work. Others might not see it, but there is a transformation happening in your work, which will hopefully be identified by a larger audience on a similar emotional frequency.

Once you allow chance and emotions to enter your work, this can become the most beautiful assignment for yourself.

See also Ventura, Walker

Eirik Johnson
Your Own Invisible City

This exercise follows an assigned class reading of the highly descriptive *Invisible Cities* by Italo Calvino, an imagined conversation between the Emperor Kublai Khan and Marco Polo. In the book, Polo describes the strange and baroque cities he has visited throughout Khan's vast empire.

> *In Chloe, a great city, the people who move through the streets are all strangers. At each encounter, they imagine a thousand things about one another; meetings which could take place between them, conversations, surprises, caresses, bites. But no one greets anyone; eyes lock for a second, then dart away, seeking other eyes, never stopping.*

Taking inspiration from the whimsical and psychological cities imagined by Calvino, work to create a series of photographs that explores your own imagined "invisible city." There are no restrictions as to what your own invisible city can or should be. It could take the form of an exploration of deconstructed architectural space, a fictional narrative love story, or an allegorical reference to urban isolation. Think about how factors such as time of day, color palette, movement, or detail can work to evoke the mood of your imagined city.

See also Moore, C. Reas

Matt Johnston
The Empowered Portrait

Enable an individual to create their own portrait through you (and your skills as a photographer). Ask the subject to think about how they would like to represent themselves. Without taking charge of the photographic conversation, empower the subject to make their own previsualization and choose a representation, a reality. Support this vision in the photograph you make together. During the process, think about how your own thoughts and ideas of a portrait of this subject differ from their own.

See also Deveney, Lampert **165**

Ron Jude
The Convincing Lie

This assignment is simply meant to demonstrate the fallibility of truth in the photographic image. Through the use of text, direction, or contextual relationships, fabricate a convincing, non-fantastical fiction in five straightforward, digitally unaltered photographs. All five images can work together to tell a single lie, or they can tell five individual lies in five unrelated photographs. Keep the images simple and direct. Prior to the assignment look at famous questionable photographs by people such as Robert Capa, Mathew Brady, and W. H. Jackson as examples of this sort of deception.

See also Halpern, McFarland

Miranda July
Mother's Nightmare

Ask a mother to describe a nightmare she's had about her child. Now work with her to recreate and document this dream in a single photo. A real child can, but need not, be used; the mother can choose or help make a stand-in. The important thing is that the mother feels the mood of the dream is conveyed. For example: if the nightmare was of a shrinking baby who kept getting lost, the mother might appear huge in the frame and frantic, searching the carpet with her fingers. For a dream about a disintegrating baby, you might fashion a baby out of a loaf of bread, then photograph the mother trying to bathe it. When you are done with this assignment, do it again. Try to make a career out of photographing mothers' nightmares.

See also Ballen, Barnes

Nadav Kander

Making, Not Taking

What makes a photograph a landscape versus a travel snapshot? In my opinion, this can be answered simply: for a landscape to have validity, it needs to be made, not just taken.

By concentrating on why you choose to photograph something and not to photograph something else, you begin to reveal more of yourself in a picture. You make conscious choices and interact with what is in front of you. You can go further by concentrating on the many other choices at your disposal in image-making: composition, intervention in the scene in front of you (for example, posing a person or adding items into the frame), manipulation of the image after it is taken, and printing, to name a few.

In a series of pictures, reveal the evidence that you have somehow interacted with the world around you to make your photograph; show that behind this set of pictures, there is a human being with an opinion and an emotional heartbeat.

See also Callanan, A. & R. Webb **169**

Ed Kashi
Be Passionate

If there is one truth I know about photography, it's that you must be passionate about what you photograph. Throughout my career, I have been fortunate to find a number of subjects that I am passionate about. It began with Protestants in Northern Ireland then proceeded to the Kurds in the Middle East, and onward to a domestic look at aging in America which lasted eight years. Then it was the issue of oil in the Niger Delta, in Nigeria. Now it's Syrian refugee youth. And in between there have been myriad other subjects that remain part of who I am.

What all of these subjects have in common is my sincere interest. Once I learned about these places, issues, or themes, I wanted to know more. I couldn't learn enough. I wanted to see more, feel it, experience it.

So the first step is to find a subject you are passionate about. Be inquisitive. Learn as much as you can. Commitment of time, and patience and compassion are essential. Get close. Bring an open heart and mind. Circle your subject. Engage. Ask questions. Show that you understand and that you care.

Photographically deconstruct your subject by using different elements of the visual language—overall shots to capture a sense of place, medium to intimate candid moments, details, portraits to capture characters. And find something different.

Keep on looking. Keep on thinking. Spend time. Hang around. Be patient. Don't stop questioning because there are no correct answers, only fractions of moments that together might just construct a story or capture a feeling, event, experience, or the soul of someone . . . in a fleeting moment that lasts forever.

See also Keeley, Walker

Matt Keegan
Questions for the Archivist

1. What is an archive? What does this mean to you?

2. What are you currently archiving? Using what method?

3. How do you document your own work?

4. Do you play an active role in the making and exhibiting of the work of your peers? How so?

5. What role do you play in viewing, reviewing, or recording the artwork that is presented in the place where you live?

6. Who will engage with your archive, and how?

7. Why is photography an important part of a conversation about the archive? What other media seems equally relevant?

8. What would you like to actively archive over the course of this year?

See also Chiara, Heiferman **171**

Dennis Keeley
The Greatness Assignment

You can eat a great meal or listen to great music or look at great art everyday, but making great work is harder than simply applying aesthetic, theoretical, psychological, and historical standards to your project. In qualifying your own efforts you should reference something that for you implies greatness.

So what is greatness? Is it a quality? An invention? A discovery? Can you compare one thing to another? I think somewhere on the edge of excellence, on its perfect edge, just before its fall into failure, is something that invites greatness. It could be a vision, an accident, or a discovery.

You have to begin by identifying the greatness in your own life. It is important that you recognize what the world regards as great, but it is equally critical that you create in your own mind an individualized hierarchy of great places, buildings, events, revelations, and memories, as well as a criteria for your personal experience of greatness. If you cannot identify, qualify, contrast, or uncover the hidden parts of greatness, it is more difficult to prioritize your own processes and procedures in making work.

It's easier than you think to make your list because greatness can speak directly to you. It should be a natural observation. It can be weather, a favorite shirt, a person, or a special memory. For me, art and music were just a natural test of my own power of observation. I couldn't help but notice the drummer's introduction of Thelonius Monk's "Epistrophy" or the first bars of Television's "Ain't That Nothin'" or Botticelli's painting *The Birth of Venus*.

We live in a world defined by "good enough" everyday. In defining greatness for yourself, you are declaring that there is more to you than meets the casual eye.

List your fifty greatest things in life, in order.

172

See also Ceschel, Moakley

Angela Kelly
The Street as a Theatrical Tableau

The subject of this assignment is urban street photography. Street photography is a kind of theater, and the street itself can function as a stage upon which multiple "actors" spontaneously interact without any self-consciousness or awareness of the "play" in progress.

Think of the camera as framing a particular aspect of the stage where people appear to linger or disappear in front of an imaginary audience. Frame an individual or multiple "actors" within the context of the limited space, using compositional devices such as line, form, light, and shadow. The space is critical to consider. It is not simply background. Consider the people and/or objects that you've isolated from the world in order to make a picture in relation to an interesting space. Be aware of composition at the edges of the frame. Think of your picture as everything contained within the rectangle instead of one object in the center. You will not crop the picture afterward, so every element you include in the picture is important. Use framing in as many different ways as possible to make the picture as dynamic and stimulating as possible.

Experiment with the following approaches:
1. Extreme symmetry and asymmetry
2. Dynamic framing, such as diagonal compositions
3. Multiple angles of view: shooting from above or below the eye line, or from the hip without looking through the viewfinder
4. Using the edge of the frame only with blank centers
5. A frame within a frame
6. Isolating two different subjects in the frame that bear no immediate relationship to each other
7. Staying in one location for a thirty-minute period of time

See also Cases, Georgiou

Robin Kelsey

Captions

1. One student makes four photographs of different subjects.

2. A second student, knowing nothing of the four photographs, makes four captions.

3. A third student matches each of the four captions to each of the four photographs.

4. A fourth student designates one photograph/caption pair a successful work of art and one pair a failure.

5. The students meet and discuss.

See also Harris, Soth

Lisa Kereszi
All Things Large and Small

In an introductory course—whether digital, analog, or black and white—I have the students empty their pockets on the first day and make photograms of the contents. This teaches them about how printing works, yes, but also to see that potential material is all around and within them. I also have them carry their camera with them and shoot on three well-trodden paths that they take just about every day, such as the walk from their dorm to our class, from one class to another, etc. This is meant to get them used to the idea of looking for pictures everywhere and to see the world anew, so that they become less of a "civilian" and more compelled to see that world through a photographer's eyes.

In Advanced Photography, I ask them to do the following: write a few paragraphs (approximately one page) about either a visual image or about something you saw in a piece of artwork or witnessed in real life that had a profound effect on you and interested you in making art. It can be something seemingly small or a major, life-changing event. (We are affected by both the large and the small things. We have to be paying attention.)

I teach in a university setting, and my students may not ultimately end up being artists and photographers, but I think this assignment, which they must share in class publicly the following week, helps them tap into a deep place for their art-making or even for their art appreciation. I find that it forces them to take what they are doing and their approach to it more seriously. I like to keep the assignment a bit open-ended so that a student can point to a work of art, rather than a grand life experience, in case he or she has not had that moment of epiphany just yet.

See also Hill, Schechter

Erik Kessels
Hot or Not?

I have given an assignment to students of the Gerrit Rietveld Academie in Amsterdam that deals with identity, especially people's identity on the Internet. My students had to get involved with the website hotornot.com—a dating site for single people who like to be instantly rated on their looks. If you upload an image to the site, others can see it and vote one to ten if you're hot or not. The students had to create an alter ego—adding the necessary description and keywords and photographing themselves for the website. In the following weeks, they had to maintain this alter ego on the site and respond to reactions they got from people who showed an interest in them. Eventually people who were interested in the alter ego would also send personal images of themselves. Some students stretched the limits, and their photographs were rejected from the website. This included male students who transformed themselves into women and photographs of a traditionally dressed Muslim woman.

The purpose of this assignment is to look at the identities of yourself and others and how you can manipulate these. We published the results in a publication called *Hot or Not*.

 See also Gossage, Lipper

Dean Kessmann
Ninety-Nine Pictures

As John Szarkowski has noted, photographs may be described as windows looking out into the world or mirrors reflecting the artist behind the camera. When a photograph is being composed through the viewfinder, the photographer is putting a frame around a very small section of the world. However, when viewing photographs, we often look through them as if they were worlds in and of themselves. A picture may be worth a thousand words, but the order of the words matters when constructing meaning.

For this assignment, properly expose ninety-nine different images and make a digital contact sheet for all of the exposures. Choose three separate scenes and make approximately thirty-three different photographs of each one. The goal is to make multiple photographs of the same scene that tell different stories. I have the students turn in three pairs of images (one pair from each scene) that demonstrate how careful in-camera cropping of the same general scene can result in vastly different interpretations.

See also La Spina, Thall

Chris Killip
Sustainability

Live in an affordable place, keeping your overhead low. You should be genuinely interested in this place, and want to make work there.

See also McCaw

Ted Kinsman

Solargraphy

In this activity, an aluminum cylinder from a soda can is modified to make a pinhole camera, and a picture is made on regular photo paper. The exposed paper is then permanently recorded with a scanner.

Convert an aluminum can into a pinhole camera by cutting off the top of the can with heavy scissors. Pop a hole in the aluminum with a pin about halfway down the can. Cut a sheet of regular photo paper in the dark so the paper will fit into the can without blocking the pinhole.

Tape the can back together and place it in a secure location so that direct sunlight will fall on the pinhole. The camera needs to be left for at least a full day, but several days are even better. The path of the sun will be recorded onto the photo paper and cause the paper to turn deep brown.

After the exposure is made, the photo paper can be placed on a flatbed scanner to record the image digitally. Test your scanner and make sure it is on the correct setting before you digitalize your photo-paper image, and turn off the lights in the room before you take the paper out of the can. Ambient light and the scanning process will also expose the paper and, over the course of several scans, will destroy the image recorded on the paper. So it is best to collect the scan the first time.

The digitized image will be a negative and can easily be inverted into a positive image in any digital editing program, like Photoshop.

This technique can be extended to record the motion of the sun throughout a season.

See also Abeles, Gottlund **179**

Martin Kippenberger

Excerpt from an Interview in Starship *Magazine*

Everyone has his successes, his moments of success. For example, some people find it a success if they are able to get up in the morning, go to work, and get there on time—even if they barely make it. Success is a time-punch card inserted at exactly the right moment. That is a moment of success. Sometimes they can live off that for one whole day. No matter how dull the work that follows . . .

Bad art, you can tinker with it and turn it into high art with your life's work. Life's work—that's what it's really all about. You must have produced something decent within your life. Actually, those are Heaven's directives. Otherwise, Hell.

See also diCorcia, Thomas

Alex Klein
What Is a Photograph?

When I teach photography, the most important thing I try to drive home to my students is that there are many "photographies." Photography is in fact different things to different people, and its historicization and implementation changes radically between disciplines.

Let's consider two images:

Lawrence Weiner, *Two Minutes of Spray Paint Directly Upon the Floor from a Standard Aerosol Spray Can*, 1968

and

John Divola, *Dark Star*, *DSB*, 2008

The first example is a black-and-white photograph that depicts a light-colored, spray-painted circle on a floor; the second is a color photograph depicting a large black circle spray-painted on a wall. Both works utilize the camera to record similar acts of vandalism by the artists on domestic surfaces. However, in the first instance the object's material properties are described as "language and the materials referred to"; while in the second the image is framed explicitly as photographic and described as an "archival digital pigment print on rag paper."

In the first example, meaning is derived through language and "concept," but one might argue that the photographic document, with its nonchalant snapshot look, is in fact an aesthetic, and that the photographic record is key to both the meaning and value of the piece. In the second example, meaning is embedded in a documentary interventionist approach, but we might observe that the artist—despite whatever he may say—was informed by the conceptual tactics of the 1960s, and

that the trace of his presence and actions are core to the meaning of his photographs.

Consider and challenge what you assume to be a photograph. Produce a body of work that is "photographic," but that does not necessarily have to be "a photograph." Sculpture, installation, film, painting—all are permissible as long as you can ultimately discuss the work's "photographic-ness," the underlying lesson being that photography is a medium in the multiple.

See also Carlsen, C. Hewitt

Mark Klett
Daily Practice

Traditionally photographers have set aside time to photograph, creating a distinction between the activity and the rest of daily life. The process of making photographs involves coordinating equipment and materials and requires preparation of thought and action. But what if the camera was always accessible and the preparation as simple as reaching inside your pocket for it and responding to the moment? Would that change what you photograph and when you choose to photograph it?

For this assignment, carry a digital camera with you at all times. I recommend a small point-and-shoot camera, or simply a good cell-phone camera that fits comfortably into your pocket or bag. Photographs must be made every day, no exceptions.

Working every day involves both discipline and an open attitude toward your work. This is harder than most may realize. In a very short time you will amass hundreds and even thousands of images. What will you do with these photographs? How can you make sense of your efforts?

See also M. C. Brown, Rickard

Gary Knight
Confronting Expectations

When you work on assignment for a publication, you are expected to deliver what they think they need. And this takes real skill, not one I particularly possess. Generally, I found that the world I was confronted with wasn't what my editors expected or wanted to see. That can be confusing and challenging.

When this happens, I recommend representing the world the way it appears and not as you think people expect to see it. Remember that the status quo is there to be challenged, not confirmed. In short, if you're working on an assignment, make yourself a servant of the observed and not the observer.

See also Kander, N. Winokur

Barney Kulok

Learning to Act

When I first picked up a camera during my junior year of high school, I was only interested in making portraits. I set up a studio in my parents' living room and photographed anyone who was willing to sit for me, including every classmate and teacher in my school. Before college, I had never taken a photography class, but I had interned for a friend's father, a photographer who made portraits in a studio. He lent me his first set of lights and an old Rolleiflex twin-lens camera. After several months of observing him, I began to feel comfortable in my improvised studio. Using techniques and strategies I had learned from watching him work, I could tell my subjects how to relax the muscles in their face, which way to hold their chin, and I knew where to put my lights to create the most flattering shadows.

Halfway through my sophomore year of college, deep into a project that had me driving to VFW posts throughout upstate New York with a portable studio in my trunk, Vik Muniz, a professor of mine at Bard, said something that forever changed the way I thought about portraits. Looking at the box of prints I had accumulated over the course of the semester (pictures of soldiers and veterans in uniform standing in front of a dark backdrop), he said: "Read Stanislavski. Read Stanislavski's *An Actor Prepares*. It will make you a better photographer. The best portrait photographers are great directors. But to know how to direct, you must first learn to act."

See also Boot, Sealy

Justine Kurland
Suggested Suggestions

1. When a student makes conventional or cliché photographs, I suggest they do a Google image search to find how many other people have made the same pictures.

2. Often younger female students make Francesca Woodman-inspired work, which I both appreciate as a right of passage and dread as a contagious disease. I try to help them break through symbolic or metaphoric self-expression and locate whatever sliver of the real world exists inside these pictures. Embracing the accidental and the incidental may free them from the oppressive airlessness of having turned so inward.

3. When a student's work seems too polished or contrived, I suggest they go back to their contact sheet or digital files and use the picture before the perfect frame; if there isn't one, I suggest they kick their tripod during their next shoot.

4. Or if they insist on a commercial photography aesthetic, I remind them it cannot simply reiterate what is already ubiquitous in advertising. I try to get them to displace the usual consumer appetite for objects and ladies. I want them to use the seductive power of photography to bring me someplace new.

5. I have railed against portraits that I describe as a pinned butterfly—those perfectly centered, well-lit frontal topographies that treat subject as specimen. I encourage students to try to animate their subject inside the frame by using a more complicated geometry in composing the picture. I also do not let them repeat the same form from picture to picture to picture.

6. I've asked students to connect their work to the political and the social. For instance, if a student is photographing their

family, I ask for details that locate the socioeconomic status of their family.

7. If a student is working with abstraction, I have them define and refine process rather than the end result. That probably goes for any kind of photography, but I'm especially against making purely retinal abstractions.

8. I have told certain students to sequence their work as a continuous walk or as a sentence or paragraph. And to revisit these chains, making photographs that connect them. Sometimes, it's a good idea to edit out all but the connective photographs so the meaning of the work is not so apologetically explicit.

9. I don't let them talk about their old photographs or their family albums as "the archive."

10. If it's really not working, I suggest they try video.

11. There is one actual assignment I give to the entire class. Over winter break, I have them read *Camera Lucida* by Roland Barthes and then photograph their mother.

See also diCorcia, Muellner

Jeffrey Ladd

Insecurity

I believe insecurity is good for the shooting process. When you are out in the world with your digital camera and see something, you raise the camera, frame, and make a photograph. Nine times out of ten, you will look at the screen and respond to what you see previewed there and maybe try again. You might repeat this process three or four times before you "see" the results you want or expect on the screen. Then you move on. When shooting film, obviously you don't have the benefit of seeing the results immediately, so you have to work with some degree of insecurity, having no idea if you "got it." Actually, the thought of "I got it" isn't part of the equation at all. The instinct is more to stay within the relationship you established when you responded to something in the first place. You keep working, shooting, and trying as many variations as your attention allows. Your attention is not continuously shifting between the world and your tools.

What I have noticed in my own process is that the photographs that interest me on my contact sheets later are often far from what had grabbed my attention initially. Most are the seventh or eighth frame into the investigation. With this in mind, you should ask yourself if, by being able to look at your results immediately, are you just confirming what you immediately responded to and capturing what you expect? Or are you actually using that "preview" as a tool to keep working and to discover something transcendent, beyond your expectations? There is capacity for both to happen. You just need to avoid the feeling of self-satisfaction that disrupts the shooting process and results in only the former and not the latter.

As an assignment, I would suggest shooting photographs without looking at them in the moment. Work with a bit of insecurity lingering over your shoulder and see what happens. Put black tape over the screen if the draw to look at it is too great.

See also Barney, A. Bell **189**

Alexis Lambrou
Arm's Length

This was one of the first assignments I received in the photo-journalism program at the Rochester Institute of Technology. My professor William Snyder was constantly quoting Robert Capa's famous saying, "If your pictures aren't good enough, you're not close enough." He gave us this assignment in an attempt to make us "get closer."

We were asked to hold our arm stretched out in front of us and focus on our fingertips. We then had to tape down the camera's focal ring in that exact position, making anything farther than an "arm's length" away out of focus and forcing us to get close to our subjects.

See also Jacobson, Visser

Andrew Lampert
Shoot Me

Your assignment is to take a good photo of me. It's hard. Facing a camera makes me feel instantly uneasy. I can't put on a fake smile or feign a serious look. When asked to be loose and spontaneous, I almost always freeze up. Begin by texting to check about my availability (+1 718 916 6697). Invite me to a pleasing destination, a place where I will feel comfortable. This might involve a good meal (for example, dim sum) or a couple drinks (whiskey, maybe tequila). Let's talk for a while, come to understand one another. Do your best to get me in the right mood. Break down my defenses. Show me some of your work to offer reassurance. Talk me through our shoot. Give me direction. Help me figure out if I have a good side, a better angle. When it is over, ask me to help you decide which is the best shot. Trash all the rejects. Don't let the whole thing take too long. I can get difficult.

See also Deveney, Weber

Jessica Lancaster

Two Assignments

20-40-10

In my sophomore year of college, my professor assigned the class a project called "20-40-10." The goal of the assignment was to create a series of images in three weeks.

Week One: Shoot twenty rolls of 35 mm film with thirty-six exposures (or equivalent if another format was chosen).

Week Two: Make forty work prints.

Week Three: Print ten images from work prints.

The Negative Exchange

Another assignment was one in which students were free to shoot and print images without direction, but they were not allowed to discuss or show their work to their peers. Once this part of the assignment was complete, they turned in their negatives to the professor, who then redistributed the negatives to the class. Each student had a different set of negatives than what they had started with. Part two of the assignment was for students to reinterpret the negatives they had received, again with no direction or input from their peers. The critique following this project compared and contrasted each set of prints made from the same negatives.

See also Maloney, Kelsey

David La Spina
24/24/24

In 1971, while shooting, developing, and printing hundreds of prints per day for an exhibit at the Seventh Paris Biennale, the Japanese photographer Takuma Nakahira didn't sleep for almost a week. Prior to completion, he abandoned the project due in part to exhaustion and due in part to a conflict with the event's organizers. But the resulting work is a veritable masterpiece—a still-photographic version of cinema verité, where the art is almost divorced from the maker because the subconscious overtakes the conscious. Nakahira's act has been compared to the practice of a Kyūdō archer, where muscle memory trumps the consciousness to make each arrow have a true release, resulting in a true target.

Within the next twenty-four hours, take twenty-four rolls of photographs on black-and-white film. Develop the rolls and select twenty-four images from which to make twenty-four prints. Be prepared to share your work at this time tomorrow.

This assignment can be modified as eight/eight/eight or twelve/twelve/twelve, depending on your level of students. This was an assignment I originally experienced while under the tutelage of Owen Butler at the Rochester Institute of Technology.

See also Harbutt, Ivis

Jason Lazarus
Impossible Pictures

Conceive of ten photos or photo projects that are impossible to make.

Three great examples:

1. A long-exposure photograph of the Big Bang (Gory Gleich)

2. A PET scan of Marcel Proust's brain as he wrote the madeleine passage in *In Search of Lost Time* (Kendra Paitz)

3. A collection of 365 self-portraits taken by Elvis in the year leading up to his death (Elise Hibbard)

See also Ballen, De Rita

John Lehr
The Envelope Project

One of the pleasures and terrors of teaching photography is that the teacher is almost never present when the students are making their work. We instill and inspire as much as we can in the classroom, but the student is often alone, surrounded by the cacophony of life, when he or she makes their pictures. A lot of what we do in critiques is point out what might have been possible in moments just before the student raised the camera. It's a sort of backward attempt at creating muscle memory, training a student to anticipate opportunities and avoid the usual pitfalls. I've often wished I could have been there with a student when they found themselves, suddenly, in the presence of some ordinary noun or verb revealing itself to be a possible subject.

The Project:

A student is presented with a series of sealed envelopes. An assignment is written on the outside of each envelope. The student is asked to complete the assignment and immediately open the envelope for further instructions.

Examples:

Envelope A:
Decide on an outdoor location where you can photograph for a couple of hours. This can be a park, city block, stadium, strip mall, patch of woods, etc.
Make photographs of five individual things you find meaningful, wonderful, troubling, etc.
Try to fill the frame with each subject.

Inside Envelope A:
Track down each subject from the first set of pictures.

Now make a photograph of each thing from a distance, as far away as you can be while still being able to maintain the significant presence of the subject.

Envelope B:
Devise an action that you will perform for the camera.
The act of photographing must drastically change the action.
The camera must not passively record the event.

Inside Envelope B:
Now devise an action that will be performed by at least twenty people.
The act of photographing must drastically change the action.
The camera must not passively record the event.

See also Gremmen, Steacy

Saul Leiter

As Remembered by Jason Fulford

My assignment was to photograph Saul Leiter and his beautiful, cluttered studio for *Aperture* magazine. We had just met that morning, and he was wary of me, but polite. At one point, I was kneeling in a corner, interested in a stack of dusty boxes behind a chair. I started to slide the chair out of the way, and Saul perked up, "Ya can't move ANYTHING. Ya have ta shoot THROUGH it." I turned around and looked at him and we both started laughing, hard. But he was serious.

See also A. Brown, Cartier-Bresson

Laura Letinsky
Still Life

In preparation for taking pictures (Step Three), complete Steps One and Two without the camera.

Step One
While listening to something you don't want to hear, or while bored, first close one eye, then switch to the other eye, noting how what you're looking at shifts in relation to what's around and behind you. Continue to observe what happens if you sway imperceptibly (so those around you don't notice your somewhat distracted, perhaps even strange behavior).

Step Two
Using a standard sheet of paper or board, make a rectangle the same size as your film plane. Close one eye and look through the rectangle, noting what happens within that rectangular plane when it's closer to your face, further away, tilted one way, then the next, and at various angles to the scene before you.

Move yourself in relation to what you're looking at. Move around the things that you're looking at through the frame so that they're in different places and relations to one another, as well as the picture's edges. Remove some things. Put in some others.

Step Three
When ready to shoot (perhaps through some combination of intrigue, frustration, maybe disinterest), try to do the following with camera and film:

1. Lose the words that identify what you're looking at, attending only to the visual relationships of what appears in your viewfinder's rectangle.

2. Suck the air out of the scene, massaging and coercing vanishing parallels in relation to horizontal and perpendicular linear indicators.

3. Distill the scene further. Still its beating heart.

4. Later, resuscitate.

See also Cwynar, Palmer

Susan Lipper
Alter Ego

Take a series of photographs that are not by you.

As viewers, we often tend to mistakenly assume the photographer should only speak with his or her own voice, not taking into account the rich tradition of writers and artists who have used the literary devices of masks and personae to convey desired messages (be they fiction or documentary), and thereby avoiding unnecessary confusion with their conscious or biological selves.

Jorge Luis Borges's short story "Borges and I" comes specifically to mind. Also, William Butler Yeats ranted as a lusty woman in her later years in his "Crazy Jane" poems—clearly in the opposite manner of his public figure as a sedate Irish politician. He also consistently deployed a roster of mythological and historic heroes that bore a resemblance to the people in his personal life.

Media literacy now implores us to take all subjectivities, including that of the reader, into account, in addition to the work's original context. That said, I believe it is now time to enjoy the freedom of other arts less tied to "reality" and to fabricate our own narrators, if that suits our purpose.

For this assignment, some of the obvious choices are to adopt a different gender, age, nationality, and time period. Alternatively, you could utilize a more subtle difference from your origins, but it still should be one that needs to be taken into account in judging the "veracity" of the series.

For extra credit, write a series of captions or a text to go with it. This might aid in defining the context of the images. Think of employing factual, scientific, diaristic, or fictional strategies.

The goal is to produce a complex body of work that can demand and reward viewers' attention, thus enhancing the photographic literacy that is essential for us as today's global citizens.

See also Fleming, Kessels

Nathan Lyons
Sequence and Series

Jacques Hadamard's investigation of creative thinking in science forms the basis of this problem. In *The Psychology of Invention in the Mathematical Field*, Hadamard concludes that "words are totally absent from my mind when I really think and I shall completely align my case with (Francis) Galton's in the sense that even after reading or hearing a question, every word disappears at the very moment I am beginning to think it over; words do not reappear in my consciousness before I have accomplished or given up the research ..."

In an appendix to his study, Hadamard includes a testimonial from Albert Einstein, which provides an exceptional construct for any consideration of the existence, as well as the relevance, of visual thinking, when he outlines his own mechanisms of thought. He describes a process of thought that might provide an important distinction between visual and verbal thinking. Einstein indicates, "The words or the language, as they are written or spoken, do not seem to play any role in my mechanism of thought. The entities, which seem to serve as elements in thought, are certain signs and more or less clear images which can be 'voluntarily' reproduced and combined." It is in this activity that Einstein terms "combinatory play" that seems to be an "... essential feature in productive thought—before there is any connection with logical construction in words or other kinds of signs which can be communicated to others." The essential conditions are identified as "visual and sometimes muscular" and "conventional words or other signs have to be sought for laboriously only in a secondary stage, when the mentioned associative play is sufficiently established and can be reproduced at will." It is the prephonetic or prelinguistic character of Einstein's thought process that provides the essential premise in my argument on behalf of visual thinking.

Often the terms serial and sequential have been used interchangeably. Before proceeding, however, I would like to attempt to distinguish between a serial concept and that of a sequential concept. Series generally are thematically related or connected, while sequences are based upon disjunctive relationship. The Latin root of each term forms another distinction—series, "to join"; sequence, "to follow." Therefore, a series is structured so that the relationship of terms is such that each successive term is derived from the one preceding it by application of a specific principle. A sequence is structured by allowing one image to follow another by an order of succession or arrangement, which is not apparently thematic or systematic. These distinctions, I think, are important to consider in expanding upon what Moholy-Nagy characterized as the "Image, Sequence/Series" that was originally published in *Telehor* in 1936.

There is no more surprising, yet, in its naturalness and organic sequence, simpler form than the photographic series. This is the logical culmination of photography— vision in motion . . . Here the single picture loses its separate identity and becomes a part of the assembly; it becomes a structural element of the related whole which is the thing in itself. In this sequence of separate but inseparable parts, a photographic series—photographic comics, pamphlets, books—can be either a potent weapon or tender poetry. But first must come the realization that the knowledge of photography is just as important as that of the alphabet. THE ILLITERATE OF THE FUTURE WILL BE THE PERSON IGNORANT OF THE CAMERA AS WELL AS THE PEN.

If metaphor is a verbal strategy to evoke images, then as a photographer the combining of images to alter associations can extend the meaning of the image itself. A juxtaposition of

images enhances this possibility, while an extended sequence of images establishes a highly interactive structure that does not simply identify objects or events in a narrative sense, but transforms the meanings of objects. It is in this act of transformation, interactively between images, that I find most challenging.

Problem:

1. Develop three to four series in response to the preceding discussion.

2. Following the first problem, continue photographing until you have enough images to draft a preliminary sequence.

See also Northrup, Patton

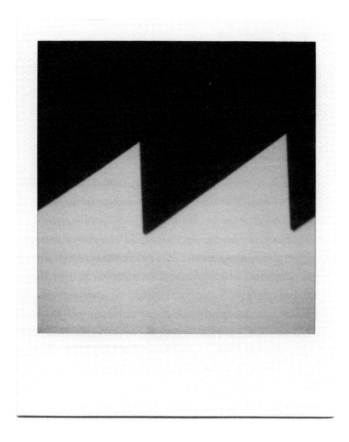

Robin Maddock
Small Ideas

I have a folder on my computer called "small ideas." I'm not going to tell you all of what's in it, but it came about through needing a break from documentary-style photography, which involves a lot of hanging around, often in places you'd rather not be.

So I needed to find a way to shoot on short visits to places, with fantasy in mind—a small idea but worked big. It's about a creative response to a place, rather than a literal attempt to understand it.

One of my small ideas is "Heist." I've done this in Italy on a few visits, where I walk around pretending I'm in a Melville film. Every bank and man reading a newspaper. There's a getaway car and a love interest. There are foreboding omens and hideouts, disguises, and tunnel entrances.

Maybe we could start a Heist club? Where we all start being suspicious of people with red carnations in their lapels? Be my guest!

Why not give the usual observational photography a breather? Come up with your own small idea and nail it in a week, or even a day. This attitude can be applied in lots of different ways to shoot an imagined story, which in a sense is what all "serious" projects are anyway. You never know, it may spring-clean your brain, and we photographers need that from time to time. Make the world come to you for once!

See also Harbutt, Meiselas

Raimundas Malašauskas
Assignment

Capture one hand clapping.

See also Elkins, Wolf

Catharine Maloney
Disrupting the Process

Through experimenting with existing photographic processes, I have occasionally found new ideas and inventions that are worth keeping. I believe that inventions occur within accidents. As Brian Eno and Peter Schmidt suggest, "Honor thy error as a hidden intention." I set up an environment of unpredictability that encourages mistakes, with the possibility of failure.

To help students achieve inventions through accident and failure, ask them to experiment with one negative by altering the steps of the black-and-white printing process, or to print in ten different ways. No idea or alteration is too ridiculous. If you're working with a group, discuss the different ways to alter a photograph and list them in advance. It is helpful to consider the elements used in making a print—the negative, the enlarger, the light, the chemicals, and the printing paper—and how they can be disrupted. There are many ways to alter a photograph. Here are a few ideas:

Alterations During the Printing Process
- Scratch, freeze, or cut the negative
- Print on a unique material
- Bend, burn, fold, crumple, tear, or carve the paper
- Change the settings on the enlarger
- Expose the print only partially
- Play with the exposure light source
- Add imagery or objects onto the paper or the lens
- Add ingredients into the chemicals
- Use heat or cold in the chemicals or directly on the paper
- Bring in a mirror to play with

Alterations After the Printing Process
- Bend, burn, fold, crumple, tear, or carve the paper after it has been printed

- Cut out and rearrange or remove sections
- Cut the print into a new shape
- Expose the print to the elements
- Add paper, paint, or mixed media on or underneath the print
- Sew on the print

See also Gottlund, Slota

Mike Mandel
Research and Invention

This project involves the integration of research with your own inventions.

First, select five objects from your life that have documentary meaning. Then research something about your family from before you were born. Next, research something about the history of the neighborhood in which you now live. For example, it could be about a business that once existed/still exists, or about a neighbor's experiences and artifacts from participating in a foreign war. When this class was taught in Chicago, our initial research included field trips to the Chicago Historical Society, the National Archives, the archives of Northwest Memorial Hospital, *Playboy* magazine, Kraft Foods, and the Lake County Discovery Museum, which owns the complete historical archive of the Curt Teich Postcard Company.

Make a list of questions that arise from your research.

The project that you will create is completely of your own invention and should derive from all the experiences and results of your research.

For your reference, a short list of artists that work in a similar vein includes Joan Fontcuberta, Susan Meiselas, Christian Boltanski, Larry Sultan, Robert Heinecken, Michael Lesy, Richard Prince, Hans Haacke, Elisabeth Tonnard, Christian Marclay, Harrell Fletcher and Miranda July, Christoph Büchel, Ant Farm, Group Material, and the publications of *Useful Photography*. You might also reference two of my previous books: *Evidence*, a collaboration with Larry Sultan, and *Making Good Time*.

See also Muellner, WassinkLundgren

Roxana Marcoci
The Logic of Photography

Photography is a generator of epistemological dilemmas.
These range from mimesis to self-reflexivity, from document to
construct, from aesthetics to sociology, from technical program
to apparatus, from production to reproduction, from freeze-
frame to filmic montage, from auratic image to society of
spectacle, from indexical to virtual, from Benjamin to Flusser,
from performative address to mass-media dissemination, from
analog to digital, from amateur to professional, from local to
cosmopolitan, from analytical study to interdisciplinarity, etc.
These dilemmas need no longer be mutually exclusive. Rather,
they are engaged in a distinctive relationship of antagonistic
indebtedness. An impure medium, photography discloses itself
as a model of contamination. It thus touches every aspect of
the world. Make a picture that documents, invents, interprets,
conducts a critical dialogue with other pictures, and invites
ongoing interpretations of its subject.

See also Barnes, Brandt

Ari Marcopoulos
Daily Destination

For one month, take photographs at a daily destination or along a route you travel daily. Make images with your camera and/or collect objects found along the way. After one month, present the work either as a book or as an installation. Assess how your feelings about the place/route changed over time.

See also Beasley, Colberg

Lesley A. Martin
Reading the Tea Leaves

I often think of sequencing a series of photographs as being very much akin to reading tea leaves. I owe this idea to Michael Hoffman, Aperture's publisher for thirty-seven years, who coached me while I stumbled through the sequences of the first photobooks I worked on. Michael, in turn, was indebted to Minor White, who trained him, and who believed intensely in the principles of gestalt and the amplified possibility for metaphor of images in sequence. So this is always my recommended starting point in editing work: place all the images out on the floor and pick out the threads and smaller sequences that are revealed—the future shape of your book in one way or another. In other words, channel Minor White for a moment and ask yourself: what is the *I Ching* of your images?

On one level, editing and sequencing a series of images is *all* about pattern recognition—identifying the patterns and using them to pull the reader into and through an individual sequence or book. These could be patterns of color, gesture, content, or composition. Identify the setting and characters of your story within those groupings. Start with the basics: "This picture goes with that one; this one leads nicely to that other image." Identify pairs and small suites of images that work together. From there, you should be able to see the shape of at least one possible structure and decide whether you're going to run toward it or away from it. Look for points where contrast and tension are going to be more helpful than "flow."

Even the most nonnarrative collections of images "tell a story" at some level—day to night; dark to light; quiet to loud and back to quiet again; point and counterpoint. Even if you want to subvert these narratives, you still need to be able to recognize them in order to avoid them.

212

See also Catanese, Morley

Katja Mater
A Beautiful Mistake

1. Think of one rule and make an image that sticks to this rule.

2. Add a second rule and make another image that follows both.

3. Add a third rule, make a third image ... continue.

Note the moment you are unable to follow all of the rules without breaking one. What does this look like?

See also Cowin, Cuomo

Stephen Mayes
You're a Publisher Now

Social media adds a thrilling new element to photography. It allows you to publish directly to your audience and opens a collaborative creative process.

Part One
Develop your social capital. Using a visual media platform (Instagram, Flickr, Tumblr, Vine, etc.) develop a following of one thousand new followers, previously unknown to you, in twelve weeks.

Part Two
Use your new network to make a story and distribute the work.

See also Kessels, Shaw

Christopher McCall
Two-Minute Drill

> *The illiterate of the future will be the person ignorant of the*
> *use of the camera as well as the pen.*
> —*László Moholy-Nagy*

This exercise is based on the belief that students should develop the skills necessary to discuss and analyze photographs at the same time they are beginning to produce and edit photographs. This knowledge helps young photographers understand that looking at, thinking about, and discussing photographs are all a key part of any photographer's practice.

Lectures about the technical and aesthetic attributes of photographs should ideally precede this exercise. Presentations exploring basic design elements, composition, and color theory will give students the tools necessary to succeed.

The exercise is simple. Prepare a slide presentation of photographs specifically selected to prompt students to explore topics previously presented during lectures and presentations. It is important to select images that highlight the technical and aesthetic topics addressed, but also photographs that are emotionally charged, historically significant, visually complex, shocking, humorous, depressing and—most important— inspired. I try to select images that become more interesting the longer you look at them. Examples I have used before are Paul Strand's *Blind Woman* (1916), William Eggleston's *The Red Ceiling* (1973), Philip-Lorca diCorcia's *Mario* (1981), and Joel Sternfeld's *Exhausted Renegade Elephant, Woodland, Washington*, June 1979.

Each student will volunteer to go without knowing what photograph will appear. When the image is presented, he or she must speak about the photograph for two minutes straight without stopping. While this may seem like a short period of time, two minutes will seem like an eternity for a young student

who is not comfortable discussing photographs—especially when asked to do so in front of peers. After each student finishes, allow comments from the class as well.

This exercise will allow you to assess each student's ability to talk about photographs in the early stages of the class. It will also help you identify the students who are shy or uncomfortable talking in front of others, as they typically volunteer to go last. Most significantly, it gets your students comfortable talking about photographs in a group setting. The length of the drill and content discussed can be adjusted depending on the age of the students and their experience with the medium.

See also de Groot

Chris McCaw
Feast or Famine

If you are in school, drop out. Student loan debt kills free time, and free time equals the ability to make art. Instead, go to the library, go to exhibitions and see actual work on walls, look through books at bookstores, and most important, do on-the-job training through assisting/interning/volunteering. Live cheaply and learn to drink (also cheaply). Embrace the feast-or-famine lifestyle because it will always be feast or famine. There's a difference between being influenced and straight-up copying others; know your art history. Folks like to work with people who are easy to work with, so don't be a pain in the ass. It's a small world (especially in the photo world). Take the long view, stay hungry, stare out the window for a while, and I'll see you at happy hour!

See also Behrend, Steacy

Sean McFarland
Create an Event

Think of an "event" that you find compelling but know very little about. It can be historical, current, or something that may happen in the future.

Find a local archive or library where you can do research. Spend time looking through books containing text and photographs related to the chosen topic. Choose at least twenty images discovered during the process and make copies of them, retaining the captions if desired.

Gather at least twenty more images using your event topic as inspiration by making original photographs and/or using found images.

Without altering the photographs—aside from cropping and the inclusion or exclusion of its original caption—create a fictional or factual slide show of around thirty slides about the past, current, or future event you've chosen. It can be about a fictional past, a factual future, or anything in between.

Take great care in the reduction of the pictures and the context created by placing them in sequence.

Present the slides and say a few words about them without stating what is fact and what is fiction.

See also Ashkin, Umbrico

Laura McPhee
Getting Lost

> *. . . getting lost was not a matter of geography so much as identity, a passionate desire, even an urgent need, to become no one and anyone, to shake off the shackles that remind you who you are, who others think you are.*
> —*Rebecca Solnit,* A Field Guide to Getting Lost

Part One:

For this assignment, you will need a map of the Boston T or an equivalent transport system in your hometown or in a city you're visiting.

Choose a stop you've never been to, one where the name intrigues you. For me, it might be Wonderland or Maverick or Back of the Hill. Don't do any research about the place. Just go with the intention of being lost. Use your camera as your companion and interpreter. Use the photographs you take as your signposts—the images are the crumbs you can use to get back to the subway. Wander.

As you work, consider how being in an unfamiliar place makes you feel. Consider what it is that you end up photographing. How do you approach your subject? What do you find yourself seeking, wanting to say or tell? How does it make you feel about yourself, about the place, about the city, the country, the world?

When you go home and have the images before you, write a reflection on your subjective experience and how it can be seen (or not) in the images.

Part Two: (Your choice)

A. Do some reading about the neighborhood in which you found yourself. Try to understand the place from perspectives supplied

by the newspaper, scholarly articles, fiction, poems, anything you stumble across. Return to the place and photograph again. Print the images and write a reflection. What changed?

B. Do the above without doing the research. Reflect on whether you are still lost once you return somewhere you have been before. Are you different this time? Does the place seem different?

See also Cases, Steinmetz

Raymond Meeks
Complete Surrender

There's no substitute for showing up and doing your work. For much of my career, I've practiced photography only at certain times under certain conditions. This usually meant leaving my camera behind because "truths" were only revealed at those certain times and not when I was out in the world, intent on capturing and bringing back images. I think this was, in part, a lack of courage to trust in the possibilities that arise when one works in agreement with, and is committed to, serving a subject. I've rarely seen Mark Steinmetz without a camera. To those, like me, who allow for a certain measure of fiction and invention in their pictures and storytelling, Mark's integrity and courage can be unnerving. He's totally committed to representing his subjects truthfully and, as a result, I think the world offers itself to him in ways that are absent to most of us. So, I've since modified my practice. I take my film camera with me (not my digital point-and-shoot), and make single exposures with the intent of aligning with my subjects and the particular rhythms and pacing unique to each.

With a digital camera and memory cards capable of storing thousands of exposures, there's a strong impulse to cast a wide net. In doing so, I can end up missing the entire experience, as the moment manages to disappear through the tiniest tear in the netting and escape me completely. Or worse, by "spraying the landscape" with exposures, I could end up so perfectly capturing the subject that the results become altogether void of wildness, serendipity, or chance. The pictures that inspired and continue to encourage my work have an inherent rawness—a slippery immediacy and messiness housed within. The picture hasn't been lassoed, tied down, and tamed. I've learned to maintain a healthy degree of mistrust of the mind's mission to organize, to bring structure and order to the world. I've lost count of the number of negatives I've made, which initially seemed

to fall short—a moment where I was off by a quarter-second or the edges of the frame were not quite where I'd prefer them. I found I would continue to return to these negatives like a riddle. They were unsolved and real, suggesting the in-between, imperfect moments as intersticcs of life we perceive. As prints, they remain the pictures I am drawn to. I wonder what I might have come away with if I'd been shooting digital with sixty frames to choose from instead of four?

What I'm working toward now is a more complete surrender to the medium and the built-in restraints of working with film and gelatin-silver paper. I recognize that the inherent limitations of the medium are also its strengths. And I'm hoping that by reengaging with analog and slowing down to invest in a relationship with my subject, that more will be revealed. It's also the key to maintaining my interest in the medium: to go out into the world and be surprised and awed and return with something that surpasses expectation.

See also Brouws, Sultan

Susan Meiselas

Alphabetography

The student locates objects, lines, and forms that most resemble each letter of the alphabet, from A to Z. Letters can be discovered in natural and man-made forms, found in shadows, or made by cropping with the frame of the camera.

(From *Learn to See: A Sourcebook of 101 Photography Projects by Teachers and Students*, 1975)

See also Rudensky, Terry

Sarah Hermanson Meister
On Close Inspection

Choose a photograph and spend some time with it. Too often we mistake the habit of reading wall labels and breezing past a row of framed pictures for the deeper pleasure of experiencing a work of art. Photography is particularly susceptible to this conflation of object and image. Don't just look at the photo you choose framed on a wall, but sit down, clear your mind, and see what you can see. This is easier than you might think. Museums have study centers that are open to the public; auction houses gladly remove works from their frames, and galleries have scores of great photographs in their plan files. Wash your hands (wear gloves if someone insists), open the mat (if there is one), and start noticing the details: is the print trimmed to the image edge or is there a border? What kind of paper is it printed on? Is it mounted? Are there interesting marks, inscriptions, stamps, or retouching? What does its condition tell you about where it's been? Take notes if you don't trust your memory.

It is, of course, a treat to behold a Julia Margaret Cameron portrait on its original mount, with or without a venerable Colnaghi blind stamp. Her elegant lettering in a pen freshly dipped in ink, or the thin gilded border that perfectly complements the deep purplish tones of her albumen silver prints signifies that you are in the presence of Art, or at least something deserving your special attention. But one can also delight in the unique characteristics of a found snapshot, where the thin glossy paper speaks of practical standards, where the shape of the image and its border are often telltale signs of a particular era and camera, or where a hastily inscribed caption serves to remind us of what we don't know. If you look closely enough at anything, even small differences begin to suggest meaning. I pride myself in being able to read Eugène Atget's loopy-penciled inscriptions, which allows me to determine a likely sequence for a group of them. Even a single photograph can

teach us something of itself. The jumble of stamps and printed captions on the back of prints from a daily newspaper's files can confirm or complicate our understanding of a picture. Subtle clues (a hand-trimmed edge, a peculiar number, a surface texture, a mounting technique) can also do the same. And these details can reveal something about an artist's intent and an object's history in endlessly gratifying ways if we take time and pay attention.

See also Gottlund, O'Toole

Mark Menjivar
Local News

The first place I turn to in the newspaper is the local section. I often wonder how people who are not normally in the news feel about being there.

1. Buy a local paper.

2. Find a story in the local section that compels you and track down the subject.

3. Interview the subject about how they feel about the story.

4. Collaboratively make a picture of them.

5. Write a new story about their response and submit it with your photograph to the same newspaper you originally saw the story in.

See also Calisch, McFarland

Darin Mickey
Adventures in the Skin Trade

A few years back, I had a student who had sort of stalled-out and was getting pretty frustrated with his work. He had hit a roadblock of inhibitions and self-doubt. I sensed that platitudes or "a coach's encouragement" were not going to do much for him.

I gave him the first few pages of the unfinished Dylan Thomas story, "Adventures in the Skin Trade" to read. It's a somewhat absurd, dark tale of a young man shedding his past skin of youth and heading out alone into the world of the unknown. With a less than optimistic start, he awakens early on the morning of his departure from the family home and, while everyone is asleep, he tears up the precious family photographs on the fireplace mantle, destroys his father's papers with a lump of coal, and smashes his mother's fine china before leaving on a train out of town never to return.

I had low expectations as to what the student would get from reading these pages and made no requirements beyond simply reading them. I hoped he would respond to Thomas's humorously dark, beautifully descriptive writing and maybe realize that the problems of photography for the most part are "luxury problems" by comparison.

The following week his new work was on the wall, and we had a great discussion that went in several directions, a few being: the metaphorical power of objects in photographs; how a picture can comment on history without being weighed down by it; looking beyond photographs for influence and inspiration; and not being afraid to take chances with your pictures, because in the end you can always tear up a photograph and start over.

See also Connors, Pushinsky

Paul Moakley
Begin at the Beginning

Revisit your earliest work—the place where your interest in photography began. Personally, I always think about a movie I saw in school about Mary Ellen Mark; that's the very moment when I decided I wanted to work with photography. It was a film about her series Ward 81, and I was totally captivated by how she could get into the lives of these people so intimately to distill and communicate something meaningful from it. I particularly loved the way she connected with the subjects' eyes. She captures the sense that the person agreed to let himself or herself be vulnerable for the moment. It's something that I've always tried to do in my photographs.

So for this assignment, I want you to rediscover why you love to make photographs. I want you to review your earliest work and ask yourself: What do you see in it? Can you find a theme that connects to your work today? What do you like and dislike about your early work? What about the photographs that made you want to be a photographer?

See also Ceschel

Andrea Modica
Weekend Portraiture

My first editorial assignment presented me with the challenge
of having just a few minutes to photograph a begrudging and
nasty professional athlete with my 8-by-10 camera. To my utter
surprise, I made a good picture, which looked unlike anything
I'd done prior.

This experience inspired an assignment I give to my Inter-
national Center of Photography students during a weekend
workshop on portraiture. The overnight assignment is to shoot
twenty pictures of one person they know very well, and twenty
pictures of a complete stranger. I encourage the students to
make the photographs in each set as varied as possible and
to take their time, listening attentively to each subject. A lab
makes small prints of all the images on Sunday morning, and
during the afternoon we have a critique of the assignment.
Among many other things, what I see year after year is the
delightful and sometimes frustrating evidence that there's no
formula for making a strong portrait.

See also Boot, Ivis

Andrew Moore
Shadows and Stories

Speaks Volumes
One of the first things you need to learn, if you're interested in photographing architecture, is how to create depth and volume within the constraints of a two-dimensional picture plane. This exercise involves working with the shifting shadows created on a building as the sun arcs across the sky.

Choose an architectural setting which ideally can be shot from all four directions; moreover, it should possess some kind of other external quality that especially intrigues you—for example, the most worn building in town, the local scary house, a house remotely sited in the landscape, or perhaps an unusually anonymous structure.

Getting up before sunrise, photograph the building during the course of an entire day, and continue to make pictures until after sunset and the sky has gone completely dark. The most important part of this exercise is to follow the shadows around the building and to shoot into the shadows as they transform the structure's presence.

Make at least twenty prints and be prepared to discuss how particular combinations of light and shadow differently render the structure's presence and potential narratives.

Building Stories
This assignment involves going out to a randomly selected town within a fifty-mile radius of your home. Ideally you should never have been there before or know very little about the place.

As before, find a building in this place that speaks to you or one which has a particularly captivating quality.

If it's a home or office that's occupied, you should try to meet the residents or inhabitants and go inside. If it's abandoned, and there is some access, you should also try to explore the interior. Make a picture of both the exterior and the inte-

rior. The interior could be anything from a detail to a portrait, or a view from a window or roof.

Upon returning to class, the teacher separately compiles the interiors and exteriors and hangs them up randomly without any verbal or written description. The rest of the class should match up an interior and exterior view and then offer up their own version of a compelling narrative based solely on the images themselves.

See also Reinfurt, Schneider

Alison Morley
Tell Me a Story

Tell me a story in five to seven pictures. It can be about anything, but it must have a beginning, middle, and end. It can be about one person or one place or one thing. Keep your focus narrow so that you really have a chance to delve into the specific story. This assignment could take a week or a year—it's all up to you. You could shoot five thousand frames or fifty.

It is not the amount of images you make that matters, rather that each picture gets to the heart, the essence of what the narrative wants to express. You may not know the actual story in the beginning, but slowly you will narrow it down so that it makes sense to the viewer without any captions at all. Humanize your subjects; inspire me to travel to wherever you are. Compel me to look.

Stories have been shared in every culture as a means of entertainment, education, cultural preservation, and instilling values. The best way to communicate and unify your work is by making a story. Show me something I may have seen already, but not in this way. Everything has been photographed before, but not by you.

See also Scheinbaum

Nicholas Muellner
The Land Speed Record

In the early nineties, I briefly strayed into to the cult of the handmade book. I was young, and everybody was doing it. Among other fetishistic objects, I made a series of "altered" books. These included a chaotic reworking of an Easter Island travelogue and a mash-up of a book on hamster care and a Marxist tract. I also hand-cut an identical square hole through every page of the 1977 *Guinness Book of World Records*. When a reader opened the intact cover and peered through the hole to the end of the book, a typed message at the bottom announced: "Squarest hole ever cut through the 1977 *Guinness Book of World Records*." Obviously, I threw all these books away.

But some impulse led me to keep those excised paper squares. Years later, I came across them in a sandwich-sized paper bag, now weathered to resemble a very delicate silk purse. In that moment, an assignment was born . . .

Every few years I teach a course called Narrative Projects in Photography. It's a classic bait-and-switch: luring in unsuspecting lovers of "storytelling" and systematically dismantling everything they think that means. The class changes every time I teach it, but it always begins the same way: with each student dipping a guileless hand into that crumbling paper bag and pulling out a two-inch square of the 1977 *Guinness Book*. Their instructions: to embark on a path of research and picture-taking beginning from whatever interest or intrigue they can squeeze from that scrap of paper.

These squares of broken sentences and fragmented pictures —often full of bafflingly decontextualized statistics—are both confusing and disappointing. Rarely are they interesting. Nonetheless, the following week each student must stand before the class, surrounded by the books, web printouts, photocopies, and contact sheets they have assembled and reconstruct the path of their research. It is the narrative of one thing leading to

another, prompted only by the action of their minds on mute subjects. Inevitably, that story is interesting to them, and they want to follow it further. Inadvertently, the students have begun to think like artists. When this assignment succeeds, assignments themselves become a little less necessary.

See also Hill

Rory Mulligan
The Abatement of Shame

> *The unknown about any excess is how excessive it's been.*
> —*Philip Roth,* Sabbath's Theater

The goal of this exercise is to begin the process of diminishing shame and therefore encourage the abandonment of censorship. A self-censored artist is a lame mule. There is no specific task for this assignment except to use yourself as compromised subject. The portrait is a charged interaction, complicated by power dynamics, presumption, and unknowingness. The self-portrait creates an even richer set of problems by removing the photographer from behind the fortress of the camera. It is one thing to move in front of the lens, it is another to submit to it. For this assignment, you must submit. The photograph(s) you submit should be one(s) you never want your parents to see. With time, you will become more at ease with the possibility of that scenario. The following props are suggested aids:

Alka-Seltzer + Pabst Blue Ribbon (or similar domestic beer)
Fish hook
Bucket of cold water and a string
Hershey's Chocolate Syrup, or Heinz Ketchup and grape jelly
Black five-gallon garbage bags (glossy or matte finish)
Red lipstick (only if male)
Dry ice
Soppressata
Kiwi or overripe peaches
Terry-cloth robe
Candles
Goat's milk or double bottle of pinot noir

Repeat as necessary until shame dissipates and reveals a thrill in the residue.

See also Delaney, N. Winokur　　　　　　　　　　　　　　　　　　**235**

Bruno Munari
From Photo-Reportage, *1944*

Every photographer should try to express himself, should discover something in nature (Another quid pro quo, chaps. Who knows how many people reading the word "nature" will immediately think of cows at the drinking trough or of sunsets behind sails, when *nature* is also an electric charge, the bacillus of Koch, an abstract thought, a dream, a devilish thought. Well, let's go on.), should think of the camera as nothing but a very quick paint brush that if it had been in the hand of old Leonardo da Vinci, who knows what photo-reportages on the human anatomy, for example, he would have passed on to us. Remember that a successful photograph is worth as much as a story and sometimes even a piece of poetry. There are no illiterate people where pictures are concerned.

See also Hill, McCall

Michael David Murphy
Notable Intersections

Frost wrote: ". . . the work is play for mortal stakes." If he's right enough about splitting beechwood or carving words on a page, why not about capturing light? Have you ever clicked your shutter and believed you trapped light in there that might outshine you?

Play for keeps. Use a sundial for direction. Make a navigational tool out of string, cardboard, a straw, and fishing weight. Predict the future, then meet it there.

The most satisfying fun I've had photographing has been when I've turned it into sport, an elaborate and arbitrary game that requires arriving in a particular place on the planet at a particular time. I don't know when or where both might intersect, but I have to go out and discover that X mark (because those intersections are always out there, whether I have a camera in my hands or not).

Originality, and the degree to which your work might be remembered, could depend on photographing something that's never been photographed, from a place where no one's wielded a camera. Trap that kind of light and bring it back. Wait a while and then release it; watch it stand on new legs, see how it leaps and stumbles.

See also Powell, Records

Laurel Nakadate
Time Capsule

When I was eighteen, I studied documentary photography at the School of the Museum of Fine Arts, Boston, with the very brilliant photographer Bill Burke. On the last day of class, he told us to make extra prints of our photographs, put them in a box, and not to look at them for twenty years. That is, he asked us to make a time capsule of sorts. I turned thirty-eight a few weeks ago, and so it was time to open the box. Inside the Kodak box was a stack of one hundred or so 8-by-10-inch color prints, mostly yellowing at the edges, dusty and printed by a younger me who had no idea how to center the image on paper. They were mostly photographs of young undergrads at private women's colleges in Massachusetts. These girls were half-dressed in their mid-'90s riot grrrl wear, red lipstick, hanging out in dorm rooms and hanging out of cars, pissing in the woods outside Mount Holyoke, vomiting illegally obtained alcohol into common-space trash cans, dancing on old oak tables at Smith, stretching out their pierced teenage bodies on luxury couches at the Wellesley feminist co-op, and reading Emily Dickinson while listening to Ani DiFranco, Belly, and Hole. There is so much adolescent ache in these pictures. There is so much lost time. And there is so much photographic think-ing happening within the frames; so much witnessing and so much not looking away. It's true I have looked at some of these images over the years—sometimes I'll show them when I speak at schools. I know that I used them when I applied to grad school at Yale. But, mostly, I have not opened the box. And I certainly haven't looked at all of them together, not in twenty years.

So, what does Bill Burke's assignment teach? What is there to take from this time capsule assignment? Perhaps this assign-ment teaches us that time changes everything and because of that, it is important to make photographs, because photographs,

among their other virtues, are markers of time. Perhaps this assignment teaches us to remember our younger selves, and the SLR, 35 mm analog world that those younger brains and bodies fumbled around inside of, and the excitement and innocence of our naive youths. Perhaps the assignment just reminds us of the cars with only radios and no heat or cruise control, and emergency blankets in the back seat where we slept; why we started out in the first place; and why we ever picked up a camera. Perhaps the assignment is to teach us that nothing stays the same and everything important will go away and no one we love will be here forever. Perhaps it is to teach us that no building will be spared, no human body will not ultimately begin to fail, no family will travel together forever without losing someone who once held the center. Perhaps the assignment teaches us that the products of that maddening light bleed on the right-hand side of our light box in 1995, which always caused a ghostly red haze on our test prints, would one day inflict great feelings of nostalgia. Perhaps it is to teach us that one day we will yearn for the late nights in the old color darkroom that always made us feel chemical and itchy, with the one boom box, owned by the darkroom manager, blaring Nirvana and then Jonathan Richman and then, 90.9 or 90.3 or 95.3 FM. Perhaps the assignment is to remind us that photographs are witnesses, unreliable yet loyal guides with perfect memories for exactly how we wanted it to be.

The prints in that box, when I looked at them, felt like old friends, lost at a party for twenty years, still in their sequined bikinis and platform '90s grunge boots, old friends who suddenly located me online after a long silence to ask how I am, as if nothing had happened between then and now. With their innocent faces, their clear memories, their romantic achy loss. In the box, there is also a print of a dear friend who was in Bill's class that year who was for a time my roommate, and went with me once or twice to Wellesley. A few years ago that friend died by suicide, but there he is, in that box. I wish I could

peel him out from the paper and bring him back. And another photograph of a woman, a professor I also studied with during that time, taken during one of my trips out to western Massachusetts, probably on my way to Mount Holyoke, who was so knowing and raw and generous and open to the world that she leaped from a great height and did not survive. That box, that assignment, could not have predicted how time would define it, but what Bill knows is that what we have now will not look like anything else we will ever have, and photographs are always about things that are already missing. What to do with that box now? The box with pictures of dead friends and mentors, girls who are now just outlines of bodies, young women who went on to make more mistakes and win more prizes, girls who barely knew anything and behaved as if everything was possible. Time kept its promise to change. What to do with the box of photographs that remembers everything?

See also Colberg, Harbutt

Judy Natal
No Answers Allowed

A primary function of art is that it thinks, acts, and sees. This is inspired by Roland Barthes' famous quote, "Ultimately, photography is subversive not when it frightens, repels, or even stigmatizes, but when it is pensive, when it thinks." To invite viewers to imagine, I believe, is one of the most subversive acts of human existence.

At least once a semester, I conduct a critique where the only form of dialogue is questions. No answers allowed! Initially, this is quite difficult for students, since they are accustomed to offering their opinions, judgments, likes, and dislikes as a standard operating procedure for most critiques. I find this is not the most useful type of feedback. So I ask every student to write a full page of questions (single-spaced) about the images that are being reviewed. There is initially huge uproar and resistance, but they usually settle down and find out that it is not as hard as it sounds. Like a painter overwhelmed by a blank canvas, students need not consider the whole blank page, but simply to ask one question at a time. Then, when they finish this task, I ask them to do another page of questions. The outcry is loud, so stand firm! Not only does this encourage a more thoughtful viewing of the photographs, but the questions students ask will ultimately move the works down insightful, imaginative paths that were never initially considered.

See also Behrend, Kurland

Erin Jane Nelson

Find Fifty-Eight Names, Tools, and Institutions (and Maybe Some Other Words as Well)

```
Y P J D Z W O C M O H V M V J P Q W Z R M N D Y P
T D E N W E E G E E L K D E H V S A O W I G A T O
B P F A W O H S E D I L S O A M I T Q T Z H G R R
M A F L R V A A Y I W V T V L T I Z A I G E U E N
N S W D R O F L U F N O S A J D Y L K U W M E H O
T T A O V N O R B W B I P H E W E A V P J O R O G
F I L R Q B E O Y O T N T O P G Y L R D X R R D R
M L L N U L P G O I I F T R R A G G E D N H E Y A
O L C R S K F K A W F O W E A S R A Q F C C O B P
Y L X O Q R P X T T H R V M Z M I G R B T A T B H
R I T J P V F N C P I L I X D I Y L O J K B Y O Y
A F R B V C R E A T I V E S U I T E V T K I P B C
D E O R E H C E B S U G E N H A O J L E O C E Z A
A E A O K O D A C H R O M E O B G R Y S R H J K N
V L D T C G A B R H S E R U V S R E A C E F P A O
E G T D O Y B A N Z A I N O C U P A D L A L A B N
Y N R H Q Z I H A I S R P T F S A E N O O F F S X
E A I B P V K R V O C I L O H O C L A D B P B J T
R E P T A A K O G A M A A I D Y E O A H T Q H S U
U D Q C O O R R Z O O L S A E I N S T A G R A M S
T I R I W P A G O I E G I Z C E D A S H W O O D W
R W L S I P S R O C N D B A P R N L A V I V R U S
E F K J H C K D S N O O F X C T O G M M C O Q P E
P I U Z J R Y O N M O E A N I B C L M Q F C E F Y
A F G Z A M T A O I D M Y R S S A L D A L E S W E
Z M D D O H D R N N L K I Y X G Q M M U N E Q D O
Y V P Q K O I K U O M B M Q U J T Q P Z G S D H T
R J L N R Y Q L O U T U A H H C S A M F A L L S O
Z I P A A M T H H D K Y M Z D B I T N A I R K Q H
W C M M J T N H U O A K P D A R I U S H I M E S P
J A A G O T E G T A Z K S E D I W Y Y U L U T J V
G U G G H W K J P N Z D V H M R J M V Y W G W F A
```

See also Chaplin, Pilson **243**

Nicholas Nixon
Flirtation

Photograph several people who you would like to sleep with, but who do not know you want to sleep with them.

See also Kessels, Walker

Abner Nolan
An Altogether Different Lesson

When I was a junior in college, I was hired to teach photography to third, fourth, and fifth graders at an elementary school. I had no experience in teaching children. My only useful reference point was the education I was receiving as an art student, which consisted largely of following my own interests and solving any necessary technical problems as my work dictated.

Using this open-ended framework as a starting point, I showed the students how use their cameras, develop their exposed film (except for the third graders, whose hands were too small to agitate the film tanks), and how to make prints in a small, makeshift darkroom. The kids took the cameras home on the weekends, and the film came back with a remarkable number of amazing pictures.

I was content to continue in this vein, but after the first several weeks, the lead teacher told me, "You have to give them assignments." I, myself, had discovered the opportunities of the camera through the regular trial and error of experimentation, the same process that most of the kids seemed to be embracing. It hadn't dawned on me, despite the fact that I was working in a public elementary school, that assignments should be part of the program.

After some debate, I began writing assignments that I thought would satisfy my obligations as an educator without disrupting, too much, the magic that was happening with the kids' work. I gave the kids shooting assignments that would direct them to use the camera as a kind of passport for seeing things that were normally unavailable, or uninteresting, to a seven-year-old: photograph underneath your beds; take a picture of the first thing you see when you wake up in the morning; make a portrait of the oldest person you know; make a portrait of a stranger holding your favorite toy (many refused to do that one).

Among the more memorable of these assignments was to "photograph your parents asleep." I was mostly trying to get them to sneak around and use the camera in a modestly provocative way. I hadn't really considered the practical problem of the kids not being able to stay up until after their parents went to sleep. To get around this, most of the kids improvised by enlisting their parents as collaborators in a ruse of sleep. The resulting pictures were hilarious, suggesting equal parts bad acting and parental neglect. The fake orchestration of sleep for the camera provided an altogether different lesson than the one I had planned: that photography is an essential agent of fiction, and the world (at least their small part of it) was endlessly malleable.

See also July, Sturges

Peggy Nolan

On John Szarkowski

Ode to The Shark

Of course we had read everything
Memorized some of it in fact
" . . . visual truths that had escaped all other systems of
detection" and such
Rolled off our tongues,
Envied his discoveries
Of Diane and Garry and Robert and William.

And now he was ours
Twenty rapt admirers not from afar any more.
Past middle age but still limber enough to
Balance his foot on the top of the lectern
Booming voice coming from the bowels of the Earth,
seemingly
Inexhaustible interest in
Looking, always looking

Beginners in other classes thought he was my grandfather
Printing with them, masses
Of unwashed careless tong wielders and
Very much liking it.
He had stories and we
Like his children begging for one at bedtime
Almost sucked our thumbs.

And I learned something
So painful:
That I was ordinary
And so were my eyes
And so were my desires

And so were my
Well not all
But most of
My thousands and thousands and thousands of pictures
But
The good ones
The few
Good
Ones
Joined a
Community of
Really good pictures
Authors forgotten
Images never.
And he welcomed me
Into
The club.

See also Carucci, Roma

Alison Nordström
The Emigrants

Read W. G. Sebald's *The Emigrants*. After you have read it, make a new edition by replacing the photographs in it with found photographs from newspapers, magazines, or flea markets. Then make a third edition using photographs you take yourself. Note that these are not illustrations of events in the novel, but evocative enhancements to them.

Repeat the exercise by adding found and self-made photographs to any story from Jorge Luis Borges's *Labyrinths* or any poem by Emily Dickinson.

Finally, line up the picture series on a wall or print rail, without text. Critique.

See also Ebner, Soth **249**

Michael Northrup
Skipreading

Back in the 1970s I was fortunate to have an opportunity
to spend some time with Frederick Sommer at his home in
Prescott, Arizona. Fred's time was the 1930s, '40s, and '50s, and
the big influence then was Surrealism, which shows up in a lot
of his work. As Fred explained, at the base of Surrealism is "the
automatic." And to see how this works he did an exercise called
"skipreading," that, I was told, the Surrealists would often do at
gatherings. He started by closing his eyes and opening a page
in a book of Shakespeare plays. And as he read across those
opened pages he would choose words quickly and randomly,
allowing the automatic, or the subconscious, to make rapid
selections. In the end what he read back was sheer poetry. It
didn't make any literal sense, but nouns, verbs, and adjectives all
lined up to create a beautiful sense of syntax and song.

The automatic comes into play every day of our lives.
Whenever I hang my shows I choose a sequence the same way
Fred read Shakespeare. I don't have some linear idea in mind
that ties my images together as I shoot. Each time I take an
image, I'm only thinking of the reality in front of me. Sequencing is a postproduction thing for me, and I think that's the way
it is with most artists.

Assignment:
Take fifteen random images from your archive and organize
them into five different sequences. Explain your response to each.

See also Rudensky, Sultan

Lorie Novak

Sketching for Computer-Based Projects

How do artists generate ideas for computer-based projects? Painters draw to work out ideas for their paintings. When we shoot film and make contact sheets, they provide a record of our thought processes while shooting and allow us to study all the options and generate ideas for the future. When we are working with hundreds of digital images, editing video, putting together slide shows, and/or creating web projects, how do we work out ideas? Here are some tips:

1. Make visual decisions visually. The movie in your head may be harder to visualize than you think. Take pictures, shoot video, record audio, make collages—just get started.

2. Let the content of your project determine its form.

3. Look at work by other artists and learn from them. Expand your research beyond photographic projects. For example, experimental and silent films from the first half of the twentieth century are great teachers for editing techniques.

4. Find ways to experiment and brainstorm your ideas. Work both on and off the computer—make notes, lists, and little sketches; print out thumbnails and work prints; make story-boards; start a blog/Tumblr, etc.

5. Don't delete in-camera unless it is a dire situation when you need card space.

6. Make different versions—Save As is a great sketching tool.

7. Don't spend hours fussing with the technical aspects of the project before you have worked out your ideas.

8. Turn off any automatic special effects (like the Ken Burns zoom), so you are in control of your project. All transitions and effects have meaning.

9. Watch and learn from your project. When making slide shows or time-based projects, randomize your images to generate ideas for new combinations and transitions. Try out different transitions and timing. Don't just accept your first sequencing.

10. Get feedback from others on your work-in-progress. Show early edits; user-test your web projects. It is hard to take in criticism when projects are finished or near completion.

See also Barney, Klett

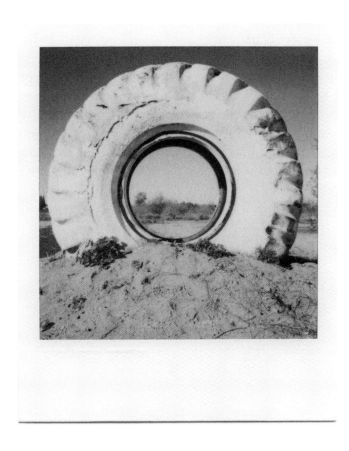

Eric Ogden
Natural vs. Artificial

See if you can create a point of view and a feeling in a photograph, first with natural light, then recreating that same feeling (it doesn't have to be the same shot) with constructed light—strobe or continuous lighting. Or start with artificial light and see if you can find that same quality and feeling in a natural light setting. Does it look like the same photographer took both pictures?

See also Perkis, Rome

Taiyo Onorato and Nico Krebs
The White Mouse

Procure some white mice from a pet shop where they are often sold as live food for snakes and lizards. Give one mouse to each student with the following instructions:

An assignment for three days:

1. This is your white mouse. You are responsible for it.
2. Do with your white mouse whatever you feel is necessary.
3. Your white mouse is your muse and your subject.
4. Your white mouse is your audience and your critic.
5. Your white mouse is your friend and your enemy.
6. Your white mouse is your slave and your oppressor.
7. The white mouse has needs and desires. Choose to respect or disrespect it.
8–10. Create with your white mouse.

See also Brown, Shimabuku

Suzanne Opton

Inspired by the News

Make a conceptual portrait based on a news story.

Photographers are apt to draw inspiration from any number of places—our histories and dreams, long walks, paintings, music, novels, other people's photographs, or the news. The task of photojournalism is, of course, to illustrate the news while adhering to a strict ethic of impartiality. But this assignment calls for quite the opposite: a conceptual portrait that is based on an idea about the news story, rather than being a document of the story itself.

Choose an ongoing or specific news item and make a photograph that reveals new insight into the story. You may be lucky enough to be able to find people whose circumstances are directly related to the story (an illegal immigrant for a story about immigration, for example). Or find a person who in some fashion matches your idea. Your photo may touch upon the history or consequences of the story or it may deal with the emotions of the subjects involved. You should feel free to be very directional with your subject and intentional about the gesture, the setting, and the light. Less is more. The simpler your concept, the stronger the image.

See also Menjivar, Palacio

Willie Osterman

Book as . . .

You will be given, or asked to find, a discarded library book that is *not* a photography book. (One year, everyone's book was on engineering from the 1950s.) React to the book by making three pieces:

1. Book as Idea: Find something printed in the book and use it as source material.

2. Book as Prop or Metaphor: Place the book in a scene and make a photograph.

3. Book as Object: Do something to the book.

See also Carlsen, C. Hewitt

Erin O'Toole
Scale

The trend toward ever-larger prints that began in the 1980s appears to have led many photographers to the erroneous conclusion that bigger is always better. I happen to like small prints myself, and feel strongly that little pictures can have a big impact. The work André Kertész made in the 1920s is one example. The scale of these tiny gems forces close inspection, and rewards the careful viewer with exquisite worlds in miniature.

Sometimes a small-scale print is simply more appropriate to a given picture, and making a bigger one would change its meaning altogether. It's doubtful that Edward Weston's *Pepper No. 30* would benefit from being enlarged to 30 by 30 inches. It is a modest photograph of a humble subject, and an 8-by-10 contact print of it draws you in from across the room without yelling "Hey, look at me!!!!" The same may be said for Alfred Stieglitz's Equivalents or Judy Fiskin's tiny pictures in her Dingbat series. Such photos achieve their power and presence through composition and grace, and not through size.

Don't get me wrong—I'm not against the creation of a big print when the subject and composition call for it. When Andreas Gursky's *99 Cent* was first shown—at what was then considered to be an absolutely monumental size—it blew people's minds, and certainly would not have had the same effect if it had been printed 8 by 10. But photos of that scale were rare in those days. Gursky's choice of a large-print format said something significant about his subject, the absurd abundance of American capitalism, and had a resonance beyond its mere dimensions. Now that big prints are the norm, however, I often get the sense that their production is more of a market decision than an aesthetic one, or the result of a reflex toward print inflation. When I encounter young photographers who make big prints by default, my advice to them is: small can be beautiful. Don't go big just because you can, go big because the picture warrants it.

See also Schechter, Tucker

Arthur Ou

Photograph Something Invisible

In almost all instances, photography is a depictive medium—always needing an existing subject in the world and therefore contrary to the idea of invisibility. It is within this inherent contradictory space that you can investigate the relationship between invisibility and photographic representation. Of course, there are the obvious aspects of photography that are unseeable: the latent image on an exposed sheet of film, the electricity that powers a digital camera, or the trapped light within the darkened chamber inside a camera.

Think about these facets of the photographic process. Related to invisibility are ideas of disappearance (think about time), hidden forces (think about wind), and degradation (think about rotting fruit). As you can see, the relationship between photography and invisibility is more intertwined than it first appears. Prior to your project, begin looking at some existing examples of work in the history of art that touch on notions of invisibility, from Yves Klein's *Air Architecture* to Tom Friedman's *1000 Hours of Staring* to Michael Asher's *Vertical Column of Accelerated Air*. This is a subject that is ripe for photographic exploration.

See also Bonajo, De Rita **259**

Trevor Paglen
Imaging Systems

Identify a photographic imaging system that creates images primarily designed to be seen by other machines (for example, a facial-recognition camera system, a license-plate reading system). Learn how the imaging system and algorithms used to "interpret" the resulting photographs/moving images work. Ask what kinds of social and political dynamics that particular imaging system contributes to—what kind of world does that imaging system help sculpt?

See also Cost, Rickard

Oscar Palacio
Blue Velvet

Watch the film *Blue Velvet* by David Lynch, and make notes on the things that strike you most about it. Choose one of the characters, interior spaces, specific objects, or sounds in the film and create a ten-image sequence of photographs responding to your selection.

While photographing, keep in mind the film's larger subjects, including gender, class, appearances, the underworld, and the nature of good and evil. Also consider the actors' roles, gestures, interactions, demeanor, and clothing, as well as the film's sense of place. How, for example, does Lynch use lighting (natural or artificial), time of day/night, and color to conceptualize the fictional town of Lumberton?

Research David Lynch and the subjects listed above to complement your photographic series.

See also Carrier, Fink

Sarah Palmer
Flea Market

This is an assignment I give myself when I am having a creative block in my own practice.

1. Go to a flea market.

2. Browse. Touch objects, hold them, grasp them, feel the texture. Sort through old magazines and hand-colored postcards and acid-riddled pulp books with colored spines. Look through maps of West Texas or Mars and vernacular photographs and tintypes and Polaroids. Look for nothing in particular but wait for the object to speak to you.

3. Buy that object if is inexpensive or if you *need* it regardless of price. Otherwise take a photograph (you may have to be secretive). Or etch it in your mind.

4. Take the object back to the studio or to a park or out to dinner or to bed. Look at it, write about it, speak to it. Shoot video of it. If it is a puzzle, put it together. If it is a map, read its names, chart its rivers.

5. Make a series of five images that somehow relate to the object. You may use the object as a springboard, a starting place, a genesis for what comes later. Or perhaps your work is a rejection of the object.

6. Photograph, draw, sculpt, and paint the object until you emerge from your block. If all else fails, return to No. 1 and begin the process again.

See also Connors, Mickey

Ahndraya Parlato
Hibernation

Stop actively looking at photographs and stop making them for a period of time. No blogs, no books, no websites. Visually hibernate. Try to forget what you think a "good" or "cool" photograph is. Try to forget what you've been taught in school.

After forgetting all that, try to remember why you wanted to make pictures in the first place. Do you still feel compelled to photograph? What do you want to photograph? Write down your answer.

When you feel hibernation is over, begin making images again.

See also Plademunt, Traub

Tom Patton
Sequential or Serial

When you create a series of images, the relationship between pictures is vital to revealing their narrative, much like sentences in a paragraph. The context you build between images often provides their most lasting impression. When placing photographs together, whether in a space, on a wall, in a book, or on a website, the connections between these images, or lack thereof, inform the viewer as to the totality of their meaning. When arranging pictures, the arrangement itself can lend to the connotations of the work.

When considering works within a series of images, through either a previsualized or postvisualized process, it will become apparent that either the order the pictures appear in is important, or it isn't. With this in mind, there are two basic kinds of series: those that are sequential and those that are serial.

A sequence by definition has a specific order; it is a definable pattern, usually one with a start, middle, and end. Sequences transition from start to finish. For example, in a sequence of three pictures, the first will relate to the second, and the second to the third, but without the second image, the first may not necessarily relate to the third. Sequences can be narrative, nonnarrative, or simply formal.

On the other hand, a serial series consists of related parts whose resonance helps build their meaning, but whose images need not be seen in a specific order. Serial images rely on multiplicity and accumulation to drive home their meaning and can generally be arranged in any sequence to create the same conclusion. Serial images strive on consistencies, while sequential imagery suggests change.

Your task, then, is to conceive of your work in either sequential or serial format, and to present it in book form. The book should contain at least six images and can be handmade or machine-made (commercially).

See also Lyons, Turyn

Philip Perkis
Exercise 6: Watching Light

Find a room where the sun comes in late in the day. Place a comfortable chair in it that looks toward the light and sit down. Sit there until it's dark. Just watch.

When I was a student at the San Francisco Art Institute, we had a senior seminar class with Fred Martin. It took place in a large room with a skylight. There were people who worked in every medium in the class, and we would discuss our work. We met from four to seven in the afternoon, and Fred Martin would not let us turn on the lights. Everything changed with the light during those three hours: the work, the people, the space, the tone of voice, our relationships with one another—everything. It was revelatory. Thank you, Fred Martin.

See also Defibaugh, Shimabuku

John Pfahl
Five Rules

1. Photograph what you (don't) know. It makes life interesting.

2. Never ask for permission first—wait until after you have finished shooting.

3. Photograph black-and-white subjects in color.

4. Always get there an hour before you think you should.

5. Pink and blue—never fails.

See also Brown, Gossage

Andrew Phelps
Photograph in Context

It is impossible to completely disregard the context in which a photograph was made. The social systems and conditions at the time, the biography of the photographer, the technical challenges, etc., all add to the relevance of a photograph, especially the images that have become milestones in the history of photography. For example, Eadweard Muybridge, *Head-spring, a Flying Pigeon Interfering*; F. Holland Day, *The Crucifixion*; or August Sander, *Pastry Chef*, represent completely different social structures and aesthetics. To ignore the context of these images is to not fully understand their power.

Assignment:
Each student is given an image by a different photographer, made sometime in the last century. It will be an analog image embracing the aesthetics of a different time/culture/personal experience. It is also important to hand out the image with only the photographer's name and not the title or date of the image. This makes the search more interesting.

Each student is to present one, and only one, response photograph to this image. Don't copy the image in the sense of trying to recreate it, but instead take the relevant aspects of the image, what it was trying to say to us at the time, who it was made for, and how it would have been viewed, and make an image which carries the same qualities in our time/culture/personal experience. React to the image. It should be an *emulation*, not an *imitation*.

The technical execution should also reflect your assessment of the image. The decision to make a pinhole camera, photograph digitally, use a copy machine, a screenshot, or the photo booth at the train station, for example, is an important decision.

See also Bunnell, Rogan

Sandra Phillips
Imagine a Country

Suppose you were asked to present a country to a group of people who have no idea what that country is—it should be an imaginary country. How would you represent it, or a certain part of it, to people who have no idea what it looks like, what its basic principles are, what its main problems are, what it faces now? You can use some text, of course, but mainly you should choose some aspect of this imaginary country and its issues and principles to describe photographically.

See also Rudensky, Schles

Sarah Pickering

The Camera Never Lies

Cropping, context, captions, and manipulation have been used since the early days of photography to construct meaning. With this in mind, make a set of photographs in response to the statement "the camera never lies."

Your interpretation of this statement might be earnest, ironic, or somewhere in between.

See also Jude, McFarland

John Pilson

Shameless

Before photography was ever taught in a classroom, assignments for a photographer had only one meaning: a paycheck for delivering on an editor's instructions or a client's big idea.

As much as I enjoy teaching, I've always been a bumbling assignment-giver. I expect students to undermine rather than implement whatever stratagem or limitation I've placed in their way. At least that's what the best students do, in turn making the assignment itself seem corny by ignoring it and/or producing something reckless or stupid or beautiful (sometimes all three). I have gotten better at the tailor-made assignment. The more a student brings to their experiments the more comfortable I am throwing an obstacle in their path. I don't want them to think like me. I want them to look at the evidence of their attractions (the evidence being on the wall, in their pictures), listen to the response their work sparks, and allow that clearly defined projects and wild unnameable ambitions can be interchangeable.

While I believe the rewards in the best assignments are found in the comparisons and contrasts of a group effort, here's an assignment for the lone browser of a book of assignments by and for photographers:

Shamelessly copy the photographers you admire but copy more than one at a time and use their styles and approaches to photograph things that you are drawn to by private understanding and inexplicable desire. The operative word being "shameless."

See also Homma, Mulligan **271**

Aleix Plademunt

Manual to Make a Good Photographic Project (Part One)

Do not look at any photobooks for the next four weeks.
Do not look at pictures.
Do not go to any exhibitions.
Take a few days to detox.
Think about what interests you most.
Think back over that for a little longer.
Go out to take photos.
The fewer, the better.

Do not edit the photos.
Do not look at them.
Do not think about them.
Do not download them/do not develop them.
Buy a new card/buy more film.
Go out again to take more photos.
Do not look for luck with insistence.
Do not be guided by chaos without resistance.
Work more.

I use a 4-by-5 field camera. I process my photos every four or five weeks. I do not edit them while I'm working. Not looking at the images helps me think through my ideas and leads me to take more photographs. A photographic work is composed by photographs, of course, but maybe the most important thing is to know what we are photographing and why.

See also Xoubanova

Eliot Porter

From the Images of Man Audiovisual Series, Mornings of
Creation: Eliot Porter, *1973*

When one is photographing bigger things of nature, land-
scapes, you can't ever go back really, and get the same picture
that you saw because when you go back it's not there anymore.
The sun is different. The atmosphere is different. So one should
never put off taking the picture if you see something. I found
that out. Nothing is stationary. Nothing is permanent. Every-
thing is changing. So what I try to do is to capture the moment
outdoors.

See also Shapton, Southam **273**

Gus Powell

Six Street Exercises

Traveler
Pick a pedestrian and follow them. Don't photograph them.
Just go where they take you and photograph along the way.
Consider yourself a passenger and make the most of where you
are taken. When you lose them, follow someone new. Repeat.

180 Degrees
Whenever you find something that gets your attention, make
your picture(s) and then take a 180 degree turn and photograph
in that opposite direction with equal or greater vigor. Never
forget that things are happening behind you and that whatever
you are photographing sees both you and all that is behind you.

Bus Stop
Wait at a bus stop. Photograph everyone who is waiting for the
bus with you. When the bus comes, don't get on it. Repeat at
same location, or move on to another bus stop.

Picasso's Blue Period
Pick a color. That color has to play out in every picture you
make. Start with a big brush (a blue wall) and work your way to
a very tiny one (blue nail polish). This can be done in the street,
or when you are editing.

The Sketches
Your bad pictures are your best sketches. Appreciate these pho-
tographs the way one appreciates a painter's drawing. Make a
set of small prints of these "sketches." Making them into prints
legitimizes them in a remarkable way. Put these prints in your
pocket and travel with them. Study them the way one looks
at a sketchbook. Think about how elements of several of them
could come together into a single image. Recognize where you

are repeating yourself, for better or for worse. Consume what is right and wrong in them as you prepare for the next new picture to be made.

A Place for Everything and Everything In Its Place
While continuously walking, make a set of pictures that have the sole objective of freezing two moving people so they are exactly side-by-side. Then do the same thing with three people. Then with four. Continue the process. The objective is not to make remarkable pictures. It is to know how to previsualize the movement of people and things through space and to arrive at the spot where you can arrange them the way that you desire. It's more about penmanship than marksmanship. You are the author of everything in the frame. You are responsible for where everything is placed.

See also Armstrong, R. Bell

Greta Pratt
Shared History

We all belong to many groups. A group can be as large as all
the people in a particular country or as small as a family. Some
of us belong to religious communities. Many of us belong to
organizations or clubs. All of these groups have a past that
is shared with new members through stories and mythology.
These stories and myths form a shared history that is under-
stood personally by the group members and binds the group
together, forming a group identity.

Pick a group that you belong to and make photographs
about the group from your point of view. Think about why you
have this point of view. Next, think about how someone outside
the group might perceive the group and make photographs
from this perspective.

See also Keegan, Mandel

Ted Pushinsky
The Human Condition

As an undergraduate English major, I concentrated on nineteenth-century literature, specifically Fyodor Dostoevsky and Charles Dickens. Their insights into the human psyche laid the groundwork for future tales of love and death and good and evil—acts of kindness and goodwill go up against betrayal and corruption. I ask students to read two chapters from Dickens's *Oliver Twist* and two chapters from Joseph Conrad's *Lord Jim*. Afterward, I have them make a photograph based on one of the two readings. I stress that I do not want a posed reproduction of a scene. I want them to make a photograph that conveys the feeling of the human condition gleaned from the pages they read.

See also Mickey, Roma

Margaret Qiao
Missing the Boat

When you feel inspired, or have an idea, stop whatever you are doing and follow the inspiration. It's very difficult to rekindle the spark once it goes out and impossible to conjure up on command.

See also Porter, Young

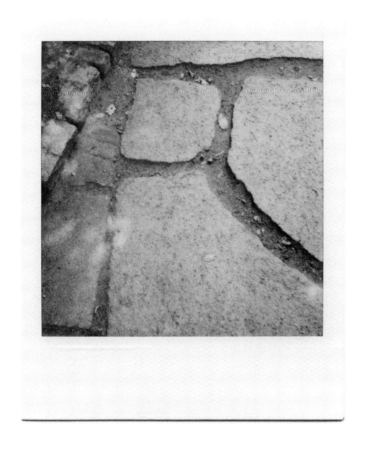

Casey Reas
Expanded Cinema

Using Chris Marker's film *La Jetée* (1962) and Choose Your Own Adventure novels as models, create a website or a book to sequence at least twelve images into a continuous, nonlinear cinematic experience. Use a sequence of photographs to tell a story that's different every time it's read. Design the possible sequences of images, the interface, and the types of motions or transition effects you want to use if it's a website. You may include text to make the narrative clear, but it's not necessary; the "story" can be vague.

See also Martin, Palacio

Paul Reas

The Discipline of Music

For longer than I dare admit, I have been trying to play jazz trumpet. What I have learned is that the discipline of jazz music is not dissimilar from that of photography. Both require huge amounts of commitment and hard work. Both have a long and important history, which, as an aspiring player/photographer, it would be folly to ignore. Both require high levels of technical facility that you must learn, log, and forget, only ever applying it with intuition and spontaneity. Both, in order for it to be felt, require a sound/vision that is unique and truthful, one that requires all of the above, plus a life lived—a life that is rich and varied in experience. It is, after all, the way our lives are "shaped" that determines our "sound" or "vision."

Whilst teaching photography in the documentary course, I will often refer to the discipline of music. Those early visual exercises our first-year students pursue, as they strive to attain a visual vocabulary, I equate to the study of musical scales. Of course, scale knowledge and a deep vocabulary are insufficient by themselves. One must have something to say. One must learn to be reflexive and dexterous. One must learn what is the most appropriate phrase or point of view to apply to a given situation. In the jazz idiom, one would "woodshed" (practice) an idea/phrase/riff in order to develop one's "chops" (skill/technique). This is frequently done by learning an established solo, something that is a part of the jazz canon, and then transposing it in all twelve keys in order to develop one's virtuosity.

My assignment would be to take an established photograph you connect with and find a situation or location that is reminiscent of the original. Once you have done this, "riff" on the ideas or expression of the original. See if you can't inject something new. This could be a different point of view, a different emotional charge. See how many different responses or interpretations you can come up with. After this act of emulation, it is inevitable that you will come up with something unique and distinct to you. This is the stuff you hone, polish, and bank.

See also Homma, Willing

Shawn Records

Out of Your Head

One of the most difficult challenges in photography is to expand your definition of what a "photogenic" subject truly is. Rather than thinking in terms of objects that you consider to be acceptable subjects, I want to force you to explore the world and think in terms of formal strategy and the elements of visual design rather than in terms of objects and things. To assist you in this regard, I'm going to limit your freedom to roam and ask you to follow chance.

Start with a pair of dice and a compass. Roll the dice three times to determine how far you're going to travel, and in what direction.

Roll 1 (one or two dice)	Roll 2 (one die)	Roll 3 (two dice)
Quantity	Time/Distance	Direction
	1: yards	2: Northeast
	2: blocks	3: Northwest
	3: paces	4: South
	4: minutes	5: Southeast
	5: songs	6: Southwest
	6: miles	7: East
		8: West
		9: Left
		10: Right
		11: Behind
		12: North

For example, if you roll an eight, a five, and a nine, you will travel eight songs to your left and then stop and photograph there, wherever there might be.

Keep in mind that the goal of this isn't to put you in any specific place, but simply to pull you out of your head and force you to see the world in front of you and think about strategy and design rather than subject matter.

See also Butler, Slack

David Reinfurt
Wonder What to Do In It

Architect Cedric Price built little in his fifty years of practice, but cast a long shadow. Everyday, he wore the same black-and-white-striped shirt with removable collar and black tie, except on May Day, when he wore a red one. He worked mornings, only until lunch, then stopped. He was fond of cigars and brandy, sometimes at breakfast. His office at Alfred Place, a three-story townhouse in central London, included a private all-white studio on the top floor which he named "East Grinstead."

All of Price's design work engaged time and indeterminacy in a direct and often witty fashion. For example, his "Fun Palace" project was designed as a piece of public theater, to be constructed on a hill in east London, enacted and assembled by its users. It was a rectangular shed, membrane roof, cranes, escalators, all held together by a metal framed exoskeleton and comprising workshops, media-production facilities, and unprogrammed space. He called it a cybernetic *Gesamtkunstwerk*, "University of the Streets," "Laboratory of Fun," a "short life toy." Price insisted that a building must respond to use and posed the question like this: "Technology is the answer, but what is the question?" He proposed working backward, through feedback loops, to determine both use and design from the situation itself as it evolves.

A number of years later, Price was asked to develop a master plan for the town of Hadspen in Somerset, England. In surveying the site, a set of small stone buildings on a rural estate caught his eye. Originally built in the eighteenth century as harrier kennels, then used for storing apples, and finally left for ruin, Price suggested a scheme for these buildings that would model his overall approach to the area. His design entailed leaving the buildings standing as-is, and inviting local contractors, one per month, to come and do one piece of work on the buildings, at their discretion. The test site would be a continual

work-in-progress. He suggested housing a small collection of books in the stone buildings: "a few architectural books might give one some ideas." The space would become a site for contemplation—a space to "wonder what to do in it."

Assignment:
Consider your studio space, or the room where you work the most. Over three hours, rearrange the room in at least twelve different configurations with the sole criteria that each rearrangement should try to transform it into a space to "wonder what to do in it." Do this by altering the layout—where the furniture sits, lighting, graphics, anything, everything. While rearranging, blast the song "Youwanner" by The Fall at full volume, which begins, "There's always a work-in-progress. You're a work-in-progress."

See also Brandt, Cyr

Richard Renaldi
Turning the Tables

Every teacher of photography knows that you continue to learn through the act of teaching.

1. Meet three random strangers and ask them to make your portrait. Instruct them how to make the portrait better by suggesting that they think about framing, composition, light, expression, and background. Offer them help if they need it. Allow them to borrow your camera or camera phone to do this.

2. Make sure you get the names and contact information for the participants. You will want to properly credit them. Remember to ask them if they would like you to send them a copy of the photo and, if so, do that.

3. Use social media (blog, Tumblr, Facebook, Instagram, etc.) to exhibit the work under the banner: "Three random strangers made my portrait."

See also Boot, Shaw

Xavier Ribas
A State of Transition (or Boiling Water)

In his studies of rituals, the anthropologist Victor Turner
(*The Forest of Symbols*, 1967) struggled to define that moment
in which something, somebody, or somewhere was in a state
of transition—a passage between two worlds which was still
incomplete, a provisional or liminal state that had no attri-
butes of either its previous or future form, like a threshold
which is neither inside nor outside, but nowhere. He seems
to have accepted the impossibility of naming it with certainty,
and only found some approximation with an analogy—that of
boiling water.

Photographers (Jean-Marc Bustamante: *Something Is
Missing*), filmmakers (Andrei Tarkovsky, *The Mirror*) and writ-
ers (William Faulkner, *The Sound and the Fury*) have dealt in
different ways with this impossibility, and in their work there
is always something opaque, something one can't see or grasp
completely; an absence or a secret behind which something
abides; something which, despite being at the center of the
representation, is unrepresentable.

See also Armstrong, Fink

Shelley Rice

Inspired by Arnheim

Read "The Gestalt Theory of Expression" by Rudolf Arnheim. Respond to this essay with a three-page analysis of a photograph of your choice.

Page One should be a 250-word, straightforward, "objective" description of the image.

Page Two will be a picture. Using tracing paper, select and trace by hand the dominant force lines in the photograph.

Page Three should, once again, be a written statement, a verbal interpretation of the image based solely on the Arnheimian "meaning" of the dominant force lines that make up its formal structure.

See also Ebner, Letinsky

Doug Rickard
Editing (Is) Everything

We are exiting the era of photography and entering the era of imagery. The historic notion of photography is expanding and changing forms. It doesn't matter anymore if you push the button; it's what you do with the masses of visual material that are now proliferating at a breakneck and exponential pace. Because of this Internet-driven evolutionary shift, the act of editing has become the lynchpin. Photography has always been about editing (an act of making visual decisions) but now, these decisions are everything.

In this new reality we take on the role of archivist, maker, sifter, and "remixer." The "eye" is no longer at the center of photography. Now, more than ever, what is between the ears is crucial, as is what you do with the material at your disposal. As images relentlessly multiply, and the global visual output increases, your ability to wield and arrange with power, beauty, and complex control becomes your greatest act.

So, for now, stop taking pictures. Set down your camera and focus on visual material that exists; it's everywhere. Pick a large archive online and download it. It can be from a government or school library, or a commercial website, or another artist, or Facebook, Google, etc. Build this up and organize it. Now, arrange it, rearrange it, crop it, rephotograph it, manipulate it, print it, set the pieces next to each other, pile them in groups, take them away, and place them on walls, place them in grids, place the pieces alone, and find visual threads—the subtext "underneath." Learn to disturb, distort, remove context, add context, and crucially, create context that did not exist. Find the strongest pieces and discard the weakest links. Learn to control and direct what's bubbling under the surface. Learn to choose and also to discard.

"Your" pictures are everywhere. Learn to work with them before you pick your camera back up. The world is your archive. Go edit it.

See also Catanese, Umbrico

Fred Ritchin
The Meta-Photographer

In an era distinguished by an overwhelming surfeit of photographs, we need people who can help us to make sense of at least a small portion of the imagery that already exists. But most important we need those who, by doing so, can assist the rest of us in understanding more about other cultures, other circumstances, and other people.

The assignment: Select twenty photographs made by others that reside on social media sites and that begin to explore the culture or subculture from which you come. The photographs should be of one geographic region (your country of origin, the town or neighborhood you live or lived in). Sequence the images, add music if you like, and then project them in class or before any other group of your choice. Be prepared when necessary to explain some of the meanings of these photographs, both explicit and implicit. Solicit questions.

If you are successful, you will have accomplished what newspapers rarely manage to do with their focus on the official and the spectacular, but something akin to what Robert Frank accomplished in *The Americans*—you will have revealed a bit of the texture and the mystery of the everyday. And you will also have completed another rare and praiseworthy task—restored the signified to the signifiers.

See also Mayes, McFarland

Will Rogan
Time Travel

Imagine what the art that people make now will look like to people in one hundred years' time, one thousand years, ten thousand.

Think about the art of one hundred years ago, one thousand, ten thousand.

Make something with these two thoughts in the front of your mind.

See also Cases, Cwynar

Thomas Roma
What Matters

I only give one assignment for Photo One: to make photographs that can be criticized in a meaningful way.

On the first day of class, I recite a rambling list of things that students' photographs may not contain. For example: nudity, children, old people, fire hydrants, rows of bicycle wheels that create interesting shapes with their shadows, mimes, one-man bands, sidewalk portrait painters, and the homeless. In other words, the low-hanging fruit for the beginning photographer. They get the idea.

To point them in a more productive direction, and inspired by Robert Frost's "no tears in the writer, no tears in the reader," I poll the class by a show of hands to see who among them has kept a diary. That usually produces a fair number. Then I ask how many have written a poem, even one that they have never shown anyone—still more hands. And finally, who has written a love letter or a letter home. By then, I have them all. I tell them the assignment is to make photographs that resonate in their lives in the same way—photographs they'll care about, and that's the only way the criticism will matter.

See also Cox, Finke **293**

Stuart Rome
Street or Setup

Choose a location or locations. These should be places that have visually powerful possibilities, allowing you to use the location as a set in which your pictures will be made or found. You may choose to photograph in the style of a street photographer using the background environment as a stage for the theater of daily life, or to set up tableaux. Your goal is to create images so well-composed that it might be misperceived as a picture you set up or that of a fabricated scene, created for the camera, to appear as if it were found.

Find the appropriate color palette (i.e., time of day, manufactured color, or type of illumination that best suits your subject).

To begin, it might be a good idea to split your pictures between each method of shooting, street or setup, and to eventually choose one cohesive project for the final version of this project. But you may also choose one way of working from the start if you have a good idea of what you would like to photograph and where you would like to work.

See also Kelly, Pickering

Jon Rubin
One Hundred Dollars

You have one week to earn one hundred dollars without getting a job. Nothing gets you out of the theoretic realm of academia and right to the sticky mess of human relations like money. Neither the currency nor the value ascribed to it are real outside of negotiation, so the challenge here is to break through all the bullshit and engage in real-world communication and problem solving using only your wits and skill. The money raised through this project will create a budget for the class, which you will then collectively decide how to spend. Any money spent on making the money for this project must be made back in addition to the one hundred dollars you earn. The task breaks down to three parts (crassly analogous to the relations of an artwork/project to the audience/participant):

1. The service or product you are offering (yes, begging could be considered a service).

2. Your audience or buyer—there are two basic strategies here: a) You have a service or product in place and target an audience who will buy it, or b) you identify an audience first and then develop a service or product you think they want.*

3. The system of communication or the pitch—how do you communicate your service or product so as to make it appealing to the public you want to buy it? This can involve showmanship or subtlety.

If for some reason you are not making money, then one of the three parts listed above needs to change.

You cannot solicit family or friends.

See also Killip, L. White

Sasha Rudensky
Clockwork Orange

> *I first heard the expression "as queer as a clockwork orange"*
> *in a London pub before the Second World War. It is an old*
> *Cockney slang phrase, implying a queerness or madness*
> *so extreme as to subvert nature, since could any notion be*
> *more bizarre than that of a clockwork orange? The image*
> *appealed to me as something not just fantastic but obscurely*
> *meaningful, surrealistic but also obscenely real. The forced*
> *marriage of an organism to a mechanism, of a thing living,*
> *growing, sweet, juicy, to a cold dead artifact—is that solely*
> *a concept of a nightmare? —Anthony Burgess, "The Clock-*
> *work Condition," the* New Yorker, *June 4, 2012*

Create your own clockwork orange.

See also Ballen, Falls

Alessandra Sanguinetti
Something Out of Nothing

The best assignment I was ever given was when I was fifteen years old and in my first photography class. We were told to make thirty-six different pictures (a whole Tri-X roll) of a park bench. It was probably the most boring assignment in the history of assignments, but I remember being excited. I felt like I had to do magic—that I had to make something out of nothing. I'm still working on it.

See also Georgiou, Steacy

Lynn Saville

Shadow Diary

As small children, we are more aware than adults of a constant companion who accompanies us everywhere: our shadow. In order to rekindle a fertile, childlike, and visual imagination, create a shadow diary.

Like a written diary, your series of ten to fifteen photographs, or visual "entries," should suggest a narrative or reveal a linked set of perceptions. You may want to trace your own shadow's "adventures," its interactions with other shadows, or your perceptions of shadows around you. Experiment with different angles and perspectives, various times of day and night, and different moods. Also, feel free to create shadows using your own lighting arrangements. As you sequence your diary, focus on elements of visual language such as shape, contrast, depth of field, and composition.

See also Meiselas, Terry

Asha Schechter
Unintended Consequences

This is for the first day of class. Take fifteen minutes to look through the photos on your phone. Choose five to ten images that you didn't intend to connect to each other, but that could make up a body of work. Project them in front of the class and tell us how and why you chose them.

See also Schwabsky, Shank

Jaap Scheeren
Secrets and Obstacles

What's your biggest secret? What does it look like? Where is it? How does it move around? Can you think of a metaphor or make it physical?

Make it visible and carry it around on trips. Make images that do this. Challenge yourself.

Replace the word *secret* with obstacle, and follow the questions again.

Secrets can be fears and obstacles can be choices.

Make connections between moments you remember and moments you want to be part of. From now on, I'll use peanut butter as toothpaste because I think brown teeth will be the next big thing.

Any questions/guidance can be directed to jaapscheeren@gmail.com and will be answered every other Tuesday between 12:00 a.m.–2:00 p.m. CET.

See also Badger, Frazier **301**

David Scheinbaum
Crushed

My advanced studies were not of the traditional kind. Rather than continue in an alternative PhD program that I was enrolled in for a number of years, I decided in 1978 to pack up and leave New York with the hope and dream of meeting and working with the person I admired most in photography, Beaumont Newhall.

In 1976 I was traveling cross-country and specifically stopped in Albuquerque to try and meet Mr. Newhall at the University of New Mexico, where he taught at the time. As it turned out, he was not in town, and his colleague agreed to meet with me and look at my portfolio. After looking through my prints quietly for a few minutes he looked up and said I should consider another field. "You are wasting valuable silver."

Crushed would be an understatement. I often wonder if some teachers realize the things they say to students. It took me the next few months to deal with what was said to me and to ultimately disregard it. Not an easy task. Those kinds of words have their ways of sneaking up on you at weird times.

The next two years I continued working and teaching in New York, until I left for Santa Fe, New Mexico. It took me a few months to get up the nerve to call Mr. Newhall. When he answered the phone he was kind enough to cut off my stumbling and ask, "Would you like to come out to my house and meet?" An hour later I was sitting face to face with Beaumont Newhall.

A gentleman of the old world, Beaumont could not have been kinder or more supportive—as I later learned, to everyone!

I worked with Beaumont for nearly fifteen years as his assistant and printer, until his death in 1993, and have continued the work as coexecutor of his estate. I am still distilling all that I learned. What stands above this long list of things learned is to tell the story and do the work only you can do.

We are all in unique positions to do our creative work, to look to our own lives and experiences, and tap that passion, whether we are preparing a lecture or preparing to embark on a body of work.

This is what made Beaumont such a great lecturer. He felt "the facts" are available to everyone who looks—tell stories from your own experiences. Give personal insights, tell what you think and feel about the topic. That's why people are coming to hear you speak. The audience can read the book, no need to repeat what's already known.

This applies to your visual work as well. Tell *your* story!

Postscript
The man at the University of New Mexico that told me to give up photography and stop wasting silver was Van Deren Coke. Once I moved to New Mexico and became Beaumont's assistant, I came to know Van as a respected friend and colleague. For the twenty or so years that we knew each other (which included hiring him to teach a history class at the College of Santa Fe, where I was chair) I never brought up that we had met before. But I learned a valuable lesson about teaching. Knowing what not to do is often as good as knowing what to do. I liked and respected him very much.

Paul Schiek
Dead-End Scenario

Jim Goldberg, a brilliant photographer and teacher, gave me an assignment in my final year of studying photography that continues to affect me to this day. He simply told me to find a depressing place with no photographic resources and do a fashion shoot there. We decided on Reno, Nevada. No rental houses. No lighting studios. No modeling agencies. Just bitter, January cold and crushed dreams as far as the eye could see.

The idea of working with few resources and pulling something out of a seemingly dead-end scenario is something that anyone can use in any career, anytime.

See also Fox, Gremmen

Ken Schles
Invent the World for Me

Take me on a journey as best you know how. Investigate the things that trouble you or show me who you love. Tell me what you think you know or are discovering for the first time. Most important, show me what you have seen as you have seen it. Invent the world for me. Reveal the nature of your curiosity. Challenge your assumptions and the assumptions of culture. Go forth and be as convincing and compelling as possible. Muster your best argument. Go deep and go with conviction. Show your renderings in a way that I may be convinced of your vision and so that no other renderings would be as convincing or as compelling in their place. Show me your images so that they enter my consciousness and I may dream your ideas anew. Change me and change yourself through your discoveries. And do this without artifice or pretension. Do it simply with mindful purpose with the tools at your disposal. Do it simply in a way that I can clearly hear your voice and know the power of your mind through the choices you present in the practice you have chosen to share.

See also Phillips, Walker

Michael Schmelling

Preconceived Notions

I had a professor who once told me something like this: if you
know what a picture is about before you take it, it's not worth
taking.

For a long time I wasn't exactly sure what she meant. Was I
supposed to actually stop myself from taking a picture? Wouldn't
that be contrary to some other more genuine impulse? And
what was I supposed to do with this idea on assignment, where
in many cases it might help to know what the photo is about
before you take it? But I've carried around this thought, as a
puzzle of sorts, for years. I think it's always served as a reminder
to avoid the obvious photos, and the easy explanations. You
should take any photo you want to—just don't make assump-
tions about what they mean, or what they might mean later.

See also Soren, Wiseman

Joachim Schmid
In Praise of Confusion

I ask questions, more questions than any of the students have ever been asked before. I ask questions until they don't have any answers anymore. In my opinion, confusing students is the best thing to do.

When there are no more certainties they can start building something from scratch.

See also Behrend, Bonajo

Gary Schneider
Interpreting Light

There is a dramatic difference between how we see light and how it is captured through the lens.

I do this exercise with my first-year students when they begin to use an analog film camera and are learning how to use the light meter, how to measure reflected and ambient light. For our purposes here, I have adapted it so that any automatic digital camera can also be used.

Set yourself up inside a room at a window, during the day. Set your camera to fully automatic and from one position make three pictures:

1. Make a picture that contains half the interior and half the exterior view.
2. Make another picture that is the exterior view (that you had included in Picture One). This contains only the window and should not include any of the interior.
3. Make a third picture that is all the interior view adjacent to the window but not including it.

Now compare these three views to your equivalent images from your camera. Isn't it extraordinary how different the pictures are from your sight? When we use our eyes, we are able to see the information inside the room and outside simultaneously. It is dramatically different from what the camera is capable of recording.

You can now use the manual function and in Picture One decide if the interior or the exterior within the frame should show detail. It is exactly at this moment that the light interpretation of a scene becomes a very useful tool.

Isn't it extraordinary how elegant our brain is? It is able to use the limitation of the photographic medium to make art.

See also Moore, Perkis

Aaron Schuman

nos·tal·gia

In her 2007 essay, "The New Color: The Return of Black-and-White," Charlotte Cotton writes:

> *[Today], for cognizant, challenging photography . . . one*
> *of the most important factors . . . is our visual recognition*
> *that the act of making and defining photographic practice in*
> *print form is increasingly nostalgic, and perhaps calls for an*
> *aesthetics of nostalgia.*

Within many photographic circles, "nostalgia" (origin: from the Greek *nostos*, "return home" and *algos*, "pain, grief, distress") is often considered taboo, or regarded as a dirty word. But as a medium that instantaneously captures and preserves the present as it transforms into the past, photography, it could be argued, inherently possesses varying degrees of nostalgia, both on the part of its practitioners and its viewers.

As an assignment, create a photographic work that consciously wrestles with the concept of "nostalgia" and photography's unique relationship to it. The work can be made in any photographic form (although Cotton's essay focuses on the black-and-white print, it is important to recognize that all forms of photography—color, digital, photograms, camera phones, screen grabs, found photography, collage, projection, and so on—are equally capable of nostalgic power).

Because of the nature of the assignment's focus, your imagery might explore notions of the past—immediate or ancient—whether it be photographic, cultural, personal, political, environmental, scientific, or otherwise. But be careful to avoid overt irony, over-sentimentalization, or "retro" pastiche. Genuinely engage with this curious and oddly powerful human emotion through the photographic image.

See also Foglia, Nakadate **309**

Barry Schwabsky
An Exercise in Photography

Alberto Giacometti wondered whether classical art didn't
have more resilience than modern art. He pointed out that we
understood the art of the Greeks from mere fragments, and
wondered, by contrast, "How would a Brancusi statue look if
it were chipped and broken?" In some way, then, the Nike of
Samothrace seems to be more fractal (self-similar at differ-
ent scales) than *Mademoiselle Pogany*. This doesn't necessarily
disqualify the latter, but it's something worth thinking about.
Likewise, in one's own work, it might be worth wondering: how
much of it need there be for my aesthetic to be communicated?
Try cutting your print down to smaller and smaller fragments
to see how far you have to reduce it to get to the point where
you no longer recognize your own viewpoint in it. Then, when
you get to that point, ask yourself whether what's left is some-
thing you might prefer to the image that does convey your
viewpoint.

See also Jakschik, Slota

Mark Sealy

Forget Berger and read Fanon.

See also Frazier, Pratt

Nigel Shafran
Thoughts

I like to think of learning photographic technique as similar to learning an alphabet, and then making your own language.

Finding out what you don't want to do can be as important as finding out what you do want to do.

There is a time to think and a time to act. I do not like to over-think while working.

Try not to let your head dissuade you from taking a picture, however irrelevant it might seem.

If you go back to take a photograph, it changes, or you do. It's never the same.

Be accepting of what is in front of you. It can lead to infinite possibilities.

Know that everything that has happened to you in the past can have an effect on your work.

Be aware that all decisions you make, from how you approach the subject, your technique, even the clothes you wear, can affect your photographs.

Look at the present as if it were the past—as if you are the future and "now" was then.

Keep in mind that including contemporary cars, fashion, packaging, etc., will date your photographs.

I like to feel that everything is connected and makes sense if you can see it.

See also Benning, Harper

Christine Shank
One-Hour Photo Project

I noticed that many students had lost a sense of experimentation and play within their work (or maybe play had never been a part of their practice in the first place). So I created this project to introduce experimentation, play, intuition, and creative problem-solving—all vital to making art. The project is fast, so students have to think quickly, trust their judgment, and not overthink their ideas. Some students really enjoy this exercise, some do not, but every time I have done this assignment, the work is always surprising and exceptional.

For the one-hour photo project, the students are told to bring their cameras with charged batteries, card readers, and their computer, if they like. I prepare for the project by going to the dollar store and buying things such as Scotch tape, balloons, bubbles, plastic tablecloths, tinsel, colored chalk, plastic bags, tinfoil, etc. I purposefully select very ordinary materials that are easy to manipulate, easy to clean up, and a little bit festive. I put each of the items in an individual brown paper bag. I close the bag so the students will not know what is inside. I tell the students that each bag contains an item they are to use in making a photograph. There are additional criteria: they have to work alone and go outside into the landscape; the material they selected needs to be included in the image; people cannot be the main focus of the image; and they are to be back in one hour with an image ready for critique.

See also Maddock　　　　　　　　　　　　　　　　　　　**313**

Leanne Shapton

Doing Laps

Photograph a subject 250 times over the course of two hours, once a day for a week.

See also July, Reinfurt

Tate Shaw
Create an Image Virus

To create an Image Virus, make an image and spread it around as many places as possible, but keep the image credit anonymous. Make copies of the image and wheat-paste them on walls and electrical boxes throughout your city. Mail prints of the image to everyone you know and leave the return address off the envelope. Staple prints of the image on corkboards at laundromats and grocery stores with little tear-away tabs that have only an e-mail address written on them; if anyone sends a message, reply with just the image as an attachment. E-mail the image to everyone in your contacts list. Make it your status; post it; blog it; tweet it; get others infected with spreading it around the Internet. If the virus becomes widespread enough, you might find it returned to you slightly mutated in form. Repeat something enough times and it will lose its meaning, at which point one can then reassign what it means.

See also Kessels, Mayes

Shimabuku

See What Is Happening

1. Using an old or cheap camera, take photos toward the sun. You might get a rainbow or a diamond.

2. When you take your own portrait, never do it by yourself. And never use the self-timer function. Ask someone to do it every time.

3. You may want to give a camera to animals and see what is happening.

4. Sleep with the camera.

See also Baldessari, Brown

Stephen Shore
Intentionality

When I first began teaching, I noticed that the students who most closely adhered to my assignments improved the fastest. I thought I had some kind of special insight and gave uniquely apt assignments. I then realized that what led to the growth was not the nature of my assignment, but the fact that the more rigorously they followed the assignment, the more they approached their photography with intentionality. It was working with intentionality that led to their growth.

See also Kurland, Pilson **317**

Aaron Siskind
A Story by Thomas Barrow

When I studied with Aaron Siskind at the IIT Institute of Design from 1963 to '64 there were five or six graduate students, and we met in his small office in the lower level of Mies van der Rohe's Crown Hall. Aaron would mention assignments that Harry Callahan and Arthur Siegel gave, but his own assignments were of a general nature: go to Morton Arboretum and think about form in nature.

He spent more time sharing his ideas about art in lengthy and illuminating monologues, and he liked to take the class on field trips. He was a colorful raconteur and a list from his topics at this time would include Shakespeare, Paul Strand's politics, the Brotherhood of Sleeping Car Porters, recent *New Yorker* fiction, and some of the artists he had known in New York City, especially Adolph Gottlieb and Franz Kline. While it was always clear that he missed New York, the Village in particular, he also had an affection for the great architecture of Chicago and the chip it wore as America's brawny "Second City."

In all of this discourse he was pragmatic, enthusiastic, and romantic. This was evident in his choices for our field trips. One such trip in particular has stuck with me; it was to the factory town of Pullman on the south side of Chicago, which has many historic and architecturally significant buildings. Though it has since been recognized for its historic importance and is now being restored, at the time it was in an artful decay. Aaron knew the town's brutal past and of the major American workers' strike against the Pullman railcar manufacturer. He talked about the importance of labor in America and told the story as if George Pullman and Eugene Debs were still alive. That day certainly made us aware that there might be more to making photographs than worrying about film speed and equipment.

We also made trips to the Art Institute of Chicago, where it was clear that Aaron could speak with knowledge and pas-

sion about many of the works in the galleries. Every so often a couple of us would press him on what all of this had to do with our photography, and he invariably replied, "Art begets art." It was, I thought then, his mantra, and, looking now at his impressive legacy, it appears it was a pretty good one. Over time, I have come to understand that what Aaron Siskind was really showing us through his teaching was how to be an artist for an entire lifetime.

See also Scheinbaum, L. White

Mike Slack
The Seven-Minute Game

For any length of time, follow these basic rules:

1. Get in a car, set a timer for seven minutes, and start driving in any direction, preferably a new direction.

2. When the alarm sounds, park the car at the first available opportunity, get out, observe your surroundings, and make some pictures.

3. Return to the car, repeat steps one and two. Keep doing this until you run out of free time or film or batteries.

The interval between stops (which can vary) is less important than obeying the alarm: force yourself to stop whether you want to or not. Don't wait for the "right" subject to materialize. Make random turns, get lost, find yourself in an unfamiliar place. Impel yourself not just to look, but to turn what you see into a composition, to make a decision. You'll either fail or succeed, but you'll amass an archive of pictures to evaluate. To enhance the exercise, add restrictions (i.e., use only one kind of lens; shoot only two frames per location; stop for only thirty seconds; don't walk farther than twenty-five feet from the car; etc.).

See also Duffy, Hamada

Gerald Slota
Four Pieces

I find that most photography students get stuck with the technical aspects of their work, which I think limits their creative process and their willingness to experiment and make mistakes while producing an image. I've noticed that when they do make a "perfect print," they are very protective of it for reasons such as the time and effort invested, as well of the cost of the print.

So, in an effort to encourage the students to push themselves in a different direction, I give this assignment for the first class:

I tell them to bring in a recent print, a favorite, that they feel is a breakthrough in their work (they assume we will critique this in the next class). Then, I have them rip it into four quarters (some students cry, but most are mad). Afterwards, all of the students put their ripped four quarters of a print onto a table, and I mix them up. Each student picks four new pieces from the table. They then create a new photo from what they received. The student can use all of the pieces or just one. They can reshoot it or construct the pieces into a object or use them as a backdrop or stare at them and create an image that reflects the mood. Anything goes!

See also Brandt, Sullivan

Aline Smithson
Words and Ideas

Most of my students are exploring photography outside the traditional educational arenas and haven't yet considered making work about concepts and ideas. My first assignment, to be produced before the class starts, is to have students make a visual connection between words and ideas. So I ask them these ten questions and they have to reply with photographs:

1. Who are you?
2. What did you look like as a child?
3. What is your main character trait?
4. What inspires you the most?
5. What do you normally never take a picture of?
6. What do you love about photography?
7. If you weren't a photographer what would you be?
8. What is the first thing you touch in the morning?
9. What is your favorite photograph? (By you or someone else)
10. What is the meaning of life?

For some reason, my favorite image is always from the question: What is the first thing you touch in the morning?

See also Bonajo, Chiara

Tabitha Soren
Advice

Be very careful before you take advice from others. There are many ways to get where you want to go, but you'll only find them if you look for yourself.

See also Kippenberger, Traub

Alec Soth
Words and Photographs

> *I think that's one of the hardest things to do—combine*
> *words and photographs. But I would certainly try it.*
> *—Robert Frank*

Part of my ongoing education as a photographer is to try and figure out how words and photographs can work together. For this assignment, print one of your photographs on one half of a sheet of paper. On the other half, write something about the picture. The key is to write something that doesn't destroy the magic of the photograph. Write in a straightforward way. Do not use adjectives or fancy words. Do not explain the picture; enhance it.

Once you are done, fold the piece of paper in half. Is the picture better without the writing? If so, repeat the assignment with different photographs until you've made a combination that is more than the sum of its parts.

See also Kelsey, Turyn

Jem Southam
Site Excavation

One of the inspirations for this exercise was Mark Dion's extraordinary work *Yard of Jungle* (1992), in which he took a cubic yard of earth from the Amazon rainforest and examined and classified the astonishing complexity of its ecological makeup. It also comes out of my own enthusiasm for making extended photographic studies of specific sites. It is one of a set of exercises that we are continually evolving along with our postgraduate "Land" students, within a wider project called Matter, Myth and Memory.

Everyone selects a small site. There is always a discussion early on about what constitutes "small" in this context—one study a few years ago involved a bowl of muesli. The sites are then "excavated" over a long period, usually months. How this is done is completely up to the individual.

The site study is intended to act as a laboratory space, in which a whole raft of different methods and forms of inquiry can be brought to bear on unpacking and then reassembling an understanding of the chosen spot. Physical and human geographies, mapping exercises, biological diversities, weather patterns, personal narratives, legal niceties, phenomenological and experiential modes of gathering, collecting, sampling, counting, and questioning are all potentially brought into play. Novels are read; short stories are written; drawings, maps, and diagrams are made; and somewhere in all this the role of photography is explored.

After the initial briefing we purposefully do not talk about what each participant's investigation involves. Then after a couple of months we have a day in which all share and discuss the progress of their study. That is always one of the most fascinating, rewarding, and revealing days of the year. At the end each student prepares and delivers a presentation and hands in a document, frequently in a large box. It is always wonderful to see what has transpired.

See also Heiferman, Keegan

Doug and Mike Starn
Thingness

For this assignment you are not going to take pictures. Look at one of your favorite photographs, one you have taken—a print of your photograph. Realize that it is not an image, it is a thing.

Consider its qualities: is it flat? Does it have a slight arc or is it curled? Is the print shiny or flat or have a luster? Is it very thin or is it a heavy stock of paper or plastic? Is it a nice thing or mundane? Or is it nice and mundane?

Go to an exhibition of early twentieth-century photographs and look at them. See how the light reflects off the surface of the prints. Notice the surface variation, the silvering, and that parts of the image itself have a thingness to them.

A print is a thing, and even images exist three-dimensionally by virtue of being printed with silver or ink.

The images that you can see in your mind—not just by conjuring, but by opening your eyes and seeing—are constructions in your mind built with perceptions. The images you take with a camera start outside of your mind, but are only visible within it. What can you do with that thing?

See also Meister, O'Toole

Will Steacy

Float Like a Butterfly

It's all a big lie. All of it. The sooner you know this and accept it, the better off you will be.

We, as artists, photographers, writers, academics, etc., spend our whole lives and careers devoted to the impossible task of chasing the truth, a fruitless attempt to translate life into a tangible commodity.

A monarch butterfly flapping its wings in frantic spasms against the window of an uptown A train at 1:47 a.m. on a Tuesday night in July.

Sitting there on that train with the exhausted workers and drunks waiting for the next stop—when the doors will swing open and that trapped butterfly will have twenty seconds to make its escape. That is art, that is life, and it will never exist as you experience it on a canvas, in a photograph, or in these concoctions of letters we call words. The best you get is a memory.

Never forget it. Never stop allowing yourself to be there on that train and notice the silent struggle of a caged beauty flapping its wings in a desperate fight for survival.

And never forget, that despite our best efforts—despite the tireless fight to capture the details and tidbits of life and attempt to share these experiences with the world in some abstracted form, from which the world will know exactly what it felt like that night in July on the subway—nothing will ever compare to the feeling of being there. Just like the hopelessly optimistic butterfly flapping its wings, the artist in us will never stop trying to capture and share the world as we experience it. Your greatest asset is an endless inventory of Tuesday night train rides. This is the only morsel of truth in the big lie.

See also Cowin, Ou **327**

Mark Steinmetz
Photograph Somewhere You Are Very Uncomfortable

There are all kinds of successful photographic approaches where the photographer is quite comfortable when taking his or her pictures. For example, I don't think André Kertész ever felt uncomfortable when taking a photograph. Someone like Brassaï, however, had a bodyguard with him at various times. Much of the best photography happens when one begins to overcome one's personal limitations. Students tend to be very shy, particularly when photographing people they don't know. They often retreat to photograph in empty, abandoned places where no one will bother them.

To do photography, for the most part, one must maneuver one's body around to be in the right spot to take a picture. The photographer must be physically in front of something. Often, students are not getting themselves in front of the things that really interest them because they aren't quite brave enough. I try to remind them that passion can't really exist in the absence of risk, or the feeling of risk. Over the years a few of my students have gone to dangerous neighborhoods and clubs, to slaughterhouses, or visited their estranged parents, but most of them never really address this assignment directly or fully—many find clever ways to avoid it. But perhaps this assignment gives them something to think about.

See also van Manen, Weegee

Brian Storm
Interview as Guide

Do an audio interview with someone you have photographed
extensively or would like to document over a long period of
time. Ask them questions about their life and use their answers
as a guide for what to photograph and how to best tell their
story.

See also Fletcher, J. Winokur

Katja Stuke and Oliver Sieber
Teaching Antifoto

Since we started Antifoto in 2010, we not only discuss topics and aspects of photography through exhibitions and artists' talks at the BöhmKobayashi University, but we also bring these topics (sometimes single works by artists from the exhibitions) into classes.

This year we published the *Antifoto Manifesto*. It includes our ten personal theses and texts by various artists, curators, and writers. It's productive to discuss these with students, and we use them as a basis for reviewing the students' works in plenum.

The Antifoto Manifesto
1. We love photography in all its glory.
2. A photo is a photo is digital, is analog, is black/white & color; is an object, is a book, is a blog, is a magazine, is a movie; is a story, is a statement; is an installation, is a sculpture; is always someone's truth; is an original, is a copy, is a reproduction, is unlimited.
3. Photography is the future & the past; photography is a medium in transition.
4. One single image is only the tip of the iceberg.
5. Use photography as an international language.
6. Never disregard progression.
7. We want to see the images we are missing.
8. Photography is too good to be regarded as art only.
9. Students: print your images.
10. Open your eyes: go visit exhibitions.

See also Cuomo, Thomas

Jock Sturges
What Is Simply True

Every year for the past several years I have been accepting a pair of summer intern assistants from the Fotofagskole in Trondheim, Norway, to help me with my work in France. Fluent in English and with high-order skills in all aspects of photography, the people graduating from this program have yet to disappoint me in any aspect. I'm very lucky to work with them.

Three years ago my two assistants were Ole and Anette. About a week after they had arrived, I suggested that they each make a portrait of our neighbor's daughter, Auregann. At seven, Auregann was exceptionally affectionate and very beautiful. Ole went first. Trained in every aspect of portrait and fashion photography, Ole knew how to make strong pictures and right away was busy posing Auregann to make the picture he wanted. A minute in, Auregann complained to me, "*Jock, il m'embête!*" (He's bugging me!). Three minutes in, Auregann dissolved in tears and buried her head in Anette's lap. Anette, in turn, was smart enough not to try and make a picture that day.

Ole had been ignoring who the child was and trying to oblige her to pose how and where he wanted. He wasn't doing anything unusual or cruel in any way. He was simply guilty of not understanding the child with whom he was working. His "idea" for his picture was more important to him. He failed.

Two months later Ole made a magnificent picture of Auregann as she lay curled up on Anette's lap. Anette was returning to Norway the following day, and both had bonded so deeply over the summer that they were very sad. The picture was redolent with this affection and beautiful. When I saw the image, I looked Ole in the eye and said, "You get it now, don't you?" He nodded his head emphatically, "I do. I do."

Ole's first picture was about who he wanted Auregann to be for him. The second was simply of who she was. No architecture of thought is ever nobler than what is simply true.

See also van Manen, Verene **331**

Josef Sudek

From Poet of Prague: A Photographer's Life, *1990*

One cannot escape being influenced by others, but these influences were only good to the extent that they forced me to go my own way. I met the Czech-American Ruzicka early in my life and through him the photography of [Clarence H.] White. At the time, I did not yet know that all mystery lies in shadow area. When Dr. Ruzicka arrived from the U.S.A. he told me often: expose for the shadows, the rest will come by itself—he was right. . . . But how to master the technique, that I did not know yet.

See also Homma

Bill Sullivan
Prison Break

I always thought that the making of a new work of art is a lot like escaping from prison. The prisons are all different. The prison could be the past and all the art that has been made before. The walls of the prison could be the art world's current conventions and its guards those who are protecting specific modes of depiction.

Your assignment is to escape the prison of your own understanding, by going through the front door.

In order to come up with a possibly successful plan, you must compile a lot of information. You must study why past escapes failed and which may have succeeded. Please understand that the planning and execution of your escape may take a while. Complete understanding of the prison and how it works is usually paramount.

Plan your escape carefully and obsessively, but have a deadline, a specific date or dates for your escape. When that time arrives go with complete confidence, but be as flexible as needed in the execution of the plan as circumstances may change on a given day and your hope for success may hinge on how you react to those circumstances.

Confidence and flexibility are key.

See also Fleming, Maddock **333**

Larry Sultan

As Remembered by Kelly Sultan

A while back, there was a period of time when Larry instituted regular "Study Hall" sessions at the studio. At some point in the afternoon, he would announce it was time for Study Hall and, for about twenty minutes or so, he and Dru Donovan and anyone else working with him that day would drop everything work-related and pick up something to read.

But there were rules: your selection should be nonfiction or poetry, and a little bit to the left or right of what you would normally reach for on the shelf. Then, everyone would go outside, or to a favorite chair, and quietly study. No talking in Study Hall. The sanctity of Study Hall even eclipsed that other near-spiritual experience (and one of his favorite sounds): the ringing phone. During this one brief period, he left it unanswered, evidencing his exquisite commitment to the read.

So take just a bit of time to sit and read. You might even double down—a real Larry thing to say—and hold Study Hall in the bath, or by the pool, or get wet with the ice cube in your mojito and read the label on the bottle. It was all interesting to him, or, invariably, led to something worthy of interest.

See also Mickey, Parlato

Peter Sutherland
Photography Through Filmmaking

Make a documentary film using standard filmmaking equipment. This includes a camera (film or video), sound equipment, a sound person if needed, lights if needed, tripod if needed, editing software, and an editor if needed.

Choose a subject for the film. It should be about something or someone that you don't already know. Choose a style that you would like to use for the look and feel of the film. It should be in line with the style you use to take your photographs.

Go and make the film. Find the subjects, find the locations, e-mail people, set stuff up, work around everyone's schedules, including subjects and crew. Talk to the subjects about their concerns about being in the film. Have them sign release forms. Edit the film and add in music or a score. Have a screening of the finished film or post it online.

The point of this exercise is to do all of the work—including collaborating with others, recording sound and image—and to make all of the decisions that go into a film. There are so many possibilities in making a film that you are forced, as a filmmaker, to choose what is most important.

If you can get through the filmmaking process, it will give you a good sense of what it takes to create a small body of work and share it with the world. After the film, your still photography projects should feel easier and your approach to them more straightforward. My first big project was a film about New York City bike couriers. I shot 220 interviews over the course of a year. I pulled favors from friends, got the film scored for free, etc. I was lucky because the film was released and distributed. After this process, taking photos has always felt freeing.

See also Ashkin, Sutton

Eva Sutton
Synesthesia

Take a photograph.

Then, add time.

Make it into a video. Include other photographs, sound, text, or video.

Then, make it into sound.

Turn it into a poem.

Turn the video/sound/poem back into a photograph.

Use any technique, analog or digital, to carry out these transformations.

See also Donovan, Turyn

Triin Tamm
Personal Library

Think of a title for a book that you wish you could check out from the library and make a cover for the book.

See also Gremmen, Nordström

Robyn Taylor
A Topical Drinking Game

This game is best played with a group of fellow students, photographers, or friends and can also work as an icebreaker at the beginning of the college year. If you can get the whole class involved, even better.

Rent a copy of Michelangelo Antonioni's 1966 film *Blow-Up*. Pick your poison; I recommend beer or wine rather than spirits. Drink every time David Hemmings, or "Thomas," takes a picture. You won't make it past five minutes, but you may end up making some lifelong friends.

See also Frame, Grannan

Rein Jelle Terpstra
Photos Not Taken

We were in a car getting lost in one of Antwerp's old neighborhoods, trying to find our way back to the ring road. We pulled over for a bit and there I saw them, slowly moving on the pavement—two young Hasidic girls, identical twins, walking next to each other, their nanny right behind them. The girls each had one eye taped over, the left girl's right eye and the right girl's left eye. Together they saw with one pair of eyes, as if to complement each other's eyesight, as if together they could see with full depth of field. How would they see, and what were they, simultaneously, looking at? Probably not at me, who kept on staring at the girls while the car started moving again, the camera sitting on the dashboard.

Many of us carry a photo in our memory—an event or a moment that we saw but failed to capture in a photograph. Perhaps the camera was out of film or the battery empty, or perhaps the moment was simply too important.

Sometimes such perceived moments haunt you like persistent afterimages. Perhaps these kinds of afterimages—fluid, because never recorded—will lead you to new thoughts and new stories.

With these considerations I invite you to write a story about your untaken photographs. The story might be better than the photograph could ever have been.

See also A. Brown, Lazarus

Sara Terry
Composing in Color

For a color photographer, learning how to compose in color
is as important as learning to compose with elements of ratio,
framing, lines, etc.

I got a great tip from a fellow photographer when I was
just beginning, about sensitizing your eye to color composition.
Here it is:

Walk down the street (without a camera) and choose a
color—a specific color—that you see in something around you:
a street sign, someone's shoes, a mailbox, whatever draws your
eye. Then look for that *exact* color in other places as you con-
tinue to walk down the street. If you chose mint green, make
sure you're looking for mint green—not apple green, or forest
green, or khaki green. Mint green. After you've searched for
your chosen color for a few blocks, move on to another color.
This is a great way to train your eye to see color and to recog-
nize it within the context of a broader canvas of activity.

I also came up with my own color exercise that I've found
useful. You can do this while you're walking, but I think it's
easier to do when sitting. Say, for example, you're having cof-
fee with a friend. While you're talking, or listening, pick out
the repetition of color in front of you, around you, behind
your friend. If your friend's coffee cup is red, for example, you
might notice that the person at the next table has a red bag, or
that the woman at the counter behind your friend has red nail
polish, or that the sign pointing to the bathroom is in red, or
that someone has thrown a red ball through the air. When I
do this, I try to let my eyes become like the lens of a camera. I
kind of flatten the scene out into a 180 degree plane, picking
up everything in the frame, without concentrating on any one
thing—and then I "look" at what I'm seeing, letting my mind's
eye bounce around the frame that my physical eye is recording.

Neither of these exercises involves taking a photo as part

of the assignment. These are mental exercises that you can do anytime, anywhere. I still play with them both frequently, almost as a matter of habit. Over time you'll find that this color play takes hold, subconsciously—you'll see it emerging in your photographs, as specific spots of color begin to provide a subtle composition in your work, moving the viewer's eye around the image that you've made.

See also Armstrong, Powell

Bob Thall
Pictures Within Pictures

This exercise is meant to focus the photographer's attention on the frame of the photograph, precise choice of camera position, and the interesting ways that the camera can translate three dimensions into two.

Find a rich, complex environment and make photographs that incorporate reflections, other images (like posters, signs, and video displays), and design elements such as poles, doorways, and windows. The goal is to produce photographs that have pictures within the picture and which, at first glance, look like diptychs, triptychs, or even collages. Sophisticated photographers know that we must carefully control how elements close to us relate to further objects in the photograph if the image is to render space clearly. The tree or pole that appears to come out of a subject's head in a portrait is a common mistake. In this exercise, it's useful to take that awareness and violate normal rules—to deliberately flatten space in a confusing way.

To prepare for this assignment, good images to look at for reference, include Gilles Peress's *Telex Iran*, the early work of Lee Friedlander, and work by the Chicago photographer Gary Stochl, among others.

See also Kessmann, Moore **343**

Hank Willis Thomas
Dear Me

If you can't tell, I'm a firm believer in earnestness. I wish there was a word called "earnesty" though. I like the sound of that better. Anyway, it's best to try to face yourself before exposing yourself to other people. This is good to do when feeling blocked. Grab a piece of paper and pen. Better yet, grab a notebook. The one you keep your ideas in. Do you have a book of ideas? Where do you log your dreams? So, now that you have that: Sit down in a quiet place. If you can, get some other creatives around to partake in the exercise. Being naked is always more fun when you have company. Take a moment to quiet your mind.

Compose a letter to yourself. You always know when you are lying so this should keep you honest.

Dear [insert your name],
Thank you for working through these exercises with me. Let's cut to the chase. The reason I decided to be an artist is _____. What I love most about it is _____. I must admit I never expected to _____. But that's okay because _____. When I'm faced with creative challenges I _____. Which is really good _____. But I wish I _____ or _____, as well as _____. What I want most out of creating art is _____. I do not want _____. But I'm okay if _____. I am driven to create by _____. What I like most about my work is my ability to _____ and when it _____ or _____. I feel best when a piece _____. I hate it when _____. I don't like when my work _____ or _____. It makes me feel _____.

I know I can't control what others see, but I would like viewers to _____ and _____ or at least _____. I don't want them to _____ or

_____.

I will consider myself successful if _____ or _____. I don't mind _____ or _____ if it means _____. [You can ad-lib from here, but try to get to the bottom of the page and end with some positive reinforcement.]

Ahhhhhh. Now doesn't that feel good?

See also Gossage, Keeley

Elisabeth Tonnard
The Death of the Photographer

1. Locate Roland Barthes' essay "The Death of the Author." A good translation can be found in *Image-Music-Text,* a collection of Barthes' essays. You can also go to ubuweb.com.

2. Find and replace all instances of the following words and phrases (for instance, by using a text-editing program):

Find:	*Replace with:*
author	photographer
language	image
literary	photographic
literature	photography
men of letters	photographers
novel	photo work
poetics	philosophy of photography
prose works	photographic works
realist(ic) novelist	documentary photographer
scriptor	maker of photobooks
sentence	portrait
story	photo work
text	photobook
word	image
words	images
write	take photographs
writes	shoots
writer	photographer
writers	photographers
writing (used as a noun)	photography
writing (used as a verb)	photographing
writings	photos
written	photographed

3. Read the resulting text and keep for future reference.

See also L. Hewitt, Kelsey

Charles Traub

The Don'ts

Don't do it about yourself—or your friend—or your family
Don't dare photograph yourself nude
Don't look at old family albums
Don't hand-color it
Don't write on it
Don't walk around with your grandfather's Leica
Don't photograph indigent people, particularly in foreign lands
Don't use alternative processes—if it ain't straight, do it in the computer
Don't avoid new technologies
Don't go to video when you don't know what else to do
Don't believe it's art just because an artist says it is
Don't believe it's worth what it sells for
Don't believe it isn't a commodity to be traded by Wall Street
Don't believe an image is worth a thousand words
Don't believe the camera sees what you do
Don't overthink it; don't be pretentious
Don't gild the lily—less is more
Don't whine, just produce

See also Baart, Davis

Anne Wilkes Tucker
Lessons for a Curator

I was blessed to have Dr. Mary Frances Williams as my art history teacher and as curator of the Randolph Macon Woman's College art collection. As a future curator I learned a great deal, although at the time I was planning to be a photographer, not a curator. She thought about when a painting would first come into view, how a response to it might change depending on its image neighbors, and all the other concerns that are basic to the curator's responsibility. This was my first exposure to the detailed thought that should go into where something is hung and how audiences might respond. For instance, she hung the brightly painted cactus flower by Georgia O'Keeffe outside the school bank because "people might be depressed and need a pickup." Her tests were tough and you could tell when someone reached a particular question by their small exclamations of surprise or exasperation. I remember best one exam question: "Van Gogh dies. St. Peter asks him to choose between countrymen Rembrandt and Vermeer as a roommate. Whom does he choose and why?" There was no wrong answer. The grade relied on the blend of our knowledge about each painter, our imaginations, and our capacities to articulate and defend our answers. The most important aspect was that there was no wrong answer. It wasn't about memorization. And playing safe lowered your grade.

See also Gordon, P. Nolan

Anne Turyn
Telephone Game

My favorite assignment grew out of the first day of a Narrative Photography class many years ago. I decided that we would do what amounted to a telephone game.

We were sitting around a conference table, and appointed members of the class wrote a narrative sentence and passed the text to their left. The next person drew an image depicted by the sentence and passed only the drawing to their left so that the drawing could be translated back into language. That text was passed left, drawn, and the drawing was passed left and translated into language again and so on. In the end we assembled the threads and had a laugh. The drawings were rough (we were photography people), but we could also see where ambiguity was created.

It was so much fun that we did the exercise with photographs over the course of a semester. The class divided into two groups, both groups each photographed and translated. Whenever I show the resulting sequence to a class, they inevitably want to do this project in their class.

See also Harris, WassinkLundgren

Brian Ulrich
Shadows and Trades

Shadows
This assignment is designed to take place over a period of two weeks. First, find yourself a partner to work with. Following this, you will take turns in "shadowing" your partner for one week while they work on their chosen project; in the studio, in the field, or on location. All decisions, whether conceptual or technical, should be talked through and critiqued in partnership with your shadow.

Trades
You will be assigned the name of a fellow student either by random, as selected by your teacher, or agreed upon by classmates. For two weeks, students will "trade" and work on their assigned partners' projects, whether in concept or practice. This exercise will culminate in a group critique.

See also Fleming, Lancaster **351**

Penelope Umbrico

An Exercise in Travel, Choice, Narrative Contingency, and Eisenstein's Idea of Collision Versus Collusion

Choose a subject that has some meaning to you and make a list of words that are relevant to that subject. Pick one word that is most relevant, or that best describes it. Go to the New York City Public Library Picture Collection* or another similar non-fine art, non-commercial picture collection. Start by looking up your selected word in the subject folders (those that contain the images) and looking through the pictures in the folder(s) until one of them resonates with you. This image need not be related to the word, but be careful not to pick an image just because it is predictably seductive (kittens, puppies, sunsets, sex). Take that image out of the folder and study it until it suggests a new subject/word. Now look up the new word in the folders, searching through the pictures until one of them resonates with you. Repeat this process ten times, numbering each image as you go (Post-it notes might be handy).

You will then have ten images from ten different folders, one leading to the next. This should feel like taking a journey in which you have no goal or idea of where you will end up. In other words, let yourself discover new images, don't think about it too much, and don't have a narrative in mind. Let the images take you where they will. At this point, the sequence of images probably won't make sense. Borrow the images, or make good copies, and bring them to the next class. In class, you will hang them in a row, left to right, in the order you found them. The class will attempt to read the sequence as a narrative, and you will likely find some new relevance to your work in this reading.

Note: Though this exercise could be done on the Internet, the idea is to take your time and contemplate the images you find with as little distraction as possible. Going to a physical picture collection is more conducive to this and will allow you to see, in

a more focused and contextualized way, how your ideas, concepts, and visual vocabulary are manifest in culture at large, and in turn, give you insight into your relationship to that visual culture.

I know—it no longer seems reasonable to go out of your way to go to a library in order to find images in physical folders that would take you ten minutes to find online. You REALLY want to do a web search instead. But I insist. A physical picture collection search is a completely different sort of exercise. The very act of working slowly through a collection, touching the prints or tear sheets that a specific individual has filed for a specific reason, and choosing from this limited (rather than limitless) stock, elicits a different kind of response than it did, say, ten years ago, when I began giving this assignment and you had no choice but to use such a collection . . . and it may not be too long before it disappears and you won't be able to.

* Mid-Manhattan Branch, 3rd Floor, 455 Fifth Avenue, NYC

See also Heiferman, Rickard

Carlo Van de Roer
Sum of the Parts

Make two photographs that you feel convey a particular subject when they are viewed together, but that do not convey the same subject when they are viewed separately. This is a way of including the viewer in the creation of meaning in your work. The subject could be an experience, idea, piece of writing, or word. Try to choose something that is of interest to you personally.

See also Colberg, Soth

Bertien van Manen
Blending In

Go to a place where you don't know anyone. Find a family or a community of people who don't object to your staying with them and taking photographs.

It is important that you feel at ease with these people.

Use an analog camera so that you won't be tempted to look at what the results are, since this would take you out of the moment and your concentration. Use a simple camera, small and easy to handle, so that you are able to react quickly to things happening and so that you won't be around as "The Photographer." Make people feel at ease with you; try to be there more as a friend who happens to take pictures. It is a challenge to find the balance between working with all of your energy while also not bothering people too much. Photograph what comes up, but do not organize events and do not force anything. Do not try to prove anything or make a political statement.

Try not to take too many shots of the same situation. Instead, try to concentrate on what you are doing, on each individual shot rather than working like a robot, hoping there will be at least one good image if you shoot like a madman. Be sure to bring enough film and at least two cameras so that you will be able to take pictures at any moment and avoid the frustration of being unprepared when something interesting is happening. It is no sin to ask someone to repeat an action that you missed, but don't do this too often.

Enjoy the fact that all of your work will be fresh to you when you get the negatives and the contact sheets back from the lab. This should be full of surprises and sometimes disappointments. Select carefully and have someone with an objective eye look at your selection and make comments.

Good luck!

See also Ivis, A. & R. Webb Webb

Paolo Ventura
The Depths

I have never loved school. I went, but without any real pleasure.
But since I was young, I have always been passionate about
stories—stories that I heard from my grandmother, from my
father, or that I imagined on my way to school. They were sto-
ries of war, circuses, the outskirts of the city, and the fog. I grew
up with these stories and they became obsessions, then later
became my work.

I didn't go to photography school. Instead, I spent a lot of
time alone wandering through my city, sitting in the café, fish-
ing, or taking long tram rides with no destination. This is how I
learned to look and to think and to correlate my thoughts with
my work.

Search for your obsessions; go to the depths and stay there.
I believe that often you don't have to go far to find them.
Actually, for me, they were things that were near to me—in my
story, in my city, in my family.

See also Behrend, A. Brown

Chris Verene
The Intimate Portrait

This is an assignment for undergraduate photography students, and may be completed using any type of camera, including mobile phone cameras. This project may be used for beginner, studio photography, portrait photography, documentary, and other related classes.

What to do first:
Choose a person with whom you have an intimate connection. Ask her or him if they will agree to participate in this project. They will be working with you for three weeks, and it is important you explain to your subject that they must stick with you through the whole project, no matter what happens.

Rules:
1. Subject must be twelve years of age or older. Younger children are not reliable enough to make a consistent project, and are too young to commit to the three-week process.
2. Subject may not be a pet, and must be a human with a real intimate connection to the photographer.
3. No photographs may be made on this college campus, unless using the studio or in a private dormitory bedroom, bathroom, etc.
4. "Intimate" connection implies that the subject and photographer are closely connected—they may be family members, neighbors, lovers, close friends, or someone you know from school.
5. If you "can't find anyone for this assignment," try to choose someone with an intimate connection to your family—for example: The best friend of the photographer's sister might not have a truly intimate connection with the photographer, but if this is as close as you can get, it will be accepted for the project.

This contract is optional, and you may choose to modify this sample.

I [subject's name], hereby agree to become a part of the art project "Intimate Portrait," which will be directed by [photographer's name]. I understand I will be photographed over three weeks, including at least three portrait sessions. I understand that the student's college class grade is contingent on my participation, and I will cooperate with the assignment as much as possible. I hereby give my permission for [photographer's name] to use my image, personality, and likeness without further approval by me and without monetary payment to me. In exchange for my work as a subject, [photographer's name] will provide me with free prints of our best pictures for my own personal use.

Signature of Subject:
Parent or guardian's permission if Subject is seventeen years of age or younger:
Signature of Photographer:

Three-Week Schedule
1. Week One: Make one hundred photographs of your subject. Use two locations, and use different clothes for both locations. One location must be outside, and the other must be in the private space where your subject lives. Edit this down to the best ten pictures over both locations, and bring to class for critique.

2. Week Two: Make two hundred photographs of your subject, this time changing your style based on the class's response to Week One. Typically at this stage, you may want to ask the subject to bring a friend along to help with the shoot, atmosphere, and costumes, and to give a different mood than Week One. Edit this down to the best ten pictures, and bring to class for critique.

3. Week Three: Make two hundred more photographs of your subject. At this point you are modifying your approach to the pictures based on critique from Week Two and Week One. The goal now is to wear out the subject, to exhaust the topic, and get to the point where you feel like you have tried everything. Don't worry if it seems tiresome, or overdone, at this stage—the goal is to "overshoot" the subject, so that you have enough pictures to choose from. Edit these down to ten. Look at the best feedback from Weeks One and Two, and bring a final group for critique of ten best works over all three weeks.

See also Hampton, Ivis

Sipke Visser
White Walls

Find a stranger and spend an hour or two in an empty room with him or her. You might want to ask a friend of a friend, since asking someone from the street to spend time with you in an empty room could be a little awkward.

Make sure the room is empty—white walls work best. Take a camera with you, but no zoom, no flash. Just a camera with a fixed lens and a few rolls of film. No props. Well, perhaps some tea or coffee. No digital cameras for this assignment, so you won't get distracted and start looking at images.

Talk and take pictures. There will be just you, the subject, and a camera. Experience how it feels to focus completely on taking a portrait of someone, on the interaction between you and the subject who agreed to spend time with you and be photographed. Notice how the personal space between you two often gets smaller during the time you spend together, how you can literally come closer with your lens after about half an hour. And notice how you have nothing to help you. You can't rely on a prop or a different background—it's just you and the person, and you'll have to deal with that and make the most out of it. You will have to really work with the person to get those tiny moments where the portrait will be best.

Enjoy!

See also Carroll, Lampert

Massimo Vitali
Mistakes

> *You've got to work with your mistakes until they look*
> *intended. Understand?*
> *—Raymond Carver*

I got this quote from a book a long time ago and I think it is
fitting for everyone trying to succeed in photography. It's only
through insisting and pretending that the errors are intentional
that you can make a real, unintentional masterpiece. Try shooting
a roll of film that's intentionally about making mistakes.

See also A. Bell, Kippenberger

Tim Walker

It's All About Love

I think photography responds well to the word *play*. Having a playful attitude to what you take a picture of is a good, positive approach to many photographic projects. Play suggests a lightness of touch. Even if you've labored over an image it should still look easy.

But that's just my love of a joyful picture. You can always tell in a picture when the photographer and subject have enjoyed the photographic playing. Of course not every worthy photography subject can be approached with play and joy. And that which can't be approached playfully should be approached with love. Actually, I believe universally that photography can only be approached with love. This is the fail-safe guide.

When I was a photographic assistant to Richard Avedon he had "only photograph what you love" written on a scrap of paper pinned to his wall. It took me a while to really understand how deeply this rule can apply to photography. In the end, photography is only good if it's true. And I think a photographer's truth is born from their love of their subject.

Anything you *ever* put in front of your camera you have to love. Truly. Madly. Deeply. Whether it's a person, a flower, a dog, or the muddy tire of a tractor, you have to be mad for it. Absolutely in love with it. Whatever anybody says you have to know in your heart that it's beautiful.

Before I make a picture of value to me, I ask myself, "Do I love this?" I analyze my love for the subject, and that study of *why* I love what I'm about to photograph gives me a grip on my day.

364 *See also Abbe, Keeley*

WassinkLundgren
Chinese Whispers

Chinese whispers (a game also known as "telephone") can be a powerful tool of creation. By slightly misunderstanding something, and subsequently filling in the gaps, you're actually creating something new.

To start, you should learn a little bit about someone else's work. Make sure the body of work is new to you, but pay little attention to the details. There are many ways you could do this. For instance, you could have a friend tell you about a great work he or she has seen and switch off halfway through the explanation. Or run through a museum at top speed—always a great thing to do.

Later on, recreate the work in your head by filling in the gaps. What does it look like? What is it about? Etcetera.

Once you've done this, check with the original to see how the two compare. Is yours a lesser version of what you see in front of you? Or is it different? Possibly even better? If so, go and make it!

See also Harris, Turyn **365**

Alex Webb and Rebecca Norris Webb
Triggering Town

> *The central metaphor of "the triggering town" is the jumping-off point, the subject—for Hugo, always a town that has seen better days, "the town [that] will have become your hometown." —Joshua Corey, poet*

Photographers sometimes have trouble photographing their homeplace because they're too close to such familiar terrain to be able to see it clearly enough, and, hence, to be able to work freely and deeply enough.

With this in mind, we adapt an exercise created by the noted poet and University of Montana professor Richard Hugo. Called Triggering Town, this exercise involves photographing a place roughly the same size and possessing some of the same characteristics as your particular hometown or city— such as similar architecture, landscape, industry, climate, longitude, kinds of people, quality of light, or blend of disrepair and newness. We'd suggest photographing this Triggering Town or city at least three times, and, if possible, at different times of day—early morning, late afternoon, dusk. Additionally, try photographing in different kinds of weather if you can—rain, fog, or full sun, for instance.

For some, this exercise may "trigger" a body of work that resonates with some of the same qualities and atmosphere as the place where you grew up—work that begins to get at what your hometown or city *feels* like, even if, of course, it's not exactly what it *looks* like. For others, it may enable you to see your homeplace with fresh eyes—and perhaps help you discover a new project closer to home.

366 *See also Hido, Johnson*

Donald Weber
Empathy and a Full Stomach

As a photographer, I am terribly nervous. I am especially nervous around people, and find it generally terrifying to go speak with somebody I do not know. However, my career really depends on making connections with people, so I have had to figure out ways to make myself, and my subjects, comfortable. Not such an easy task, but there are ways to cope with a debilitating fear. I've discovered that we're both (photographer and subject) looking to make a connection, to find a commonality that we share, allowing a fleeting moment of understanding.

Often, I have been invited back to somebody's home. Here, our friendship of a few hours begins. Many moments with total strangers have revealed much more about both of us than I have had with friends and even family; for some reason, a camera allows me to fall into a world of vulnerability. The further I am away from my own sense of reality, the more I am willing to share and let go. Same with the subjects I have photographed. With our vulnerability comes trust. And with trust comes access.

There are times when I spend just a few minutes with a subject; other times days, and even years. But generally, it is over a meal where we form our photographic bond, where conversations happen. It's the usual things we all share in common—friends, family, our countries, bizarre political behavior of countries' leaders, etc. Mutual recognition, a desire to check for similarities. Are they like me? Am I like them?

Sometimes I take a photo, mostly I just eat. At the end of the day, I know my photographs will be good not because of their technical or artistic brilliance, but because of our genuine connection, however fleeting. I often wonder if a subject thinks, "Will he remember my soup? Our coffee together, or that cup of tea? Will he remember this?"

And this is what I share with my students—if you have genuinely connected with a subject, they will want this to last.

See also Adams, Weegee **367**

Weegee (Arthur Fellig)

From the Candid Recordings audio series Famous Photographers Tell How, *1958*

To me, pictures are like blintzes—ya gotta get 'em while they're hot. . . .

Say you have a camera, you make good pictures, everybody likes them. But you have to get out of the class where you only photograph your friends and relatives indoors. That's very nice, but if you want to do it professionally—and I don't see any reason why you shouldn't—go out and photograph strangers. I know you're afraid to do it at first. I was scared stiff myself. But you have to do it. And most people like to be photographed. They consider it an honor to be picked out of a big crowd. In other words, you can't be a Nice Nelly and do photography.

See also Steinmetz, Traub

Shen Wei
Hotel Self-Portrait

For me, the strongest self-portraits are taken when I am in the right frame of mind for making images. Generally, this happens when the situation is unplanned and open to uncertainty. Many of my self-portraits are taken when I am traveling, when I have found myself in many different hotel rooms.

I find that the banality of the hotel room gives me time and space for unexpected and introspective thinking. Since they are temporary private places that can be both intimate and impersonal, they can inspire surprising and interesting behavior.

For this assignment, take a series of self-portraits alone in a hotel room. Assuming you will have the room for at least one night, only shoot when you feel the timing or moment is right. If this moment does not happen, then wait for the next time you are in a hotel room again.

See also Delaney, Gilden

Hannah Whitaker

Fruit First

As teachers, we're trapped between teaching how to take photographs properly and teaching not to take photographs properly. We pose unanswerable questions and, often, accidentally delve into armchair psychology or social experimentation.

Last winter, in an overheated, sunny classroom off of Fifth Avenue, I led a group of students in a brainstorming exercise to come up with assignments for each other that defied their own tendencies. I spent most of the conversation trying to goad them into weirder, more sadistic ideas (like, you can't use your arms) than their initial, more manageable proposals (like, use available light). In the cacophony of suggestions, one student misheard his assignment as, "Make a documentary about fruit," a misunderstanding that we ultimately went with. We reveled in its absurdity. The results? Well, the results don't matter. Something to revel in was the point.

Indeed, one can be handed a subject about which to make art. Something arbitrary, innocuous, and funny will do the trick. The point is not to suppress the big questions, but to approach them from the side, to learn to transform thinking into making. And to practice first on fruit.

See also Baldessari, Onorato & Krebs

Charlie White
The Entirety of a Problem

Imagine an entire story or the entirety of a problem—either personal or political—or the totality of some profound concern or issue that you grapple with. Commit yourself to one photograph that does all that it can to speak acutely to that issue, that problem, that concern.

Do not wallow in technical complexity. Instead, aim to find the simplest means to communicate your idea—the goal here is to refine your idea to the point that you are able to capture it through simple means, not elaborate production.

Consider every aspect of your photograph to work toward the assignment's resolution: its title, its scale, its use of the medium and material, as well as its presentation and its presence.

See also Barney, Plademunt

Lindsey White

The American Road Trip: The Ultimate One-Day Experience

What you'll need:
Fifteen-person passenger van
Stack of signed permission slips
Road trip mix
Phone car charger
List of pit stops in chronological order
Final driving destination
Student co-pilot (preferably a navigator)

Students should bring:
Camera gear
Money
Water
Snacks
Proper shoes

For this road trip to go smoothly, you must present it like the true adventure that it is. Nothing will go according to plan, but, in the end, whatever happens is perfect. You will need to pick a final destination and a rough driving route to share with the class. Each student will need to investigate the route and pick one place to stop along the way—somewhere they might like to photograph or investigate. No stop is too small or weird, but the stop must be somewhat on route. Everyone should do some research on the route and share their findings with the group. A road trip mix is CRUCIAL. If you do not have the right music, the trip will fail. Have each student give you five songs and place all of the songs on a road trip playlist. Magically, everyone will be on board with this democratic mix—just put it on repeat and you're done. (I add a couple of extra songs that I like throughout the mix to keep me sane.) As long as you make this mix and choose a final destination, all will go as "planned."

It might be impossible to hit all the pit stops, but usually an on-the-fly vote will settle the matter. It's important to remain open to stops that aren't on the list. Tell students to holler if they want to pull over. I know this sounds like a long day, and it is, but it's the best bonding experience around. It's really something to pick a place on a map and then drive there. Hopefully, everyone will make some good photographs along the way— this usually happens. The trip is about fueling curiosity and wonder, while sharing some important tools for self-discovery and independence.

See also Brouws, Records

Grant Willing

Rhythm and Melody

Pick a film or a piece of music that you find especially compelling for one reason or another. Create a series of photographs that resemble or interpret the chosen work using a sense of narrative structure, motion, or sound (an element that is physically lacking in photography).

Consider how to create tempo, melody, or suspense in imagery. How do you build drama? How do you frame time? How do you depict sound? Do not simply create a series of images that represent a sequence of events; rather, think how you might frame some of the same objectives and intentions from the original piece.

Consider which visuals are important. Is it especially pertinent to be literal or can you explain core concepts in an abstract manner? How do you develop visuals based on something nonvisual? Does context play a part in how the original piece was read versus how your images will be seen?

Consider how an edit will impact the final presentation of your images. Is sequence especially important? How can the ordering of images relay a sense of rhythm that is heard? Think of how adjectives relating to time and action can be applied to still images.

See also Donovan, P. Reas

Julie Winokur
Expansive and Deeper

Scene 360

As someone who works in multimedia and video, I am always asking people to stretch themselves to cover a situation fully. A single frame isn't enough. It takes an entire series of frames to tell a story across time. Seeing through fresh eyes, finding interesting angles, and collecting a variety of images from a single situation forces a shooter to become expansive within boundaries.

Choose one scene and capture the following: the situation, the characters, an interaction, a reaction, a detail that seems obvious, a detail that is surprising, and the view looking in from the outside.

Speak Before You Shoot

Too often, people shoot first and ask questions later. Conducting an interview before you lift your camera not only teaches you about what to shoot, it builds trust and makes the subject part of a collaboration.

In addition to all the great advice out there about interviewing techniques, here are a few things that I've found helpful:
1. Figure out what really interests you about this person and delve deeper. What do you really want to know?
2. If you're superficial, your subject will be superficial.
3. Prepare a series of questions beforehand and don't be afraid to throw them away.
4. Follow your subject's lead; don't lead your subject.
5. Make and maintain eye contact as much as possible.
6. Reveal some of your own life, but don't overtake the interview.

See also Mandel, Wiseman

Neil Winokur
Odd Assignment

About twenty-five years ago, when Michael Collins, the photographer, was photo editor of the *Daily Telegraph Sunday Magazine* in London, he commissioned me to do a very odd assignment. I was to go to the morgue at Bellevue Hospital and photograph various organs for a magazine article.

It seems that the article was about using pig organs as replacement organs for human transplants. I was to photograph pig organs (heart, liver, kidney, lungs) and also human organs (heart, liver, kidney, lungs). The pig and human organs were very similar and it was thought that they would be able to replace each other. This appeared to be a very straightforward assignment.

The catch was that I had to do this in the morgue because the organs were coming to me from a recently deceased woman. As the organs were removed from her body they were brought to me to photograph. Another catch was that she was very old and sickly as were her organs, while the pig organs were very young and fresh. He had not died of old age!

As my gallery dealer, Janet Borden, had set this project up, I thought it only fair that she accompany me, my 4-by-5 camera, my strobes, my backdrops, etc., to the scene of the non-crime. Upon arrival, we were told we would have to wear face masks and gloves throughout the procedure. This was all very surreal.

Actually, the shoot went very smoothly and we were very happy to complete it and leave. There was one other aspect to this article that I haven't mentioned. Michael decided that I had to photograph a live pig for the cover of the magazine. Henrietta the pig was delivered to my studio by pickup truck. The super of my building was rather surprised when she was brought into his freight elevator. Henrietta was a full-grown pig weighing approximately a thousand pounds, and she barely fit on my backdrop. She did not smell very good. This also went very smoothly and the odor disappeared in about three or four days.

376

See also A. Brown, Falls

Frederick Wiseman
Chance, Luck, and Good Judgment

Commissioning editors at television networks in many countries require documentary filmmakers to submit summaries of the films they propose to shoot in advance of the actual filming. This is occasionally possible for a film where a filmmaker has a particular thesis and knows in advance what they want to shoot and the information they expect to elicit from people they interview or follow. However, for most documentaries this kind of advance precision is both impossible and, if done, false or phony. If the filmmaker is following people, there is no way in advance to know who he is going to follow, what they will say, or whom they may meet. The best material in documentary film comes from the filmmaker putting himself in a position where he can respond to whatever situations chance, luck, or good judgment may lead him to. A documentary that is planned in advance risks being even more boring and mechanical than one that is open to what the filmmaker finds. The pre-filming summaries too often required by networks are demanded more to protect the commissioning editor in the power struggles and hierarchal positioning in the networks than they are needed for the filmmaker to do his job and make a good film. The filmmaker's surprise will be the subject of the film and provide the energy to nourish the material.

See also Bey, Hido

Silvio Wolf
Real and Possible

Things are not what they seem. Nor are they otherwise.
—Traditional Buddhist saying

Things are exactly the way they are meant to be.
—Christopher Isherwood

It is not about the way things are, it is about the way you see them.
—Silvio Wolf

We see things not as they are, but as we are.
—Talmud

The true mystery of the world is what can be seen, and not the invisible.
—Oscar Wilde

See also De Rita, Gossage

Denise Wolff
Notes to Self

When I first learned photography, I carried a little Post-it around with the camera that said:

Remember to ask yourself:
What is your subject here?
How can I emphasize it?
How can I simplify it?

After I'd been shooting for a while, I carried a different note that said:

Remember to take off the lens cap.
Wait until something interesting happens, then shoot.

See also Bright, Cox

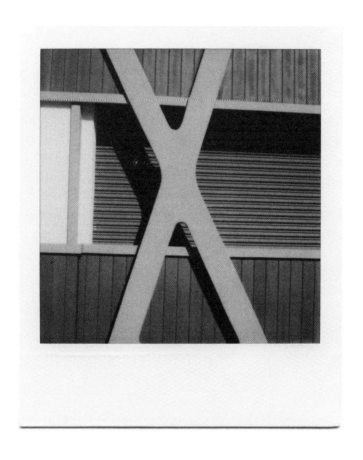

Antonio M. Xoubanova

Manual to Make a Good Photographic Project (Part Two)

Look at as many photobooks as you can for the next four weeks.
Go to as many exhibitions as you can.
Take a few days to intoxicate yourself.
Don't think about what interests you most.
Don't try to think back over that again.
Go out to take photos.
The more, the better.

Edit your photos.
Look at them.
Think about them.
Download them/develop them.
Empty the card/buy more film.
Go out again to take more photos.
Look for luck with insistence.
Be guided by chaos without resistance.
Work more.

See also Plademunt **381**

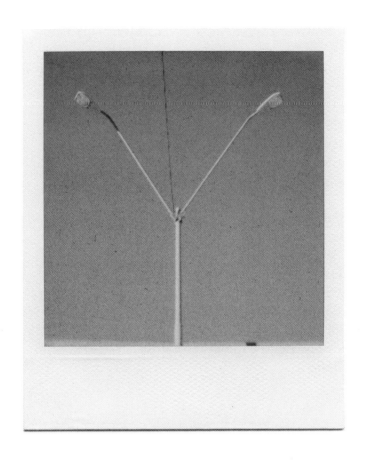

Roby Yeoman
Keywords

Make a photograph, or a series of photographs, that fits into at least twelve of the categories listed in the Subject Guide of this book.

See also Schmelling, Steacy **383**

Steve Young
U–Turn Rule

Whenever you are driving, and pass something that makes
you want to grab your camera, you must immediately pull a
U-ey, go back, and shoot it. If you don't, you'll spend the next
ten miles thinking about it, and then you'll have to add twenty
miles to your trip.

See also Porter, Slack

Contributor Bios

Dan Abbe, a photography writer, was born in San Francisco in 1984 and moved to Tokyo in 2009.

Kim Abeles's installations and community projects cross disciplines and media to explore biography, geography, and environment. Abeles received a John Simon Guggenheim Memorial Foundation Fellowship in 2013. Her work is in several collections, including the Museum of Modern Art Library Collection, New York; Los Angeles County Museum of Art; and the National Geospatial-Intelligence Agency, Richmond, Virginia, among others. Abeles's journals, artist's books, and process documents are archived at the Center for Art + Environment, Nevada Museum of Art.

Shelby Lee Adams was born in Hazard, Kentucky, in 1950. He received a John Simon Guggenheim Memorial Fellowship in 2010 and is the author of four monographs: *Appalachian Portraits*, *Appalachian Legacy*, *Appalachian Lives*, and *Salt and Truth*. His photographs are in numerous collections, including the Musée de l'Elysée, Lausanne, Switzerland; National Gallery of Canada, Ottawa; the Whitney Museum of American Art, New York; and Amon Carter Museum of American Art, Fort Worth, Texas. He divides his time between the Berkshire Mountains and eastern Kentucky.

Christopher Anderson has been a member of Magnum Photos since 2005. He has served as a contract photographer for *Newsweek* and *National Geographic* and is presently the first photographer-in-residence at *New York* magazine. He first gained recognition for his pictures when the handmade, wooden boat, named the *Believe In God*, he had boarded with Haitian refugees trying to sail to America, sank in the Caribbean. In 2000, the images from that journey received the Robert Capa Gold Medal. He is the author of four monographs, including *Capitolio* and *SON*.

Amy Arbus has published five books, including *On the Street 1980-1990, The Inconvenience of Being Born*, and *The Fourth Wall*. Her photographs have appeared numerous periodicals, including *New York* magazine, the *New Yorker*, and the *New York Times Magazine*. She teaches portraiture at the International Center of Photography, NORDphotography, Anderson Ranch, and the Fine Arts Work Center. Her work is in the collections of the National Theater in Norway, New York Public Library, and Museum of Modern Art in New York.

Bill Armstrong is a New York-based fine art photographer who has been shooting in color for over thirty years. He is represented by HackelBury Fine Art, London, and ClampArt, New York, and his work is in many museum collections, including the Vatican Museum; Victoria and Albert Museum; Philadelphia Museum of Art; Brooklyn Museum; Museum of Fine Arts, Houston; and Bibliothèque Nationale de France. He is on the faculty at the International Center of Photography and the School of Visual Arts.

Michael Ashkin was born in New Jersey and studied Middle Eastern languages before becoming an artist. His work has been shown at the Whitney Biennial, MoMA's Greater New York, Documenta 11, and Vienna Secession. His work in photography, sculpture, installation, video, text, performance, and painting generally deals with issues of landscape and the built environment. His photography publications include *Garden State* and *Untitled (Experience of Place)*. He teaches at Cornell University.

Jane Evelyn Atwood was born in New York, but has lived in France since 1971. She works primarily in the tradition of documentary photography, following individuals or groups of people on the fringes of society for long periods of time. She is the author of ten books on prostitution, the Foreign Legion, the blind, women in prison, landmine victims, and Haiti. Atwood has won many prestigious international prizes, including the W. Eugene Smith Award, Alfred Eisenstaedt Award, Paris Match Photojournalism Award, and Leica's Oskar Barnack Award. Her first retrospective was produced by the Maison Européenne de la Photographie, Paris, in 2011, and traveled to the Botanique, Brussels, in 2014.

Theo Baart lives near Amsterdam Schiphol Airport and has produced two books, *Bouwlust* and *Eiland 7*, on the impact of globalization on a rural community. He also made the book *Snelweg Highways in the Netherlands* with Cary Markerink.

Gerry Badger has been a photography critic for nearly thirty years. He is a photographer, as well as an architect and curator. He has written for dozens of periodicals and his previous books include *The Photobook: A History, Volumes I and II*, coauthored with Martin Parr, and *The Pleasures of Good Photographs* (Aperture, 2010). Badger lives in London.

John Baldessari's artwork is internationally recognized and has been featured in more than two hundred solo exhibitions and over one thousand group exhibitions in the U.S. and Europe. His work includes books, videos, films, billboards, and public works. He has taught at the California Institute of the Arts, Valencia, and the University of California, Los Angeles. He currently lives in Santa Monica, and works in Venice, California.

Roger Ballen was born in New York City in 1950 and has lived and worked in Johannesburg for almost thirty years. During this period, he has produced many bodies of work, including *Dorps: Small Towns of South Africa, Shadow Chamber, Boarding House,* and most recently, *Asylum of the Birds.* Ballen's work has been shown in important institutions throughout the world and is represented in many museum collections, including Centre Georges Pompidou, Paris; Victoria and Albert Museum, London; and the Museum of Modern Art, New York, among others.

Tim Barber grew up in Amherst, Massachusetts; lived for a few years in the mountains of northern Vermont; studied photography in Vancouver; and now lives in New York City. A photographer, curator, and designer, Barber runs the website time-and-space.tv (formerly known as tinyvices.com).

Richard Barnes is a New York-based photographer, whose work has been shown in solo exhibitions at such institutions as the Museum of Photographic Arts in San Diego and the Carnegie Museum of Art in Pittsburgh, among others. His works can be found in numerous public and private collections. Barnes has served as an adjunct professor/visiting artist at the San Francisco Art Institute and has taught at the California College of the Arts in San Francisco. A monograph of his work entitled *Animal Logic* was published 2009.

Tina Barney was born in 1945 in New York. Since 1975, she has been producing large-scale photographs, which chronicle the complexity of interpersonal relationships. These lush color prints have been exhibited and collected internationally by major institutions, including a 1991 mid-career exhibition at the Museum of Modern Art, New York, and a European touring exhibition. Barney was the recipient of a John Simon Guggenheim Memorial Foundation Fellowship in 1991, and the 2010 Lucie Award for Achievement in Portraiture. She has published four monographs of her work. Barney lives in New York and Rhode Island.

Thomas Barrow studied at the Kansas City Art Institute and the Institute of Design at IIT with Aaron Siskind. After graduation, Barrow began his career at the George Eastman House International Museum of Photography and Film in Rochester, New York, becoming assistant director and editor of publications before moving to New Mexico in 1973. At the University of New Mexico he was associate director of the Art Museum. His work has been exhibited widely and is in the collections of the George Eastman House International Museum of Photography and Film; Los Angeles County Museum of Art; National Gallery of Art, Washington, D.C.; the Center for Creative Photography, Tucson, Arizona—where his archive is housed—and numerous others.

Douglas Beasley explores the spiritual aspects of people and places, and how this is expressed in everyday life. Much of his personal work, including *Sacred Sites of the Lakota, Disappearing Green Space, Sacred Places,* and *Earth Meets Spirit,* are supported by grants and commissions, and have been widely exhibited and collected. He is the founder and director of Vision Quest Photo Workshops, and teaches at art and cultural centers across the United States and in Ireland, Peru, Italy, Guatemala, Norway, Japan, and China.

Ute Behrend teaches at various schools and universities in Germany. She currently has four publications available: *The Last Year of Childhood, Zimmerpflanzen, Märchen/Fairy Tales,* and *Girls, Some Boys and Other Cookies.* She lives and works in Cologne, Germany.

Adam Bell is a photographer and writer. He is the coeditor and coauthor of *The Education of a Photographer.* His reviews and essays have been published in *Afterimage, Ahorn Magazine, Foam, photo-eye, Lay Flat, Paper Journal,* and the *Brooklyn Rail.* He is currently on staff and faculty at the School of Visual Arts' MFA Photography, Video and Related Media Department in New York City.

Roberley Bell is a professor in the School of Photographic Arts and Sciences at Rochester Institute of Technology. Bell is a former Fulbright Scholar to Turkey. She is the recipient of several fellowships including a Pollock-Krasner Grant, a New York Foundation for the Arts Fellowship, and a Turkish Cultural Foundation fellowship. Her work has been exhibited internationally, including the exhibition *Shape of the Afternoon* at the deCordova Sculpture Park and Museum.

James Benning is an independent filmmaker from Milwaukee. Over the course of his forty-year career, Benning has made over twenty-five feature-length films that have shown in many different venues across the world.

Dawoud Bey is a photographer and artist whose work for the past thirty-five years has been concerned with making portraits of everyday and socially marginalized subjects. He received his MFA

from Yale University School of Art, and is professor of art and Distinguished College Artist at Columbia College Chicago, where he taught for the past sixteen years.

Lucas Blalock is a photographer living in Brooklyn. He holds degrees from Bard College and the University of California, Los Angeles, as well as having attended the Skowhegan School of Painting and Sculpture. In 2013, he released his third artist's book, entitled *Windows Mirrors Tabletops*, which is available from Morel Books.

Melanie Bonajo's work has been exhibited and performed in international art institutions, such as de Appel arts centre, Amsterdam; Centre for Contemporary Art, Warsaw; Stedelijk Museum, Amsterdam; Moscow Biennale; and National Museum of Modern and Contemporary Art, Seoul. Her films have played in festivals such as International Documentary Film Festival Amsterdam and Berlinale. In 2012, she initiated the collective Genital International, which tackles subjects around feminism. She has written for several art magazines, been creative editor of *Capricious* magazine, and published several books, including *Modern Life of the Soul, I Have a Room With Everything, Spheres*, and *Furniture Bondage*.

Chris Boot became executive director of Aperture Foundation in 2010. Previously he was director of London's Photo Co-op (since renamed Photofusion), an independent photography education center; director of Magnum Photos, first in London, and then in New York; and editorial director at Phaidon Press. His company Chris Boot Ltd., launched in 2001, published the award-winning photobooks *Lodz Ghetto Album*, 2004, and *Things as They Are: Photojournalism in Context Since 1955*, 2005. He is the author and editor of *Magnum Stories*, 2004.

Yannick Bouillis is the founder and director of Offprint Projects, a traveling art publishing fair for emerging practices in art. He is currently working on an essay about the future of art mediations (museums, books, magazines). His core interests are in photography/image-making and contemporary political issues.

Frish Brandt is partner and executive director of Fraenkel Gallery. Opened in 1979, the gallery has witnessed the evolution of photography from non-art to high art and represents work from the nineteenth, twentieth, and twenty-first centuries. Over the years, the gallery increasingly played with the ever-blurring lines of what photography is by incorporating artists in other mediums and mounting exhibitions along the lines of *The Unphotographable* and *Not Exactly Photographs*. In

addition to her work at the gallery, she serves on the board of San Francisco Art and Film for Teens, is a long-time fan of the Exploratorium, and is active at the San Francisco Museum of Modern Art, serving on the Director's Circle committee.

Deborah Bright is a Brooklyn-based photographer, writer, and educator. Prior to becoming Chair of Fine Art at Pratt Institute, she held a joint appointment as professor of photography and history of art/visual culture at the Rhode Island School of Design. Her work has been exhibited internationally, including at the Victoria and Albert Museum; the Museet for Fotokunst, Copenhagen; Nederlands Foto Instituut, Rotterdam; and the Canadian Museum of Contemporary Photography, Ottawa. Her photographs are included in numerous collections, including the Whitney Museum of American Art; Smithsonian Museum of American Art; Fogg Museum, Harvard University; and the California Museum of Photography, among others. She has received several awards for her photography and critical writing, and edited *The Passionate Camera: Photography and Bodies of Desire*.

Adam Broomberg and **Oliver Chanarin** are artists living and working in London. Together they have exhibited at numerous international venues, including the Museum of Modern Art, Tate Galleries, the Gwangju Biennale, the Stedelijk Museum, the International Center of Photography, the Photographers' Gallery, and Mathaf: Arab Museum of Modern Art. Broomberg and Chanarin are visiting fellows at the University of the Arts London. Their work is represented in major public and private collections, including Tate Modern; the Museum of Modern Art; Stedelijk Museum; Victoria and Albert Museum; Musée de l'Élysée; and the International Center of Photography. They were awarded the Deutsche Börse Photography Prize 2013 for their work *War Primer 2*.

Jeff Brouws is a photographer and graphic designer residing in upstate New York. His current passions involve documenting older elements of the railroad environment and mastering the challenging Thelonious Monk songbook on guitar. Brouws has four monographs in print, including *Approaching Nowhere*. His work is in numerous public and private collections throughout the United States and Europe. He, along with Wendy Burton and Hermann Zschiegner, co-conceptualized and coedited *Various Small Books*, published by MIT Press in 2013, a catalog of homages to Ed Ruscha's seminal photobooks from the 1960s.

Able Brown makes photographs, writes, and is a park ranger in the Bay Area. He is at his most crusty and peaceful when in the sea. He has published photos in tinyvices.com, J&L Books, *Canteen*,

Korduroy.tv, and *Zoetrope: All-Story*, curated by Bonnie Prince Billy. He has published writing in *Arthur* magazine and the *Surfer's Journal*. He hopes you will honk at anyone driving a Volvo 240 and also think before you consume.

Michael Christopher Brown is based in Brooklyn, and is a Magnum nominee. In 2011, he documented the Libyan Revolution using a phone camera, exploring ethical distance and the iconography of warfare. He was the subject of the 2012 HBO documentary *Witness: Libya*. Photographs from his work in Libya have been shown at the Massachusetts Institute of Technology; Instituto Cervantes, New York; Museum of Fine Arts, Houston; Annenberg Space for Photography; and Brooklyn Museum. These images also appear in his book, *Libyan Sugar*.

Peter C. Bunnell is the McAlpin Professor of the History of Photography and Modern Art Emeritus at Princeton University and faculty curator of photography emeritus at the Princeton University Art Museum, where he was also responsible for the Minor White Archive. A graduate of the Rochester Institute of Technology, he holds graduate degrees from Ohio University and Yale University. Prior to coming to Princeton in 1972, Bunnell was curator of photography at the Museum of Modern Art in New York. Bunnell has taught at New York University, Dartmouth College, and Yale University, and has lectured extensively in the United States and abroad. He is an Honorary Fellow of the Royal Photographic Society of Great Britain.

Owen Butler. Seventy-five years old. Sixty-three years a photographer. Forty-five years as a teacher. He is currently photographing and writing poetry. Everything else is too much to remember!

Nolan Calisch is a socially engaged artist, photographer, and farmer. He holds a BA in cinema from Denison University and a MFA in art and social practice from Portland State University. He is part of several ongoing artistic collaborations, including *Farm School* and *Public Doors and Windows*. He lives on an organic farm near Portland, Oregon, where he grows food for thirty families through a Community Supported Agriculture program.

Reid Callanan is founder and director of the Santa Fe Photographic Workshops. In addition to educational programs in Santa Fe, New Mexico and Havana, the Workshops partners with National Geographic to offer workshops around the world. In 1994, Reid founded the non-profit Santa Fe Center for Photography, now known as Center, and is currently president of its board of directors. Reid started photographing in 1974 has been making images ever since, using a variety of photographic processes including silver halide, Polaroid imagery, and digital capture.

David Campany is one of the best-known and most accessible writers on photography. His books include *Walker Evans: The Magazine Work*, *Jeff Wall: Picture for Women*, *Photography and Cinema*, and *Art and Photography*. His essays have appeared in numerous books and he contributes regularly to *Aperture*, *Frieze*, *Photoworks*, and *Oxford Art Journal*. Campany lives and works in London, where he is a Reader in Photography at the University of Westminster.

Asger Carlsen lives and works in New York. Carlsen has received critical praise around the world for his series Hester and the accompanying book. Recently, Carlsen has exhibited in Tokyo, Vienna, Los Angeles, New York, Sydney, and Istanbul. He has recently started a collaborative project with Roger Ballen, which was featured in the *Vice* Photo Issue 2013. His distinctive style of portraiture has recently been featured in the *Journal*, *Garage Magazine*, and *Wired* magazine. He is currently collaborating with Anders Trentemøller on the artworks for Trentemøller's latest series of records.

J Carrier spent most of the past decade living and working in Africa and the Middle East. He currently lives in Brooklyn. He has an MFA in photography from the Hartford Art School. His work was selected for inclusion in the 2013 ICP Triennial and has been nominated for the John Gutmann Photography Fellowship and the Santa Fe Prize for Photography. His commissioned work has been featured in a variety of publications and media outlets, including the *New York Times Magazine*, *Time*, *Newsweek*, *Men's Journal*, *National Geographic*, and CNN. He is the author of two books, *Elementary Calculus* and *mi'raj*.

Eric William Carroll was born and raised in the Midwest. He has bounced between New York and San Francisco and currently teaches at Macalester College in St. Paul. His work has been exhibited widely, including at the New Orleans Museum of Art, Camera Club of New York, Museum of Contemporary Photography in Chicago, and Pier 24 Photography. Carroll has participated in residencies with the MacDowell Colony, Rayko Photo Center, and the Blacklock Nature Sanctuary. He is also the winner of the 2012 Baum Award for An Emerging American Photographer.

Keith Carter holds the Walles Chair of Art at Lamar University in Beaumont, Texas. He is the recipient of the Texas Medal of Arts, the Dorothea Lange-Paul Taylor Prize, and the Regents' Professor Award from the Texas State University System. His work has been shown in over one hundred solo exhibitions in thirteen countries. He is the

author of eleven books, including *Fireflies, A Certain Alchemy, Ezekiel's Horse, Holding Venus, Keith Carter Photographs: Twenty-Five Years, Heaven of Animals,* and *From Uncertain to Blue.* Carter's work is included in numerous private and public collections, including the National Portrait Gallery, Washington, D.C.; the Art Institute of Chicago; the San Francisco Museum of Modern Art; J. Paul Getty Museum, Los Angeles; Museum of Fine Arts, Houston; George Eastman House International Museum of Photography and Film, Rochester, New York; Smithsonian American Art Museum, Washington, D.C.; and the Wittliff Collections at Texas State University.

Henri Cartier-Bresson (1908–2004) was one of the most influential, well-known, and beloved figures in the history of photography. His inventive work in the early 1930s helped define modern photography and photojournalism, particularly through the idea of "the decisive moment." He was also one of the founders of the Magnum photo agency. Cartier-Bresson covered many of the biggest events of the twentieth century, including World War II, China during the revolution, the Soviet Union after Stalin's death, and the United States in the postwar boom.

Elinor Carucci was born in Jerusalem. She graduated from Bezalel Academy of Arts, and has lived in NYC since 1995. She has had solo shows at Edwynn Houk Gallery, Herzliya Museum of Contemporary Art, and Gagosian Gallery, London, and group shows at the Museum of Modern Art, New York and the Photographers' Gallery, London. Her work is in the collections of the Museum of Modern Art, New York; Brooklyn Museum; and Museum of Fine Arts, Houston. Her work has appeared in the *New York Times Magazine,* the *New Yorker, New York* magazine, *W* magazine, *Aperture, ARTnews,* and many others. She was awarded the ICP Infinity Award, Guggenheim Fellowship, and New York Foundation for the Arts Fellowship. Carucci has published three monographs: *Closer, Diary of a Dancer,* and *Mother.* She currently teaches at the graduate program of photography at the School of Visual Arts.

Ricardo Cases was born in Orihuela, Alicante, Spain. He holds a BA in Sciences of Information from the Universidad del País Vasco, Bilbao, Spain. In 2006, he joined the Blank Paper Photography Collective. He has published three books: *Belleza de Barrio, La Caza del Lobo Congelado,* and *Paloma al Aire.*

Melissa Catanese lives in Pittsburgh and is the cofounder of Spaces Corners, an artist-run photobook shop and project space. Her artist's book *Dive Dark Dream Slow* was short-listed for the Paris Photo-Aperture Foundation PhotoBook Awards

for First PhotoBook in 2012. Catanese's books can be found in library collections throughout the U.S. and abroad, including the Museum of Modern Art Library and Tokyo Metropolitan Museum of Photography Library.

Bruno Ceschel is a writer, curator, and lecturer at the University of the Arts London. He is the founder of Self Publish, Be Happy, an organization that supports and promotes the work of emerging photographers. SPBH has organized events at a number of institutions around the world, including the Photographers' Gallery, the Institute of Contemporary Art, the Serpentine Galleries, C/O Berlin, Aperture Foundation, and Kunsthal Charlottenborg, among others, and has most recently published books by Adam Broomberg and Oliver Chanarin, Cristina De Middel, Brad Feuerhelm, and Lorenzo Vitturi. Ceschel writes regularly for a number of publications such as *Foam,* the *British Journal of Photography,* and *Aperture* magazine, and has guest-edited issues of *Photography and Culture, Ojo de Pez,* and *The PhotoBook Review.*

Lewis Chaplin is a London-based photographer and publisher. Since 2009, Chaplin has co-run *fourteen-nineteen,* a project dedicated to publishing, supporting, and discussing young photography. He is currently studying anthropology at Goldsmiths, University of London.

John Chiara is a photographer and educator based in San Francisco. His photography has been widely exhibited in group and solo exhibitions nationally and abroad, and collected by institutions such as J. Paul Getty Museum, Los Angeles; Haggerty Museum of Art, Milwaukee; the Museum of Photographic Arts, San Diego; National Gallery of Art, Washington, D.C.; the Pilara Foundation, Pier 24 Photography, San Francisco; and the San Jose Museum of Art, California. Chiara was an artist-in-residence at Crown Point Press in 2006 and the Marin Headlands Center for the Arts in 2010.

Jörg M. Colberg is a writer, photographer, and educator based in Northampton, Massachusetts. Since its inception in 2002, his website *Conscientious* has become one of the most widely read and influential blogs dedicated to contemporary fine-art photography. Articles by Colberg have been published in photography and design magazines, and in photographers' monographs. He is a professor of photography at Hartford Art School.

Lois Conner is known for her large-scale panoramic photographs relating to a global landscape. Her pictures are characterized by their narrative sweep, a sense of place, and their implicit attention to history and culture. Many of her projects span decades, including her work in China, the

Navajo Reservation, and the American West. Her work was featured in the exhibition *Chinese Gardens: Pavilions, Studios, Retreats* at the Metropolitan Museum of Art. Recent exhibitions include *Beijing: Contemporary and Imperial*, Cleveland Museum of Art; *Searching for Van Gogh*, Dali, China; and *Drawing the Land*, Hangzhou, China.

Linda Connor has spent more than twenty-five years exploring and investigating exotic and spiritual places. Connor's publications include *Odyssey* and *Spiral Journey*. She is the recipient of many awards, including two National Endowment for the Arts grants and a Guggenheim Fellowship. Her work is part of numerous collections, including at the Art Institute of Chicago; Museum of Modern Art, New York; the San Francisco Museum of Modern Art; and the Victoria and Albert Museum in London.

Matthew Connors is an associate professor in the photography department at the Massachusetts College of Art and Design in Boston. He received an MFA from Yale University and a BA in english literature from the University of Chicago. His work has been included in some shows and he has received a few awards. He lives and works in Brooklyn.

Frank Cost is the James E. McGhee Professor of Visual Media in the School of Photographic Arts and Sciences at Rochester Institute of Technology. He has taught a wide variety of courses in the field of visual media for more than three decades. Frank has been photographing professionally since 1975 and has authored both textbooks and experimental photobooks exploring new forms of graphic expression enabled by digital technology.

Charlotte Cotton is a curator and writer. She has held positions including the head of the Wallis Annenberg Department of Photography at the Los Angeles County Museum of Art, and curator of photographs at the Victoria and Albert Museum. She is the author of *The Photograph as Contemporary Art* and founder of *Words Without Pictures*—which Aperture published as a book in 2010—and Eitherand.org. She has recently been a visiting scholar at Parsons The New School for Design, New York, and California College of the Arts, San Francisco.

Eileen Cowin's work has been in over thirty solo exhibitions and more than 165 group exhibitions and is included in major public and private collections, including the Brooklyn Museum; J.Paul Getty Museum, Los Angeles; and the Los Angeles County Museum of Art. Cowin has received numerous awards, among them three individual fellowships from the National Endowment for the Arts, a commission from the Public Art Fund in New York, and a CCF Fellowship for Visual Artists. In fall 2011, her work was exhibited at the Museum

of Contemporary Art, Los Angeles, and the J. Paul Getty Museum, Los Angeles. She is Professor Emeritus of California State University, Fullerton, where she was a professor in the Department of Visual Arts from 1975 to 2008.

Reuben Cox is a photographer and luthier living in Los Angeles. His work has been shown in numerous group and solo exhibitions. Cox's most recent book is *The Work of Joe Webb*.

Barbara Crane was born in Chicago. She attended Mills College, completing her BA at New York University. She received her MS in photography from the Institute of Design at Illinois Institute of Technology. Her work has been the subject of eight retrospective and over ninety solo exhibitions. A world-renowned art photographer and educator, Crane is Professor Emerita at the School of the Art Institute of Chicago. An early investigator of repetition and deconstruction of visual information, Crane has explored photography as a vehicle for creative expression for over sixty years, creating a body of conceptually consistent experimental work. Crane's publications include three major monographs. She has received National Endowment for the Arts Grants, a John Simon Guggenheim Memorial Foundation Fellowship, and an Illinois Arts Council Fellowship.

Yolanda Cuomo is an art director, designer, and educator, who has collaborated with both visual and performing artists for over two decades. Her studio designed and produced the worldwide exhibition and book *Diane Arbus Revelations*. Other notable book projects are *Pre-Pop Warhol*, *New York September 11 by Magnum Photographers*, and *Farewell to Bosnia: Gilles Peress*. In 2004, she was recognized for her art direction of *Aperture* magazine, which received the prestigious National Magazine Award from the American Society of Magazine Editors. She currently teaches at the School of Visual Arts, New York.

Sara Cwynar is a New York-based artist working in photography, installation, and bookmaking. Her work involves a constant archiving and re-presentation of collected visual materials. She was recently awarded Printed Matter's Emerging Artists Publication Series grant for her forthcoming book *Pictures of Pictures*. Solo exhibitions include Cooper Cole Gallery, Toronto; the Foam Photography Museum, Amsterdam; and Foxy Production, New York. She is a former staff graphic designer at the *New York Times Magazine*.

John Cyr is a Brooklyn-based photographer, printer, and educator. He earned his MFA from the School of Visual Arts and teaches at the International Center of Photography in New York

City. Cyr's photography is represented in many notable public and private collections, including George Eastman House International Museum of Photography and Film, Rochester, New York; the Photographic History Collection at the Smithsonians National Museum of American History, Washington, D.C.; and the New York Public Library.

Tim Davis is an artist and writer currently at work on a long-form music and video project called *It's OK to Hate Yourself.* His work is in the collections of the Metropolitan Museum of Art, Whitney Museum of American Art, Guggenheim Museum, and the Walker Art Center, among many others. He teaches photography at Bard College.

Denis Defibaugh is a tenured professor of photography at Rochester Institute of Technology. Beyond teaching at RIT, and lecturing internationally, he has presented workshops for Yellowstone National Park, Zion National Park, Florida A&M University, Spéos Paris Photographic Institute, and RIT's T&E Photography Workshops, and personally coordinated workshops in Cuba; Brazil; Oaxaca, Mexico; Surabaya, Indonesia; and Seoul, Korea. His work *Family Ties Do Not Die: The Day of the Dead in Oaxaca, Mexico* has been exhibited in Texas, San Francisco, Miami, Rochester, Buffalo, and Montana. His first book is *The Day of the Dead.*

Sam de Groot graduated from the Gerrit Rietveld Academie's graphic design department in 2008. Since then, he has worked as a freelance designer for cultural clients, published books under the TRUE TRUE TRUE imprint, and created music and lecture performances, often in collaboration with artist Paul Haworth. Since 2011, he has taught typography at the Gerrit Rietveld Academie.

Janet Delaney received her MFA from the San Francisco Art Institute. Her photographic work explores the line between documentary and fine art. Delaney has received numerous awards, most notably three National Endowment for the Arts Grants. Her work is in collections such as the San Francisco Museum of Modern Art and the Pilara Foundation. She has shown her photographs nationally and internationally in solo and group exhibitions. In 2013, she published *South of Market.* For the past fifteen years, she has held the position of lecturer in visual studies at the University of California, Berkeley.

Cristina De Middel is a photographer based in London who has been working for newspapers in Spain and with NGOs, such as Doctors Without Borders and the Spanish Red Cross, for more than eight years. She combines her strictly documentary assignments with more personal projects that challenge viewers to question the language and

veracity of photography as a document, blurring the border between reality and fiction. Her work has been exhibited widely and received several awards, including the Deutsche Börse Prize and the Infinity Award from the International Center of Photography, New York.

Lorenzo De Rita was born in Rome. He is currently the director of The Soon Institute, a collective of inventors experimenting with new forms of communication. Among his inventions are: the longest water pipe in the world; the first travel agency for mind travelers; a clothing line of items you can buy only by paying with your blood; a navigational system for the kitchen; and the most powerful gaming console ever created (it's called Brain). Aside from prototyping the next society, Lorenzo publishes difficult books, has a school for (very) young inventors called The Sooners, cultivates digital flowers, and thinks phosphorescently.

KayLynn Deveney is a full-time lecturer in photography at the University of Ulster in Belfast, Northern Ireland. She has earned both a master's degree in documentary photography and a practice-based PhD in photography from the University of Wales, Newport, and she is a past recipient of an artist grant from the Anonymous Was A Woman Foundation. Deveney's work has been exhibited in group and solo shows internationally and is held in permanent collections, including the Museum of Contemporary Photography, Chicago; Light Work, Syracuse, New York; and the Portland Art Museum, Oregon. Deveney is coauthor of the book *The Day-to-Day Life of Albert Hastings.*

Philip-Lorca diCorcia is one of the most influential photographers working today. He is known for creating images that are poised between documentary and theatrically staged photography. In 2013, a major survey of his work was organized by the Schirn Kunsthalle Frankfurt, which traveled to Museum De Pont, Tilburg, the Netherlands, and the Hepworth Wakefield, England. His work is held in public collections internationally, including the Centre Georges Pompidou, Paris; Museo Nacional Centro de Arte Reina Sofia, Madrid; the Museum of Modern Art, New York; and Tate Gallery, London, among others. DiCorcia lives and works in New York.

Elspeth Diederix was born in Nairobi, Kenya, in 1971. She studied at the Gerrit Rietveld Academie in Amsterdam from 1990 to 1995 and later at the Rijksakademie van Beeldende Kunsten from 1998 to 2000. She lives and works in Amsterdam.

Dru Donovan received a BFA in photography from California College of the Arts and an MFA in photography from Yale University, where she was awarded the Richard Benson Prize for excellence.

Donovan was included in the 2010 California Biennial at the Orange County Museum of Art and *reGeneration2: Tomorrow's Photographers Today*, at the Musée de l'Elysée in Lausanne, Switzerland. Her work has been published in *Blind Spot*, *Wallpaper*, and the *New York Times Magazine*. TBW Books published her first book, *Lifting Water*. She has taught at a variety of institutions, including Yale University, Parsons The New School For Design, California College of the Arts, School of Visual Arts, and Lewis and Clark College.

Jim Dow studied graphic design and photography at the Rhode Island School of Design during the 1960s. He has been the recipient of numerous commissions, fellowships, and grants that have allowed him to travel and photograph throughout the United States, England, Argentina, Uruguay, and Mexico City. He has also exhibited and published extensively. His subjects include folk art, roadside architecture, signs, county courthouses, baseball parks, soccer stadiums, private clubs, barbeque joints, and taco trucks. He lives in Boston and teaches photography history and contemporary art at Tufts University and the School of the Museum of Fine Arts.

Doug DuBois' photographs are in the collection of the Museum of Modern Art in New York, San Francisco Museum of Modern Art, J. Paul Getty Museum, and Los Angeles County Museum of Art. He has received fellowships from the John Simon Guggenheim Foundation, the MacDowell Colony, and the National Endowment for the Arts. DuBois has exhibited at the J. Paul Getty Museum, Los Angeles, and the Museum of Modern Art, New York. He has published a monograph, *All the Days and Nights*, and photographed for magazines, including the *New York Times Magazine*, *Time*, *Details*, and *GQ*. DuBois teaches in the College of Visual and Performing Arts at Syracuse University.

Schuyler Duffy, a native New Yorker, holds a BA in art and French from the University of California, Los Angeles. He works in the education and public programs department at Aperture Foundation.

Shannon Ebner is an artist who lives and works in Los Angeles. She is an associate professor of the practice of fine arts at the University of Southern California's Roski School of Fine Arts. For the 2014 spring semester, she will be the Teiger Mentor in the Arts at Cornell University.

Amy Elkins was born in Venice Beach, California, and received her BFA in Photography from the School of Visual Arts in New York City. Her work has been exhibited nationally and internationally, including at the Kunsthalle Wien in Vienna; Carnegie Art Museum in California; North Carolina Museum of Art; and the Minneapolis Institute of Arts.

Lisa Elmaleh is a Brooklyn-based photographer and educator at the School of Visual Arts and the Center for Alternative Photography. Using a portable darkroom in the back of her truck, Elmaleh photographs by the nineteenth-century wet collodion process. She has been awarded the Ruth and Harold Chenven Foundation Grant, the Aaron Siskind Foundation IPF Grant, and the Everglades National Park artist residency. Her work has been exhibited nationally and internationally and has appeared in *Harper's* magazine, *PDN*, and *Rangefinder*, among others.

Charlie Engman is an artist living and working between New York and Paris. He graduated from the University of Oxford with a BA in Japanese and Korean studies in 2009. His commercial and editorial clients include *Vogue*, the *New York Times*, *Time*, Hermès, and Louis Vuitton. His work has been exhibited internationally in venues such as the Manchester Art Gallery; Foam Gallery, Amsterdam; and the Lisson Gallery, London.

Barbara Ess is an artist who lives and works in New York City and Elizaville, New York. She is an associate professor of photography at Bard College and on the faculty of the Milton Avery Graduate School of the Arts, also at Bard.

James Estrin is a senior staff photographer for the *New York Times*. He is also a founder of *Lens*, the photography blog of the *New York Times*, and has been its coeditor since it went online in May 2009. Estrin has worked for the *New York Times* since 1987 and was part of a Pulitzer Prize-winning team in 2001. In addition to photographing, editing, and writing, he produces audio and video for nytimes.com. Estrin is an adjunct professor at the City University of New York Graduate School of Journalism. He attended Hampshire College and the graduate program at the International Center of Photography.

Wendy Ewald, conceptual artist, has collaborated with communities around the world for more than thirty years. She has received many honors, including a MacArthur fellowship in 1992. Her work has been exhibited extensively in museums and galleries, and was included in the 1997 Whitney Biennial. She is a senior research associate at the Center for International Studies at Duke University, Artist in residence at Amherst College, and director of Literacy Through Photography International. *Secret Games*, a retrospective of her work, was published in 2000, and her most recent book is *Literacy & Justice Through Photography*.

Kota Ezawa is a San Francisco-based artist who often reworks images from popular culture, film,

and art history, stripping them down to their core elements. While working in a range of mediums, Ezawa maintains a keen awareness of how images shape our experience and memory of events. His work has been shown in solo exhibitions at Hayward Gallery Project Space, London; Artpace San Antonio; and Wadsworth Atheneum Museum of Art, Hartford, Connecticut. He participated in group exhibitions at the Museum of Modern Art, New York; Whitney Museum of American Art, New York; the Andy Warhol Museum, Pittsburgh; and Musée d'Art Moderne de la Ville de Paris.

Sam Falls received his BA from Reed College and MFA from ICP-Bard. His recent solo shows include Galerie Eva Presenhuber, Zurich; Balice Hertling, Paris; and T293, Rome, with upcoming solo exhibitions at Hannah Hoffman Gallery, Los Angeles, and Pomona College Museum of Art, Claremont, California. Falls lives and works in Los Angeles and Hudson, New York.

Andreas Feininger (1906–1999) was an American photographer and writer on photographic techniques. He took photographs with subjects concerning science and nature and is well known for his black-and-white scenes of Manhattan. He wrote comprehensive manuals for photography such as *The Complete Photographer*. Feininger's photographs are in the permanent collections of museums such as the Center for Creative Photography, Tucson, Arizona; the Museum of Modern Art, New York; and the Victoria and Albert Museum, London.

Ann Fessler is a photographer, filmmaker, installation artist, nonfiction author, and professor of photography at Rhode Island School of Design. Her recent documentary film, *A Girl Like Her*, has been subtitled in five languages. Her critically acclaimed book, *Girls Who Went Away*, received the Ballard Book Prize for advancing the dialogue about women's rights. Fessler has received grants and fellowships in the visual arts from the LEF Foundation; Radcliffe Institute for Advanced Study at Harvard; Rhode Island and Maryland State Arts Councils; Art Matters, New York; and the National Endowment for the Arts.

Larry Fink is an internationally known fine art and editorial photographer. He has won two Guggenheim Fellowships, two National Endowment of the Arts Grants, and has had shows at the Museum of Modern Art, the Whitney Museum of American Art, and countless other institutions. Fink, in his words, was born to photograph. He had no schooling, he's been to jail, and he's taught at Yale. He has been teaching for fifty years and is presently a professor at Bard College. His pictures are informed by music, painting, farm work, bodily functions, and critical love.

Brian Finke graduated from the School of Visual Arts in New York City with a BFA in photography. His work is in museum collections worldwide, he is the recipient of a New York Foundation for the Arts Fellowship, and the author of *2-4-6-8: American Cheerleaders and Football Players*, *Flight Attendants*, and *Construction*. His editorial clients include the *New York Times Magazine*, the *New Yorker*, *Rolling Stone*, and many more.

J. W. Fisher received a BA in English from the University of New Hampshire and a MFA from the Rhode Island School of Design. From 2006 to 2007, Fisher worked and studied at the Hochschule für Grafik und Buchkunst in Leipzig, Germany, on a Fulbright Fellowship. Fisher was a visiting assistant professor at the Rochester Institute of Technology, an area head of photography at the City College of New York, and is currently an assistant professor of Art at Lewis and Clark College.

Steve Fitch, after graduating from the University of California, Berkeley, with a degree in anthropology, worked for five years photographing along America's two-lane highways, publishing a book of the project, *Diesels and Dinosaurs*. Since then, his photographs have been published in several books, including *Marks in Place*, *Gone*, *Llano Estacado*, and *Motel Signs*. For the past thirty-five years, he has taught photography at the University of Colorado, the University of Texas, Princeton University, and the Santa Fe University of Art and Design. Fitch has received three National Endowment for the Arts fellowships, as well as the Eliot Porter Fellowship. He lives off the grid with his wife in a passive solar adobe house that they built themselves in rural New Mexico.

Linda Fleming's drawings and sculptures create places of shadow and light. She has exhibited widely throughout the United States and her works are in international collections in Moscow, Baghdad, Sydney, and Seoul. Fleming's work has been reviewed in numerous periodicals, including: *Art in America*, *Sculpture* magazine, and the *New York Times*. She is a founder of Libre, a community of artists in the Rocky Mountains of Colorado, where she maintains a studio. Fleming has received awards from the Pollock-Krasner Foundation, the Adolph and Esther Gottlieb Foundation, Art Matters, and the Athena Foundation. She received the California College of Art Distinguished Faculty Award.

Harrell Fletcher has produced a variety of socially engaged, participatory projects since the early 1990s for institutions all over the world. He received his MFA from California College of the Arts, studied organic farming at University of California, Santa Cruz, and went on to work on a variety of small farms, which impacted his work as

an artist. He was a participant in the 2004 Whitney Biennial and is the 2005 recipient of the Alpert Award in Visual Arts. In 2002, Fletcher created *Learning to Love You More* with Miranda July, a participatory website now in the collection of San Francisco Museum of Modern Art. Fletcher is an Associate Professor of Art and Social Practice at Portland State University.

Lucas Foglia grew up on a small family farm in New York and graduated from Brown University and the Yale School of Art. Foglia's photographs are exhibited and collected internationally. Foglia's second book, *Frontcountry*, focuses on people living in the midst of a mining boom in the modern American West.

Anna Fox is professor of photography at the University for the Creative Arts in Farnham, England. She has cowritten the postgraduate course in photography at the National Institute of Design, India, and is now photography consultant at Srishti School of Art, Design and Technology, Bangalore. Fox is an internationally acclaimed photographer exhibiting and publishing her work. Her work has been in numerous group shows, including *Warworks*, Canadian Museum of Contemporary Photography; *Centre of the Creative Universe: Liverpool and the Avant-Garde*, Tate Liverpool; *How We Are: Photographing Britain*, Tate Britain; and *Documentary Dilemmas*, a British Council touring exhibition. Fox coedits *Langford's Basic Photography* and *Behind the Image*. Her monographs include *Anna Fox: Photographs 1983–2007* and *Resort 1*.

Allen Frame lives in New York, where he teaches photography at the School of Visual Arts, Pratt Institute, and International Center of Photography. His work has been included in exhibitions at the Baltimore Museum of Art and the Fotomuseum in Winterthur, Switzerland, among others. His monograph, *Detour*, contains over a decade of work. He is an executive producer of Joshua Sanchez's feature film *Four*, released in 2013. He graduated from Harvard University in 1974.

LaToya Ruby Frazier uses the conventions of social documentary to probe and upend traditional narratives of urban growth and the triumph of industry. Exposing the underbelly of corporate practices—rapid deindustrialization and outsourcing, environmental negligence, and inner-city gentrification—Frazier's work examines the crises of postindustrial communities and class divisions wrought by capital. Her work is informed by late nineteenth and early twentieth-century modes of representation in documentary practice. With an emphasis on postmodern conditions, class, and capitalism, Frazier investigates issues of propaganda, politics, and the importance of subjectivity. Aperture

Foundation will publish her first book *The Notion of Family* in 2014.

Adam Frelin received his BFA from Indiana University of Pennsylvania, and his MFA from the University of California, San Diego. He has shown at venues such as the Los Angeles County Museum of Art, Getty Research Institute, Aldrich Contemporary Art Museum, and the Contemporary Art Museum St. Louis. He has received awards and grants from the National Endowment for the Arts, New York Foundation for the Arts, and College Art Association, among others. Frelin has published two books of photography and has received several commissions for artworks. Currently, he is an associate professor of art at State University of New York, Albany, and lives in Troy, New York.

Jason Fulford is a photographer and cofounder of the non-profit publisher J&L Books. He has lectured at more than a dozen art schools and universities and is a contributing editor to *Blind Spot* magazine. Fulford's photographs have been featured in *Harper's*, the *New York Times Magazine*, *Time*, *Blind Spot*, *Aperture*, and on book jackets for Don DeLillo, John Updike, Bertrand Russell, Jorge Luis Borges, Terry Eagleton, Ernest Hemingway, and Richard Ford. His published books include *Sunbird* (2000), *Crushed* (2003), *Raising Frogs for $$$* (2006), *The Mushroom Collector* (2010), and *Hotel Oracle* (2013).

Tierney Gearon is an acclaimed Los Angeles-based contemporary photographer. Discovered by Charles Saatchi, she was one of the main photographers in the famed *I Am a Camera* exhibition at the Saatchi Gallery in London. *The Mother Project* and *Daddy, Where Are You* both give the viewer an intimate look into Gearon's relationship with her mentally ill mother—not only capturing the raw intensity, but also celebrating her free spirit. She did a twenty-four-page feature of thirteen Oscar Award-winning women for the *New York Times Magazine* and recently published a book for children, entitled *The Alphabet Book*. Gearon is currently working on completing her COLORSHAPE body of work, which will culminate in a book and exhibition in 2015.

George Georgiou received a BA in photography, film, and video arts from the Polytechnic of Central London, University of Westminster. He joined Panos Pictures and photographed extensively while living and working in Serbia, Greece, and Istanbul from 1999 to 2009. Work from this period has resulted in the *British Journal of Photography* project prize, two World Press Photo prizes, and Pictures of the Year International first prize. His book *Fault Lines: Turkey/East/West* was released and exhibited internationally. His work was included in the prestigious *New Photography 2011* exhibition

at the Museum of Modern Art. Georgiou's work is in several collections, including the Museum of Modern Art, and the Elton John collection. He lives in Folkestone, England.

Melinda Gibson was born in the UK, and lives and works in London. She studied at the London College of Communication and is an hourly paid lecturer in photography at Nottingham Trent University. Gibson exhibits internationally. Selected shows include *The Constructed View: UK Photography Now*, Donggang Museum of Photography; the Houston Center for Photography; Centro del arte Contemporáneo de Cádiz; Quad Gallery; Perth Institute of Contemporary Arts; and Australian Centre for Photography. She has produced two publications, *The Photograph As Contemporary Art* and *Miss Titus Becomes A Regular Army Mac*.

Bruce Gilden is known for his confrontational and unique style of street photography. His powerful images have been dividing opinions since the beginning of his career in 1968. In 2013, Gilden was the recipient of a John Simon Guggenheim Memorial Foundation fellowship and that same year he published two books, *Foreclosures* and *A Complete Examination of Middlesex,* work made on the streets of London, commissioned by the Archive of Modern Conflict. Some of his previous publications include *Facing New York, Haiti, Go, Coney Island,* and *A Beautiful Catastrophe*. Gilden has worked on personal essays in England, Haiti, Ireland, India, Japan, Russia, Australia, and Colombia. Since 2009, he has started directing his lens on America and participated in the collective project Postcards from America.

Jim Goldberg is a professor of art at the California College of the Arts and a member of Magnum Photos. He has been exhibiting for over thirty years and is well-known for his innovative use of image and text. He has published several books, including *Raised By Wolves* and *Open See*, and his work is in numerous private and public collections, including the Museum of Modern Art, and Whitney and Museum of American Art, New York; San Francisco Museum of Modern Art; the J. Paul Getty Museum, Los Angeles; and the Art Institute of Chicago, among many others.

Daniel Gordon earned a BA from Bard College and an MFA from the Yale School of Art. His notable group exhibitions include *New Photography 2009* at the Museum of Modern Art in New York and *Greater New York* 2010 at MoMA PS1. He is the author of *Still Lifes, Portraits and Parts, Flowers and Shadows*, and *Flying Pictures*. In 2013, Gordon was a critic in photography at the Yale School of Art. He lives and works in Brooklyn.

John Gossage, since the age of fourteen, has devoted his life to photography and the music of Charles Edward Anderson Berry.

Nicholas Gottlund is an artist and book publisher based in Los Angeles. He is the founder of the Gottlund publishing house and has exhibited most recently at Signal, New York; Temple Gallery, Paris; and Foam Photography Museum, Amsterdam.

Katy Grannan is a photographer and filmmaker living and working in the Bay Area. Grannan received her BA from the University of Pennsylvania and her MFA from Yale School of Art. There are five monographs of her work: *Model American, The Westerns, Boulevard, The Nine,* and *The Ninety Nine.* She is currently working on a feature-length film, also entitled *The Nine*. She has been a visiting artist and lecturer at Yale, California College of the Arts, University of Southern California, and Cranbrook Academy of Art, among others. Grannan's photographs are included in important collections such as the Guggenheim Museum and Museum of Modern Art in New York; San Francisco Museum of Modern Art; and the Museum of Contemporary Art, Los Angeles.

Eliza Gregory is an artist and educator. Her work illuminates diverse experiences in a given community using images, relationships, experiences, interviews, events, and many other media. Trained as a fine art photographer, creative writer, and social-practice artist, Gregory lives and works in San Francisco.

Hans Gremmen is a graphic designer, working in the field of photography, architecture, and fine arts. He edited and curated the book and exhibition *Objects in Mirror: The Imagination of the American Landscape* and made a five-hour movie titled *The Mother Road* about Route 66. Gremmen gives lectures and workshops at various international universities and academies, among them are the Delft University of Technology, Bauhaus-University in Weimar, and University of Kassel. He recently received the Golden Medal for the Schönste Bücher aus aller Welt for the design of book *Cette Montagne, C'est Moi*.

Gregory Halpern received a BA in history and literature from Harvard University and an MFA from California College of the Arts. His third book of photographs, entitled *A*, is a photographic ramble through the streets of the American Rust Belt. His other books include *Omaha Sketchbook* and *Harvard Works Because We Do*. He currently teaches at the Rochester Institute of Technology.

Kyoko Hamada grew up in Japan, until her father's job relocated the family to West Virginia when she was fifteen years old. Her subject matter is often about ordinary people and objects, stylized and staged into subtle quiet self-referential moments and

various metaphors. Her work has been shown at the National Portrait Gallery in London, among others. She shoots commercially for a numbers of clients, including the *New Yorker*, *T* magazine, Uniqlo, and Vitra. Her series, *I Used to Be You*, is soon to be published as a book. She lives in New York.

Léonie Hampton released her first book, *In the Shadow of Things*, in 2011. The work explores her attempts to help her own mother, whose house and life had become overwhelmed by objects as a result of her OCD and hoarding disorder. The work combines photography, film, and sound to navigate the tide of emotions that erupted when this landscape of possessions was disturbed. *In the Shadow of Things* was nominated for Deutsche Börse Photography Prize 2011, won the Paul Huf Award 2009, and the F Award for concerned photography in 2008.

Charles Harbutt's pictures have been widely collected and have been exhibited at the Museum of Modern Art, New York; Los Angeles County Museum of Art; and the Bibliothéque Nationale, Paris, among others. His archives were acquired by the Center for Creative Photography, Tucson, Arizona. He has published three books: *Departures and Arrivals*, *Progreso*, and *Travelog*, which was the Arles prize book in 1974. For his first twenty years, Harbutt was a photojournalist working mostly through Magnum Photos. He has taught at Rhode Island School of Design, Massachusetts Institute of Technlogy, and Cooper Union, among others. In 1999, he was appointed associate professor at Parsons The New School for Design.

Sharon Harper received an MFA in photography and related media from the School of Visual Arts in New York. Her work explores technology and perception. It is in permanent collections at the Museum of Modern Art, New York; Whitney Museum of American Art, New York; Museum of Fine Arts, Houston; Harvard Art Museums; Portland Art Museum, Oregon; Nelson-Atkins Museum of Art, Kansas City, Missouri; and New York Public Library, among others. She is currently a professor of visual arts in the Department of Visual and Environmental Studies at Harvard University.

Melissa Harris is editor-in-chief of Aperture Foundation. She was editor-in-chief of *Aperture* magazine for over ten years, has edited over fifty books, and has curated photography exhibits at venues, including Aperture Gallery; Visa Pour l'Image, Perpignan, France; Philadelphia Museum of Art; Institute at Contemporary Art, Philadelphia; DiverseWorks, Houston; Villa Pignatelli, Naples; Peggy Guggenheim Collection, Venice; and Milano Triennale. A contributing editor of *Interview*, Harris teaches variously at Columbia University's Graduate School of Journalism, Yale University,

and New York University's Tisch Photography and Imaging department. She served on New York City's Community Board 5, and is currently on the board of LOOK3 and a trustee of the John Cage Trust.

Cig Harvey's photographs and artist's books have been exhibited widely and are in the permanent collections of major museums and collections, including the Museum of Fine Arts, Houston; the Farnsworth Art Museum, Rockland, Maine, and George Eastman House International Museum of Photography and Film, Rochester, New York. She was recently nominated for the John Gutmann Photography Fellowship Award and was a finalist at Prix Virginia, an international photography prize for women. Harvey had her first solo museum show at the Stenersen Museum, Oslo, in conjunction with her monograph *You Look at Me Like an Emergency*. Harvey teaches workshops and regularly speaks on her work at institutions around the world.

Jacqueline Hassink is a Dutch visual artist, well-known for her interest in economic power and the spaces in which it is exercised and staged. Her work has been widely collected and exhibited, including at Huis Marseille, Amsterdam; Fotomuseum Winterthur, Switzerland; International Center of Photography, New York; Tokyo Metropolitan Museum of Photography; and the Victoria and Albert Museum, London. She was short-listed for the prestigious Prix Pictet 2012 and Henri Cartier-Bresson Award in 2013. Hassink has lectured at Harvard University in conceptual photography and at the International Center of Photography in New York. Her work has appeared in the *Financial Times*, *Le Monde*, the *New York Times*, and *El País*.

Sebastian Hau, after studying comparative literature, worked for the specialized photobook shop, Schaden, until moving to Paris to run LE BAL books. He has written for *Foam* magazine and other publications. He curated an exhibition in the 2011 F/Stop Festival in Germany, which resulted in the show *Sea of Promise*, uniting bookwork and photographs by contemporary European documentary photographers on the subject of immigration. In 2012, he codirected the Fotobookfestival hosted by LE BAL. In 2014, he created an ephemeral market for photobooks called Books & Coffee. Hau created a new publishing label, Yellow Magic, with Pierre Hourquet, recently publishing books by Susan Meiselas and Robert Adams.

Ron Haviv is an award-winning photojournalist and a cofounder of the photo agency VII. He has produced images of conflict and humanitarian crises that have made headlines around the world. Numerous museums, galleries, and institutions have featured his work, including the Louvre, United Nations, and the Council on Foreign Relations.

He has published critically acclaimed collections of his photography with the books *Blood and Honey: A Balkan War Journal*, *Afghanistan: On the Road to Kabul*, and *Haiti: 12 January 2010*. Haviv has been a central character in four documentary films, including National Geographic Explorer's *Freelance in a World at Risk*, that explores the hazards inherent in combat photography.

Marvin Heiferman, an independent curator and writer, organizes projects about photography and visual culture for institutions that include the Museum of Modern Art, Smithsonian Institution, International Center of Photography, Whitney Museum of American Art, and the New Museum. A contributing editor to *Art in America*, Heiferman has written for numerous publications, catalogs, monographs, and magazines, including the *New York Times*, *Artforum*, *Bookforum*, *Aperture*, and *BOMB*. His most recent book is *Photography Changes Everything*. New entries to Heiferman's Twitter-based project, WHY WE LOOK (@whywelook) are posted daily.

Corin Hewitt's work incorporates sculpture, installation, performance, and photography. Hewitt received a BA from Oberlin College and an MFA from Milton Avery Graduate School of Arts at Bard College. He has had several solo exhibitions, including those at the Whitney Museum of American Art; Museum of Contemporary Art, Cleveland; Atlanta Contemporary Art Center; and the Seattle Art Museum. Hewitt is a recipient of a Guggenheim Fellowship in 2011 and a Joan Mitchell Foundation Grant in 2010. He is currently an assistant professor of sculpture and extended media at Virginia Commonwealth University.

Leslie Hewitt lives and works in New York City. She studied at the Cooper Union for the Advancement of Science and Art and Yale University School of Art. She was included in the 2008 Whitney Biennial. A selection of recent and forthcoming exhibitions include ones at the Museum of Modern Art, New York; the Studio Museum in Harlem; Artists Space, New York; Project Row Houses, Houston; the Kitchen, New York; and LA><ART in Los Angeles. In 2012, she was the Guna S. Mundheim fellow at the American Academy in Berlin.

Todd Hido is a San Francisco Bay Area-based artist whose work has been featured in *Artforum*, the *New York Times Magazine*, *Eyemazing*, *Wired*, *Elephant*, *Foam*, and *Vanity Fair*. His photographs are in the permanent collections of the Getty Center, Los Angeles; the Whitney Museum of American Art, New York; the Solomon R. Guggenheim Museum, New York; the San Francisco Museum of Modern Art; and the Los Angeles County Museum of Art, as well as in many other public and private collections. He has over a dozen published books; his most recent monograph, entitled *Excerpts from Silver Meadows*, was released in 2013.

Nicole Jean Hill received a BFA in photography from the Nova Scotia College of Art and Design and an MFA from the University of North Carolina at Chapel Hill. Her photographs have been exhibited throughout North America, and Australia, including at Gallery 44 in Toronto, the Australia Centre for Photography, and the Blue Sky Gallery in Portland, Oregon. Hill has been an artist-in-residence at the Center for Land Use Interpretation in Wendover, Utah, the Ucross Foundation in Wyoming, and the Newspace Center for Photography in Portland, Oregon. She is an associate professor of art at Humboldt State University, California.

Darius Himes is director of Fraenkel Gallery, San Francisco. Prior to that, he was a cofounder of Radius Books, a non-profit publisher of books on photography and the visual arts, where he continues to serve on the board. He was founding editor of *photo-eye Booklist*, a quarterly magazine devoted to photography books, which ran from 2002 to 2007. A lecturer and writer, he has contributed to *Aperture*, *Blind Spot*, *Bookforum*, *BOMB*, *PDN*, and *American Photo*. He is the coauthor, with Mary Virginia Swanson, of *Publish Your Photography Book*.

Takashi Homma was born in Tokyo. In 1999, he won the twenty-fourth Kimura Ihei Award for *Tokyo Suburbia-Tokyo Kogai*. In 2010, he was assigned to be a guest professor at the graduate school of Tokyo Zokei University. His traveling exhibition, *New Documentary*, was shown at the 21st Century Museum of Contemporary Art, Tokyo Opera City Art Gallery, and the Marugame Genichiro-Inokuma Museum of Contemporary Art.

Rob Hornstra is a photographer and self-publisher of slow-form documentary work. He has been commissioned by international magazines to produce documentary series and taken part in numerous exhibitions. In 2009, together with the writer and filmmaker Arnold van Bruggen, he started The Sochi Project, which over five years would document the host city for the 2014 Olympics. In addition to his work on The Sochi Project, he is also the founder and former artistic director of FOTODOK, Utrecht, the Netherlands.

David Hurn is a leading reportage photographer. He first gained this reputation with his work on the Hungarian Revolution in 1956. He became a full member of Magnum in 1967. In 1973, he set up the school of documentary photography in Newport, Wales. He returned to photographing full-time in 1989 and has also conducted numerous workshops

in Arles, Venice, New Zealand, Turkey, New York, Arizona, Rotterdam, and Qatar, among others. He has collaborated on two books with Professor Bill Jay: *On Being a Photographer* and *On Looking at Photographs*. Hurn's own books include *Land of my Father* and *Living in Wales*.

Connie Imboden is represented in many permanent collections, including the Museum of Modern Art, New York; San Francisco Museum of Modern Art; Bibliothèque Nationale de France, Paris; and Museum Ludwig, Cologne, Germany. Imboden's first book, *Out of Darkness*, won the Silver Medal in Switzerland's Schönste Bücher aus aller Welt. Her most recent monograph, *Reflections: 25 Years of Photography*, was published in 2009 with essays by Arthur Ollman, Julian Cox, and John Wood. She currently teaches at the Maryland Institute College of Art and many workshops around the world, including the Maine Media Workshops, the Center for Photography at Woodstock, New York; and the Fine Arts Work Center in Provincetown, Massachusetts.

Jessica Ingram's photography and video practice is motivated by her desire to understand how people relate and what motivates the choices they make. Born in Nashville, Ingram is based in Oakland, California, where she is assistant professor in graduate fine arts and undergraduate photography at California College of the Arts. She received degrees in photography and political science from New York University and her MFA from California College of Arts and Crafts. Ingram's work has been shown around the world, and her collaborative projects have been featured at the Sundance Film Festival and installed publicly at the Oakland International Airport, Birmingham International Airport, and Oakland Museum of California.

Natalie Ivis received her BFA in studio art with a focus in photography and a BA in international studies from the University of South Florida. She went on to attend the Salt Institute for Documentary Studies, Portland, Maine. She currently lives in Brooklyn and is a work scholar at Aperture Foundation.

Jeff Jacobson, born in Des Moines, Iowa, in 1946, has published three books: *My Fellow Americans*, *Melting Point*, and *The Last Roll*. Jacobson's photographs are in the permanent collections of the Whitney Museum of American Art, New York; the San Francisco Museum of Modern Art; the Museum of Fine Arts, Houston; George Eastman House International Museum of Photography and Film, Rochester, New York; the Center for Creative Photography, Tucson, Arizona; and the Center for Photography at Woodstock. Jacobson is widely exhibited and teaches workshops around the world.

Margarete Jakschik is a photographer born in 1974 in Ruda Slaska, Poland. She was a student of Thomas Ruff's from 2000 to 2005 at the Kunstakademie Düsseldorf, Germany. She lives and works in Los Angeles.

Eirik Johnson has exhibited his work at spaces, including Museum of Contemporary Photography, Chicago; Institute of Contemporary Art, Boston; and George Eastman House International Museum of Photography and Film, Rochester, New York. His photographs are in the permanent collections of the San Francisco Museum of Modern Art, the Seattle Art Museum, the Museum of Fine Arts, Houston, and the Nevada Museum of Art, among others. His books include *Sawdust Mountain* and *Borderlands*. Johnson is a visiting faculty member at both the University of Washington and Cornish College of the Arts in Seattle.

Matt Johnston is a photographer, educator, and researcher based in the UK. His pioneering work at Coventry University, codeveloping several "world-leading" open photography classes, has received numerous plaudits from photography and education-based peers around the world. Alongside this, he works to promote and enable discussion around the physical photobook, launching the Photobook Club in 2011. This project encourages groups and communities to form around the photobook and it currently has more than thirty active branches, from Auckland to Bangalore.

Ron Jude is a photographer from rural Idaho, currently living in Ithaca, New York. His books include *Fires*, *Lick Creek Line*, *Executive Model*, *emmett*, *Other Nature*, and *Alpine Star*. He recently exhibited work at the Museum of Contemporary Photography, Chicago, and has a forthcoming exhibition at Fotohof in Salzburg, Austria. He is the cofounder of A-Jump Books.

Miranda July is a filmmaker, artist, and writer. She wrote, directed, and starred in *The Future* and *Me and You and Everyone We Know*. July's published works include *No One Belongs Here More Than You*, *It Chooses You*, and *The First Bad Man*. In 2000, July created the participatory website *Learning to Love You More* with artist Harrell Fletcher, and a companion book was published in 2007. July's interactive sculpture garden, *Eleven Heavy Things*, debuted at the 2009 Venice Biennale. In 2013, 104,897 people from 170 countries subscribed to her e-mail-based artwork, *We Think Alone*, commissioned by Magasin 3 Stockholm Konsthall. Raised in Berkeley, California, July lives in Los Angeles.

Klara Källström and **Thobias Fäldt** are photographers based out of Stockholm who collaborate under the constellation KK+TF.

Since 2005 the duo have worked on projects together ranging from books to exhibitions, public installations, and films. They are two of the founders of B-B-B-Books, through which they publish the majority of their works.

Nadav Kander lives in London. In 2009, he was awarded the Prix Pictet for his series Yangtze, The Long River and named International Photographer of the Year at the Lucie Awards. The same year, his portraits of President Barack Obama and his closest colleagues, aides, and advisors were published in the *New York Times Magazine*. He has exhibited internationally at venues, including Musée de l'Elysée, Switzerland; Museum of Photographic Arts, San Diego; Museum of Applied Arts, Cologne, Germany; the Photographers' Gallery, London; National Portrait Gallery, London; Palais de Tokyo, Paris; and Herzliya Museum of Contemporary Art, Israel. His monographs include *Bodies: 6 Women, 1 Man*; *Yangtze, The Long River*; and *Beauty's Nothing*.

Ed Kashi is a photojournalist, filmmaker, and educator. A member of VII photo agency, Kashi is recognized for his complex imagery and compelling rendering of the human condition. In addition to producing seven books, he is a pioneer and innovator of multimedia whose award-winning work has been published and exhibited worldwide.

Matt Keegan is an artist based in Brooklyn. His work is included in numerous private and public collections, including the Whitney Museum of American Art, the Solomon R. Guggenheim Museum, and the Metropolitan Museum of Art, New York. Keegan is the cofounder of *North Drive Press*, an art publication published from 2004 to 2010. In 2012, Keegan edited ==, an art edition, ==#2 will be launched this fall.

Dennis Keeley has worked as an artist, photographer, and teacher for more than thirty years. His photographs have been exhibited in numerous solo and group shows and included in many books. He has had work commissioned by the California African American Museum; Museum of Contemporary Art, Los Angeles; and J. Paul Getty Trust, Conservation and Research Institutes. His book *Looking for a City in America: Down These Mean Streets a Man Must Go* won numerous awards. He is the current chair of the photography and imaging program at Art Center College of Design.

Angela Kelly is a photographic artist and an associate professor of imaging arts at Rochester Institute of Technology, New York. Her work addresses memory, landscape, and history of place. She is included in books such as *A History of Women Photographers*, *Photography and the Artist's Book,* and *The Photograph and the Album*. An illustrated essay,

"Catharsis: Images of Post-Conflict Belfast," was published in the journal *Photographies*. Her work is in collections, including the Center for Creative Photography, Tucson; School of the Art Institute of Chicago; MacArthur Foundation; Museum of Contemporary Photography, Chicago; Kansas City Art Institute; High Museum of Art, Atlanta; and Arts Council of London.

Robin Kelsey is Shirley Carter Burden Professor of Photography and chair of the history of art and architecture department at Harvard University. He holds a PhD in art history from Harvard and a JD from Yale Law School, and has practiced law in California. A specialist in the histories of photography, landscape, and American art, Professor Kelsey has received various awards for his scholarship and teaching, including the Arthur Kingsley Porter Prize for his work on the nineteenth-century survey photography of Timothy O'Sullivan.

Lisa Kereszi is a photographer and educator. She studied at Bard College and then at the Yale University School of Art, where she has taught since 2004 and is now the director of undergraduate studies. She has published five books, including *Fun and Games* and *Joe's Junk Yard*. Her work is in the collections of the Whitney Museum of American Art, New York, and the Brooklyn Museum, and has appeared in the *New Yorker*, *Harper's*, and the *New York Times Magazine*.

Erik Kessels is a founding partner and creative director of KesselsKramer, an independent international communications agency. Kessels works for national and international clients and has won numerous awards. He published several books of vernacular photography through KesselsKramer Publishing, including the In Almost Every Picture series. Since 2000, he has been one of the editors of *Useful Photography*. He has taught at the Gerrit Rietveld Academy and at the Amsterdam Academy of Architecture where he curated a celebration of amateurism. Kessels has curated exhibitions such as *The European Championship of Graphic Design*, *Graphic Detour*, *Loving Your Pictures*, *Use Me Abuse Me*, *From Here On*, *24HRS of Photos*, and *Album Beauty*. In 2010, Kessels was awarded with the Amsterdam Prize of the Arts and in 2012, elected as the most influential creative in the Netherlands.

Dean Kessmann is an associate professor at George Washington University, where he teaches undergraduate and graduate students. Kessmann's work has been included in exhibitions at the Orlando Museum of Art; Miller Gallery at Carnegie Mellon University, Pittsburgh; American University Museum, Washington, D.C.; Massachusetts Museum of Contemporary Art, North Adams, Massachusetts; and Photographic Resource Center, Boston, among

others. His exhibitions have been reviewed in *Art Papers,* the *Washington Post,* the *Boston Globe, St. Louis Post-Dispatch,* and *Artforum.* In 2009, he was an artist-in-residence at Light Work.

Chris Killip, the author of six books on his work, has taught at Harvard University since 1991.

Ted Kinsman has an AS in Optics, a BS in Physics, and a MS in Science Education. He has worked as an optical engineer, a physicist, and a physics instructor before joining the facility at Rochester Institute of Technology to teach the technical side of imaging. Kinsman is one of the few active high-speed photographers able to photograph at times less than 1/1,000,000 of a second—faster than a speeding bullet. Recently, Kinsman's work has expanded to the X-ray region of the spectrum, where he continues to explore imagery for books and magazines. His work has appeared on the Discovery Channel, *The X-Files, South Park,* ABC, NBC, PBS, CBS, and the British Broadcast Corporation. He lives in Rochester, New York.

Martin Kippenberger (1953–1997) was born in Dortmund, Germany. An extremely prolific artist, Kippenberger worked in multiple mediums, which include paintings, sculpture, installation, drawing, posters, photography, and collage. Both during his life and since his passing, Kippenberger's work has been exhibited extensively throughout the United States and Europe. Recent solo exhibitions have been held in institutions such as the Hamburger Bahnhof, Museum für Gegenwart, Berlin; Picasso Museum Málaga; Museum of Contemporary Art, Los Angeles; Museum of Modern Art, New York; Tate Modern, London; and K21 Kunstsammlung Nordrhein-Westfalen, Düsseldorf; Museum Moderner Kunst Stiftung Ludwig Wein, Vienna; Van Abbemuseum, Eindhoven, the Netherlands; Museum für Neue Kunst, Karlsruhe, Germany; and Kunsthalle Tübingen, Germany. Kippenberger died in Vienna.

Alex Klein is an artist working between Los Angeles and Philadelphia. She is the Dorothy and Stephen R. Weber (CHE'60) Program Curator at the Institute of Contemporary Art, University of Pennsylvania. Klein is the cofounder of the editorial project and publishing imprint Oslo Editions and is the editor of the critical volume on photography *Words Without Pictures* (Aperture, 2010). Her writing has appeared in publications such as *How Soon Is Now?, First Among Equals,* and *The Human Snapshot.* She is currently working on the first museum survey of artist Barbara Kasten, which will open at the Institute of Contemporary Art, Philadelphia in 2015.

Mark Klett is a photographer interested in the intersection of cultures, landscapes, and time. His background includes working as a geologist

before turning to photography. Klett has received fellowships from the Guggenheim Foundation, National Endowment for the Arts, and Japan-U.S. Friendship Commission. Klett's work has been exhibited and published in the United States and internationally for over thirty years, and his work is held in over eighty museum collections worldwide. He is the author/coauthor of fifteen books. Klett lives in Tempe, Arizona, where he is Regents' Professor of Art at Arizona State University.

Gary Knight is cofounder of the VII photo agency and founder of the Program for Narrative and Documentary Practice at the Institute for Global Leadership at Tufts University.

Barney Kulok is a graduate of the Bard College photography program. His work is infused with subtle references to minimalism and architecture, and explores the slippage between public and private space in the urban landscape. Kulok's first monograph, *Building: Louis I. Kahn at Roosevelt Island,* was published by Aperture. He lives and works in New York City.

Justine Kurland received her BFA from the School of Visual Arts and her MFA from Yale University. Her work has been exhibited extensively at museums in the United States and internationally. Recent museum exhibitions include *Looking Forward: Gifts of Contemporary Art from the Patricia A. Bell Collection* at the Montclair Art Museum, New Jersey; *More American Photographs* at the Wexner Center for the Arts in Columbus, Ohio; and *Off the Grid #1* and *#2* at FOTODOK in the Netherlands. She was the focus of a solo exhibition at CEPA in Buffalo, New York, in 2009. Her work is in the public collections of institutions, including the Whitney Museum, Guggenheim Museum, and International Center of Photography in New York, and the Montreal Museum of Fine Arts, among others.

Jeffrey Ladd is an American photographer born in Elkins Park, Pennsylvania. His work has been exhibited at the Art Institute of Chicago; Oklahoma City Museum of Art; International Center of Photography, New York; and the Museum of the City of New York, among others. He splits his time between photographing and writing about photography. From 2007 to 2012, he wrote over 450 articles for his website, dedicated to discussing and reviewing photography and art-related publications. Ladd is one of the founders of the publishing company Errata Editions.

Alexis Lambrou is a Brooklyn-based photographer. Her work has been published in the *New York Times,* the *New York Times Lens* blog, *Education Week,* the *Times* (UK), and numerous local publications near her native Pittsburgh. She earned her BA in photojournalism from the Rochester

Institute of Technology. In 2012, she was a recipient of the Magnum Foundation Emergency Fund Fellowship and accepted into the Eddie Adams Workshop XXVI. Lambrou has taught youth photography at Brooklyn Community Arts and Media High School and at Photoville in Brooklyn.

Andrew Lampert lives in New York City, where he makes films, videos, live performances, and photos that are regularly exhibited in festivals, museums, galleries, and other venues in the United States and abroad. While he loves shooting with digital, he still occasionally uses 35 mm film because he misses the mystery and excitement of getting actual prints back from a photo lab.

Jessica Lancaster was born and raised in the Detroit metropolitan area. She has studied in Washington, D.C., and Paris. She graduated from the Corcoran College of Art and Design in 2013 with a BFA in fine art photography. She is currently a work scholar at Aperture Foundation.

David La Spina is currently based in Brooklyn. He completed a BFA from the Rochester Institute of Technology and an MFA in photography at Yale University School of Art. Currently, he is a visiting assistant professor at Bard College at Simon's Rock in Great Barrington, Massachusetts, and at Pratt Institute, New York. Exhibitions include ones at the Architectural Foundation of Cincinnati; Galerie Thomas Flor, Düsseldorf; Capricious Space, New York; Gallery 339, Philadelphia; and the New York Photo Festival. He has published work with *Notes from the Foundry*, the *New York Times Magazine*, *Esquire*, *Newsweek*, J&L Books, and *Blind Spot* magazine.

Jason Lazarus is a Chicago-based artist, curator, writer, and adjunct assistant professor at the School of the Art Institute of Chicago.

John Lehr earned his MFA from Yale University and a BFA from the Maryland Institute College of Art. His work is included in the collections of the Museum of Modern Art, Morgan Library and Museum, and Metropolitan Museum of Art in New York. He has taught photography at the Yale University School of Art, Purchase College SUNY, and the School of Visual Arts. He works and lives in Queens, New York, with his wife and daughter.

Saul Leiter (1923–2013) was a photographer and painter whose early work in the 1940s and '50s played an important part in the creation of the New York School. He began to experiment with color photography in 1948 and then, in the late 1950s, his color fashion work was published in *Esquire*, and later in *Harper's Bazaar*. Leiter continued to work as a fashion photographer for the next twenty years, publishing photographs in *Show*, *Elle*, British *Vogue*,

and many other publications. His work is known worldwide particularly for his abstracted forms and innovative compositions that have an almost painterly aesthetic.

Laura Letinsky has exhibited at the Museum of Contemporary Art, Chicago; the Photographers' Gallery, London; Denver Art Museum; and Museum of Modern Art, New York, among others. Her work is included in collections such as the Art Institute of Chicago; J. Paul Getty Museum, Los Angeles; Hermès Collection, Paris; Montreal Museum of Fine Arts; Museum of Fine Arts, Houston; and San Francisco Museum of Modern Art. She is a professor at the University of Chicago. Grants she has received include the Richard H. Driehaus Foundation, Anonymous Was A Woman Foundation, John Simon Guggenheim Memorial Fellowship, and Canada and Manitoba Arts Councils. Publications include *Feast*, *After All*, *Hardly More Than Ever*, *Blink*, and *Venus Inferred*.

Susan Lipper is chiefly known for her monographs: *Bed and Breakfast*, *trip*, and *Grapevine*. Lipper is a New York-based artist. She received her BA in English literature from Skidmore College and her MFA in photography from Yale University School of Art. She is represented in the collections of the Metropolitan Museum of Art; Museum of Contemporary Art, Los Angeles; and Victoria and Albert Museum, among others. Her work exists both within and outside the documentary tradition and often concerns itself with the intersection of word and image. At present, she has been working on a long-term project in the California desert.

Nathan Lyons has had a lifelong engagement with photography, as an artist, author, curator, historian, and educator, and as founder of Rochester's Visual Studies Workshop. He was the associate director and curator at the George Eastman House, working alongside Beaumont Newhall. In 1963, Lyons cofounded the Society for Photographic Education, and in 1972 launched the periodical *Afterimage*, both remain in operation today. Lyons's work as a photographer has been exhibited in museums around the world, and in 2000 he received the Infinity Award for Lifetime Achievement from the International Center of Photography.

Robin Maddock is a British photographer best known for his first two documentary books: *Our Kids Are Going to Hell*, concerned with the fate of minor drug dealers in London, and *God Forgotten Face*, about the population of Plymouth in the country's southwestern reaches, where his family hails from. Since these works on the UK, Maddock has lived a more itinerant life. His latest book, *III*, is a more playful result of time spent in California.

Raimundas Malašauskas was born in Vilnius. He curates in the world, writes occasionally.

Catharine Maloney photographs men in brightly colored turtlenecks. She uses play, candy colors, and outer space in her photographs and drawings. Maloney received an MFA from Yale University and an MA in art education from Teachers College, Columbia University. She is also a member of the band Teen Men.

Mike Mandel's work often questions the meaning of photographic imagery within popular culture and draws from snapshots, advertising, news photographs, and public and corporate archives. Much of this work is in the form of artist's books including a collaborative effort with Larry Sultan entitled *Evidence*—a book comprised of archive photographs from engineering, corporate, and government agencies. Since the early 1990s, Mandel has worked extensively on public art projects transforming photographic imagery into large-scale glass and ceramic tile mosaic murals. His most recent projects have been in collaboration with his wife, Chantal Zakari. Their book, *The State of Ata*, speaks to the clash between Islam and secularism in Turkey. Their book *They Came to Baghdad*, is a response to the Iraq War.

Roxana Marcoci is senior curator of photography at the Museum of Modern Art, New York. Her exhibitions include *The Shaping of New Visions: Photography, Film, Photobook*; *Taryn Simon: A Living Man Declared Dead and Other Chapters*; *Sanja Iveković: Sweet Violence*; and *The Original Copy: Photography of Sculpture, 1839 to Today*, awarded "Outstanding Catalogue Based on an Exhibition" from the Association of Art Museum Curators. She is preparing the retrospective *Christopher Williams: The Production Line of Happiness*, coorganized by the Museum of Modern Art, and the Art Institute of Chicago. Marcoci received her PhD in art history from the Institute of Fine Arts at New York University.

Ari Marcopoulos is an Amsterdam-born photographer and filmmaker, living and working in New York and California. He has been documenting the American subculture since the 1980s, photographing icons such as artist Jean-Michel Basquiat and legendary hip-hop group Public Enemy. His work is in numerous museum collections, including the Whitney Museum of American Art, New York, and the San Francisco Museum of Modern Art.

Lesley A. Martin is publisher of the Aperture book program and of *The PhotoBook Review*, a newsprint journal dedicated to the evolving conversation surrounding the photobook. Her writing on photography has been published in

Aperture, American Photo, Foam, and *Lay Flat*, among other publications, and she has edited over seventy-five books of photography, including *Reflex: A Vik Muniz Primer*; *On the Beach* by Richard Misrach; *Paris • New York • Shanghai* by Hans Eijkelboom; *Tokyo* by Takashi Homma; *Paul Strand in Mexico*; *Illuminance* and *Ametsuchi* by Rinko Kawauchi; and *Enclave* by Richard Mosse.

Katja Mater's work focuses on photography from a meta-perspective, with an interest in perception of time and space. She documents dimensions beyond what we can see in hybrids between photography and other media. Her work has been exhibited in institutions such as Stedelijk Museum Bureau, Amsterdam; La Casa Encendida, Madrid; Temporary Gallery, Cologne, Germany; and Fotogalleriet, Oslo. In 2013, Mater's book *Multiple Densities* was published.

Stephen Mayes has worked at the top levels of photography for twenty-five years in the areas of journalism, art, commercial, and fashion—most recently as CEO of VII photo agency, representing the world's leading photojournalists. He served as Secretary to the World Press Photo competition from 2004 to 2012. He was senior vice president at Getty Images, overseeing the content strategy, and later senior vice president at eyestorm.com representing high-end artists in the consumer market. Mayes also worked with Art and Commerce as director of the image archive. Mayes regularly writes and broadcasts on the ethics and realities of photographic practice in the new digital environment.

Christopher McCall is the director of Pier 24 Photography in San Francisco, one of the largest exhibition spaces devoted to photography. In 2002, McCall received his MFA in Photography from California College of the Arts, studying under Jim Goldberg and Larry Sultan. After teaching for seven years, he joined Pier 24 Photography in 2009 as the inaugural director, assisting in the conceptualization of the organization's mission and operating principles. Since opening the doors of Pier 24, McCall has overseen the presentation of five exhibitions and spearheaded the creation of the Larry Sultan Visiting Artist Program, a program in collaboration with the San Francisco Museum of Modern Art and California College of the Arts.

Chris McCaw was forced by his mom to take a photo course at age thirteen at the community center. He was hooked. Concurrently, McCaw spent his youth in the punk and skateboarding scenes, taking the DIY motto of those cultures and applying it to photography. The first camera he built in 1995 was a 7-by-17-inch view camera to make contact negatives for platinum prints. Over

the ensuing decades—and particularly with his Sunburn project—McCaw has used photographic materials, especially expired gelatin-silver paper, in groundbreaking ways. His work is held in numerous public collections, and in 2012 a monograph, *Sunburn* was published.

Sean McFarland's work explores the relationships between the processes of image-making, photographic truth, and the representation of landscape. He earned his MFA from the California College of the Arts. He has exhibited at the San Francisco Museum of Modern Art; Berkeley Art Museum; and White Columns, New York, among others. He received the 2005 Phelan Art Award in Photography, 2009 Baum Award for an Emerging American Photographer, 2009 John Gutmann Photography Fellowship, and a 2011 Eureka Fellowship. His work is the collections at San Francisco Museum of Modern Art, Milwaukee Art Museum, Oakland Museum of California, Berkeley Art Museum, and the Whitney Museum of American Art Library. McFarland currently lives in San Francisco and teaches at the San Francisco Art Institute.

Laura McPhee works in a variety of genres, including portraits, landscapes, still lifes, and interiors. Most often, her work has concerned place and the way we see ourselves in regard to the land—whether in Calcutta or the American West. Her photographs provoke questions about our attitudes and beliefs about the earth we inhabit, questions sometimes environmental, cultural, or geographical. Her books include *No Ordinary Land* (in collaboration with Virginia Beahan), *River of No Return*, and *Home and the World*. McPhee is a professor at the Massachusetts College of Art and Design, and lives in Brookline, Massachusetts, with her daughter.

Raymond Meeks was born in Ohio in 1963 and currently lives and works in New York City. Meeks is the cofounder of *Orchard Journal*, which was established as a collaborative dialogue between artist, subject, and viewer. Featured artists have included Wes Mills, Deborah Luster, and Mark Steinmetz. *Orchard Volume 1: Crime Victims Chronicle* was nominated as international "book of the year" by Gerry Badger. Meeks has published several monographs, as well as numerous, self-published titles under his imprint, Dumbsaint Editions.

Susan Meiselas is a documentary photographer and a member of Magnum Photos since 1976. She is the author of several books, including *Carnival Strippers*, *Nicaragua*, *El Salvador: The Work of 30 Photographers*, *Chile from Within*, and *Kurdistan: In the Shadow of History*. In 2007, Meiselas and fellow members of Magnum Photos formed the Magnum Foundation to support the production of documentary photography and use of visual imagery

to promote positive social change. She currently serves as the Foundation's executive director and is an active board member. Her awards include the Robert Capa Gold Medal, Leica Award for Excellence, Maria Moors Cabot Prize, Hasselblad Award, Cornell Capa Infinity Award, Lucie Award for Achievement in Photojournalism, Kraszna-Krausz Book Award, and LUMA Historical Book Award. In 1992, she was made a MacArthur Fellow. Her photographs are included in several American and international collections.

Sarah Hermanson Meister is a curator in the Department of Photography at the Museum of Modern Art, New York. Recent exhibitions at MoMA include *Bill Brandt: Shadow and Light*, *Walker Evans American Photographs*, *Picturing New York*, *Eugène Atget: Documents pour artistes*, and *Pictures by Women: A History of Modern Photography*. With a special focus on the development and preservation of the Museum Collection, she oversees its many conservational, educational, and research initiatives. She is preparing a major exhibition of the work of Horacio Coppola and Grete Stern for 2015.

Mark Menjivar is an artist and photographer based in San Antonio. His work explores diverse subjects through photography, stories, and found objects while emphasizing dialogue and collaboration. He has a BA in social work from Baylor University and his MFA in social practice from Portland State University.

Darin Mickey is a photographer based in New York City. His work has been exhibited in both solo and group exhibitions in New York, Kansas City, Seattle, Atlanta, Copenhagen, Sydney, and Tokyo. He is the author of *Stuff I Gotta Remember Not to Forget*. His images have appeared in the *New York Times Magazine*, the *Washington Post Magazine*, *ID*, *Foam*, and *Doubletake* among others. Darin also teaches photography at the Cooper Union and the International Center of Photography.

Paul Moakley has been the deputy photo editor of *Time* since 2010. He covers national news and special projects such as Person of the Year and the *LightBox* photo blog. Previously, he was senior photo editor at *Newsweek* and photo editor of *PDN (Photo District News)*. Moakley was an adjunct professor at the School of Visual Arts in New York City, as well as a photographer and filmmaker. He lives at the Alice Austen House Museum, as caretaker and curator of the museum.

Andrea Modica lives in Philadelphia and works as a photographer and associate professor at Drexel University's Antoinette Westphal College of Media Arts and Design. She is a Guggenheim Fellow and a Fulbright Scholar. Modica's work is published

in several monographs, including *Treadwell, Minor League, Human Being*, and *Fountain*. Her photographs are included in the permanent collections of the Metropolitan Museum of Art, New York; Whitney Museum of American Art, New York; George Eastman House International Museum of Photography and Film, Rochester, New York; Smithsonian American Art Museum, Washington, D.C.; Bibliotèque Nationale de France, Paris; and many others. She teaches workshops at the International Center of Photography, the Center for Photography at Woodstock, and the Maine Media Workshops.

Andrew Moore is best-known for his large-format photographs of Cuba, Russia, Times Square, Detroit, and most recently, the American High Plains. His photographs are held in the collections of the Metropolitan Museum of Art, New York; Whitney Museum of American Art, New York; Yale University Art Gallery, New Haven, Connecticut; Museum of Fine Arts, Houston; George Eastman House International Museum of Photography and Film, Rochester, New York; and Library of Congress, Washington, D.C., among many others. His publications include *Cuba, Detroit Disassembled, Russia: Beyond Utopia, Governors Island*, and *Inside Havana*. He teaches a graduate seminar in the MFA Photography, Video, and Related Media program at the School of Visual Arts in New York City.

Alison Morley is a photo editor, consultant, and educator. She has been the chair of the documentary photography and photojournalism program at the International Center of Photography in New York since 2000. As a photo editor, she has been the photography director of the *New York Times Sophisticated Traveler, Audubon, Life, Civilization, Esquire, Mirabella, Elle*, and the *Los Angeles Times Magazine*. Currently, she works as a consultant and has edited several monographs and curated touring exhibitions for *Blood and Honey: A Balkan War Journal* by Ron Haviv and *The Ninth Floor* by Jessica Dimmock, among others. She has written for magazines and books and has lectured and led workshops in the United States, as well as Argentina, Bangladesh, China, Colombia, Hungary, Peru, the Philippines, Spain, Thailand, and Uganda.

Nicholas Muellner is an artist whose work operates at the intersection of photography and writing. Through books, exhibitions, and slide lectures, his projects investigate the limits of photography as a documentary pursuit and as an interface to literary, political, and personal narratives. His recent textual and visual books include *The Photograph Commands Indifference* and *The Amnesia Pavilions*. His work has been supported by MacDowell and Yaddo Colony Fellowships, as well as the Trust for Mutual

Understanding and CEC ArtsLink. He teaches photography and critical studies at the Park School of Communications, Ithaca College.

Rory Mulligan was born in New York in 1984. He received a BA from Fordham University and a MFA from Yale University. His work has been exhibited both nationally and internationally and is included in the permanent collection of the Philadelphia Museum of Art. Mulligan's work has been published by J&L Books and *Blind Spot* magazine. He has taught at Drew University and Bard College at Simon's Rock, and lectured at Sarah Lawrence College, Princeton University, Wesleyan University, Parsons The New School for Design, and the International Center of Photography, among others.

Bruno Munari (1907–1998) was an Italian painter, sculptor, graphic artist, industrial designer, theoretician, and author of many books for both children and adults. His work and teaching often revolved around play and hands-on games.

Michael David Murphy is an artist and writer in Atlanta. His most recent project, We Are the 15 Percent, received global notice, including from the *Katie Couric Show*, MSNBC, *The Today Show*, and the *Huffington Post*. His installation *Unphotographable* was shown at Festival Images in Vevey, Switzerland, in 2012. Murphy's photographs and writing about photography have been published worldwide. He is program manager for Atlanta Celebrates Photography and editor for Fall Line Press.

Laurel Nakadate is a photographer, filmmaker, and video artist. Her first feature film, *Stay the Same and Never Change*, premiered at the Sundance Film Festival and went on to be featured in New Directors/New Films. Her second film, *The Wolf Knife*, premiered at the Los Angeles Film Festival, was nominated for a Gotham Independent Film Award and an Independent Spirit Award. Her ten-year survey show, *Only the Lonely*, premiered at MoMA PS1 in 2011. Her work is in many collections, including the Museum of Modern Art, New York; Whitney Museum of American Art, New York; Yale University Art Gallery, New Haven, Connecticut; and the Saatchi Collection.

Judy Natal is author of *EarthWords* and *Neon Boneyard Las Vegas A-Z*. Her photographs are in the permanent public collections of the Center for Creative Photography, Tucson, Arizona; International Museum of Photography, New York; and Museum of Contemporary Art, Chicago, among others. Her work has been exhibited at the Nelson-Atkins Museum, Kansas City, and the São Paulo Biennial in Brazil, among others. She has received numerous grants and fellowships, including a Fulbright Travel Grant, Illinois Arts Council

Photography Fellowships, Polaroid Grants, and New York Foundation for the Arts Photography Fellowships. Natal is a professor of photography and coordinator of graduate photography, Columbia College Chicago.

Erin Jane Nelson is an artist and writer living in Oakland, California.

Nicholas Nixon is known for his black-and-white large-format photography. Nixon has photographed porch life in the rural South, schools in and around Boston, cityscapes, sick and dying people, the intimacy of couples, and the ongoing annual portrait of his wife, Bebe, and her three sisters. Nixon has been awarded three National Endowment for the Arts Fellowships and two Guggenheim Fellowships. Nixon had a solo exhibition at the National Gallery of Art, Washington, D.C., and the Cincinnati Art Museum, and has exhibited at the Museum of Modern Art, New York; Modern Art Museum of Fort Worth, Texas; and Museum of Fine Arts, Boston. His work is included in the collections of the Metropolitan Museum of Art; Museum of Modern Art, New York; Los Angeles County Museum of Art; and Museum of Fine Arts, Boston, among others.

Abner Nolan is a California-based artist and educator. He has been teaching photography since 1994 with students ranging in age from seven to seventy-five. Nolan is currently a senior adjunct professor at the California College of the Arts, where he also studied with Larry Sultan. He lives in San Francisco with his wife Clare and two children, Alice and Wyatt.

Peggy Nolan is a photographer and the mother of seven, working in South Florida. Her work is collected and exhibited by major institutions, including the San Francisco Museum of Modern Art; Museum of Modern Art, New York; Norton Museum of Art, Palm Beach, Florida; National Museum of Women in the Arts, Washington, D.C.; Wedge Collection, Toronto; Light Work Permanent Collection; and the Martin Z. Margulies Collection. She has twice won the South Florida Cultural Consortium Individual Artist Grant and was selected for Light Work's artist-in-residence program in 2005. She is a full-time staff member of the art department at Florida International University.

Alison Nordström is an independent writer and curator based in Cambridge, Massachusetts. Formerly founding director and senior curator of the Southeast Museum of Photography, Dayton Beach, Florida, and senior curator of photographs at George Eastman House International Museum of Photography and Film, Rochester, New York, she has worked with students of photography, art, and

photographic preservation at numerous international institutions. She is the author of over one hundred published essays on photographic topics and has curated over one hundred photographic exhibitions in nine countries. She holds a PhD in cultural and visual studies.

Michael Northrup began a lifelong commitment to photography in 1970 when Jack Welpott and Judy Dater took him on as an apprentice. They introduced him to and he proceeded to study and work with, Frederick Sommer, Minor White, Imogen Cunningham, Ansel Adams, Cherie Hiser, and Barbara Crane. All this before his MFA at the Chicago Art Institute! This rich experience has, for some reason, led him to a great appreciation of "the ironic"—that tension between humor and tragedy. He thinks of his images as "serious humor."

Lorie Novak is an artist and professor of photography and imaging at Tisch School of the Arts, New York University, and associate faculty at the Hemispheric Institute of Performance and Politics. She also directs Future Imagemakers/Community Collaborations at NYU, a free digital photography workshop program for New York City youth. Her photographs, installations, and Internet projects have been in numerous solo and group exhibitions, and her photographs are in many museum permanent collections. Novak's collectedvisions.net, from 1996 to present, exploring how family photographs shape our memory, was one of the earliest interactive storytelling websites.

Eric Ogden is a photographer, director, and artist living in Brooklyn. Born and raised in Flint, Michigan, the lives and landscape of the Midwest still figure prominently in his work. His photographs have appeared in such publications as the *New Yorker*, *Vanity Fair*, *Esquire*, and the *New York Times Magazine*, as well as in advertising for major brands, TV networks, and record labels. His images have been awarded publication in the American Photography Annual Awards, *PDN* magazine, the SPD Awards, and in the book *American Character: A Photographic Journey*. His fine art work has been exhibited internationally.

Colette Olof is a curator for photography. She curated at Foam Photography Museum Amsterdam for ten years, and is currently working for the Fondation Vincent van Gogh Arles, a contemporary art institution in France. Interested in the dialogue between photography and contemporary art, graphic design and fashion, she has been responsible for many shows and projects with several artists and insitutions such as Broomberg and Chanarin, Melanie Bonajo, Henri Cartier-Bresson, Larry Clark, Mitch Epstein, Helen Levitt, Philip-Lorca diCorcia, JR, Ryan McGinley, Anne de Vries, Hedi

Slimane, and Mario Testino, as well as *Capricious*, Colette, Magnum, Offprint Paris, and *Purple* magazine, among many others.

Taiyo Onorato and **Nico Krebs** studied photography at the Zurich University for the Arts. They have worked together since 2003 and participated in numerous solo and group exhibitions throughout Europe and the United States and published several books, among them *The Great Unreal*; *As Long as It Photographs, It Must Be a Camera*; *Light of Other Days*; and *Raise the Bar*.

Suzanne Opton, a self-taught photographer, is the recipient of a Guggenheim Fellowship and grants from the National Endowment for the Arts, New York Foundation for the Arts, and the Fledgling Fund. Opton's *Soldier Billboard Project* presented portraits of American soldiers on billboards and in subway stations in eight cities in 2008 to 2010 with accompanying book *Soldier/Many Wars*. Her work is in the permanent collections of the Brooklyn Museum; Cleveland Museum of Art; Museum of Fine Arts, Houston; Musée de l'Élysée, Lausanne, Switzerland; and Nelson-Atkins Museum of Art, Kansas City, among others. Opton lives in New York City and teaches at the International Center of Photography.

Willie Osterman is the program chair of fine art photography at Rochester Institute of Technology. He is the author of *Déjà View: A Cultural Re-Photographic Survey of Bologna, Italy*. In 2010 he received a Fulbright Scholar award to develop an MA photo degree program, the first in the country, at the University of Zagreb, Croatia. He has had over eighty exhibitions in the United States, Italy, Turkey, Austria, China, and Croatia. His work is included in the collections of, among others, George Eastman House International Museum of Photography and Film, Rochester, New York; the Museum of Contemporary Photography, Chicago; University of New Mexico Art Museum; Alinari Photographic Archive, Florence; and Zagreb City Museum, Croatia.

Erin O'Toole is associate curator of photography at the San Francisco Museum of Modern Art. Most recently she collaborated with Leo Rubinfien and Sarah Greenough on the retrospective exhibition *Garry Winogrand* in 2013. She previously organized *The View from Here* in 2010, a large-scale survey of California photography drawn from the San Francisco Museum of Modern Art's permanent collection, and is at work on a retrospective of the work of Anthony Hernandez, slated for 2016. She is a contributing author of *Janet Delaney: South of Market*; *Garry Winogrand*; *San Francisco Museum of Modern Art: 75 Years of Looking Forward*; *Brought to Light: Photography and the Invisible, 1840-1900*; and the forthcoming *The Photographic Object, 1970*.

Arthur Ou is an artist and writer based in New York City. He is an assistant professor of photography in the school of art, media, and technology at Parsons The New School for Design. His work has been featured in publications, including *Aperture*, *Blind Spot*, *Art On Paper*, *North Drive Press*, *Art in America*, and the book, *The Photograph as Contemporary Art*. His writing has been published in *Aperture*, Afterall.org, *Bidoun*, *Fantom*, *Foam*, *Words Without Pictures*, and *X-Tra*.

Trevor Paglen's work blurs the lines between science, contemporary art, journalism, and other disciplines to construct unfamiliar, yet meticulously researched ways to see and interpret the world around us. Paglen's work has been exhibited at the Metropolitan Museum of Art, New York; Tate Modern, London; Walker Art Center, Minneapolis; San Francisco Museum of Modern Art; 2008 Taipei Biennial; 2009 Istanbul Biennial; and numerous others. He is the author of five books and holds a BA from University of California, Berkeley, an MFA from the School of the Art Institute of Chicago, and a PhD in geography from University of California, Berkeley. Trevor Paglen is based in New York.

Oscar Palacio is a Colombian-born, Rochester, New York-based photographer. He received his MFA in photography from the Massachusetts College of Art and Design and a bachelor of architecture from the University of Miami. His work is included in the permanent collections of the Fogg Art Museum at Harvard University, the Center for Creative Photography at the University of Arizona, and the Massachusetts Institute of Technology in Cambridge. His work has been exhibited widely. Artist residences include the Addison Gallery of American Art and Light Work at Syracuse University. In 2013, he published *American Places*.

Sarah Palmer was born in San Francisco and lives in Brooklyn. Her work has been shown most recently in the exhibitions *Useful Pictures* in Harlem and *BLOG REBLOG* in Brooklyn in 2013, as well as at the Center for Photography at Woodstock and Foam, Amsterdam, in recent years. She was awarded the 2011 Aperture Portfolio Prize and has had solo exhibitions at Wild Project and Aperture Gallery. Her writing has been published variously, including in Foam's *What's Next?* project in 2011. She is a member of the photography faculty at Parsons The New School for Design.

Ahndraya Parlato was born in Kailua, Hawaii. She has a BA in photography from Bard College and an MFA from California College of the Arts. She has forthcoming books scheduled. In 2013, Parlato received an artist's fellowship from the New York Foundation for the Arts and an Emerging photographer award from the Magenta Foundation,

and was short-listed for the MACK First Book Award. In addition, she has been a Light Work grant recipient, a nominee for the Paul Huf Award from the Foam Museum in Amsterdam, and a nominee for the SECA Award from the San Francisco Museum of Modern Art.

Tom Patton received a BFA from San Francisco Art Institute, and an MA and MFA from the University of New Mexico. He has taught full-time since 1982 at the University of Missouri-St. Louis and California State University, Chico. Patton's artwork has appeared in some 250 exhibitions in the United States, Australia, Japan, and Europe, and is included in the collections of the National Gallery of Australia; San Francisco Museum of Modern Art; St. Louis Art Museum; Seattle Art Museum; and the Nelson-Atkins Museum of Art, Kansas City. He's been included in sixty publications and received fellowships from the James D. Phelan Foundation and the National Endowment for the Arts.

Philip Perkis began photographing in 1957 while serving as a tail-gunner on a B36 heavy bomber (visual wonders). He has been making photographs regularly ever since. He taught photography for approximately forty of those years. He has shown regularly in galleries and museums and has three published books with a fourth on its way. He is a Guggenheim Fellow and recipient of several other grants. His work is in the collections of many major museums. He lives and works in Rockland County, New York, with his wife, the artist Cyrilla Mozenter.

John Pfahl, after studying art and photography at Syracuse University, spent his teaching career at the School of Photographic Arts and Sciences at the Rochester Institute of Technology. His photographic work is exhibited and collected throughout the world. He has published numerous books, catalogs, and portfolios, including *Altered Landscapes*, *Picture Windows*, *Arcadia Revisited*, *A Distanced Land*, *Waterfall*, and *Extreme Horticulture*. He received an honorary doctorate from Niagara University in 1991 and was named as the Honored Educator of 2009 by the Society for Photographic Education. He has served on the Board of Trustees at the George Eastman House International Museum of Photography and Film, Rochester, New York, since 1998.

Andrew Phelps is an American photographer who has been living in Europe since 1990. His work is influenced by the cross-cultural lifestyle he now leads, dividing his time between the deserts of Arizona and the Alps of Austria. He works closely with Galerie Fotohof in Salzburg as curator and board member. Alongside his own work, Phelps keeps a blog about special-edition photography books called *Buffet* and is a member of the Piece of Cake collective.

Sandra S. Phillips is senior curator of photography at the San Francisco Museum of Modern Art. She has been with the museum since 1987, and assumed her current position in 1999. Phillips has organized numerous critically acclaimed exhibitions of modern and contemporary photography, including *Exposed: Voyeurism, Surveillance and the Camera Since 1870*; *Diane Arbus Revelations*; *Dorothea Lange: American Photographs*; *Daido Moriyama: Stray Dog*; *Crossing the Frontier: Photographs of the Developing West*; and *Police Pictures: The Photograph as Evidence*. She holds degrees from the City University of New York, PhD; Bryn Mawr College, MA; and Bard College, BA. Phillips was previously curator at the Vassar College Art Museum.

Sarah Pickering has worked with the emergency services, pyrotechnic manufacturers, prop makers, and the police to produce some of her most recent work. Exhibitions include *How We Are: Photographing Britain*, Tate Britain; *Theatres of the Real*, Fotomuseum, Antwerp; *An Orchestrated Vision: The Theater of Contemporary Photography*, St. Louis Art Museum; and *Living in the Ruins of the Twentieth Century*, UTS Gallery, Sydney. Solo exhibitions include *Incident Control* at the Museum of Contemporary Photography, Chicago, and *Art and Antiquities* at Meessen De Clercq, Brussels. Her most recent body of work, *Celestial Objects*, was commissioned by Locus+ in 2013.

John Pilson is a photographer and video artist. His exhibitions include *The Shapes of Space*, Guggenheim Museum, New York; *Skyscraper Souls: New Video and Photography by John Pilson*, Contemporary Arts Center, Cincinnati; *to: Night: Contemporary Representations of the Night*, Hunter College, New York; *Frolic and Detour*, video installation, Museum of Modern Art; and *September 11*, MoMA PS1. He is a visiting assistant professor in Bard College's photography program and a critic at the Yale School of Art photography MFA program. His published monograph is *Interregna*.

Aleix Plademunt lives and works in Barcelona. For the last ten years he has worked ceaselessly on his personal photographic projects, the highlights of which include: Almost There, All, DubaiLand, Nada, and Espectadores. He has published two books, *Almost There* and *Movimientos de Suelo*. In 2011, together with photographers Roger Guaus and Juan Diego Valera, he founded the editorial project Ca l'Isidret Edicions as a platform to publish their own work. He has exhibited his work in over forty group shows and fifteen individual exhibitions.

Eliot Porter (1901–1990) was a photographer best known for his color photographs of nature and for possessing a strong environmentalist ethic. In the 1930s, he mastered black-and-white photography,

409

then took up color in 1939, using Eastman Kodak's technique of making dye transfer color prints. Porter published several books, including his 1962 book, *In Wildness Is the Preservation of the World*. He exhibited his work many times, and was the first photographer to exhibit a one-person color photography show at the Metropolitan Museum of Art in New York.

Gus Powell attended Oberlin College, where he majored in comparative religion. He is best known for his street photography and a body of work inspired by Frank O'Hara's book *Lunch Poems*. The series was published as *The Company of Strangers* and exhibited as a solo show at the Museum of the City of New York. He teaches in the graduate program at the School of Visual Arts. Powell's photographs have been exhibited at the Art Institute of Chicago; Museum of Fine Arts, Houston; Museum of Modern Art, New York; and Foam, Amsterdam.

Greta Pratt is the author of two published books of photographs, *In Search of the Corn Queen* and *Using History*. Pratt's works are represented in major public collections and have been shown at prestigious venues around the world. Pratt was nominated for a Pulitzer Prize, served as photography bureau chief of Reuters International in New York City, and her photographs have been featured in the *New York Times Magazine* and the *New Yorker*, among others. Pratt is currently an associate professor of photography at Old Dominion University.

Ted Pushinsky was born in New York and raised in public housing projects in Queens. His first job as a photographer was shooting for boxing magazines. A talent for photographing moving bodies got him a job with the San Francisco Ballet. The regimentation was too constricting, and he left to do more personal work. His commitment to *a way of seeing* was reinforced by Henry Wessel, who was his classmate at Pennsylvania State University and by Garry Winogrand when Pushinsky was working as a screenwriter in Los Angeles, Winogrand's home in the early 1980s.

Casey Reas lives and works in Los Angeles, where he is a professor at the University of California, Los Angeles's Department of Design Media Arts. His software, prints, and installations have been featured in numerous solo and group exhibitions at museums and galleries in the United States, Europe, and Asia.

Paul Reas is a contemporary of Martin Parr and part of the pioneering generation of photographers who revealed and critiqued British class and culture in the 1980s and 1990s. Strongly influenced by his working-class upbringing in Bradford, Reas used humor and sharp observation to comment on a new corporate and commercial world epitomized by heritage industry sites, retail parks, and

supermarkets. He is currently the program leader of the documentary photography course at the University of South Wales, Newport, in the UK.

Shawn Records holds a BA from Boise State University and an MFA from Syracuse University. His artwork is in the permanent collections of the Museum of Contemporary Photography, Chicago; Light Work, Syracuse, New York; and the Portland Art Museum, Oregon. He has been shown widely, including two solo shows at Blue Sky Gallery and group shows at the Portland Art Museum, Photo Center Northwest, and Jen Bekman Gallery, among others. In addition to his personal work, Records teaches photography in Portland, Oregon, and shoots editorial and commercial assignments for clients, including the *New York Times Magazine*, *Le Monde*, *Dwell*, *W*, and *Modern Painters*.

David Reinfurt is an independent graphic designer and writer in New York City. He graduated from the University of North Carolina and received an MFA from Yale University. Reinfurt formed O-R-G inc., a flexible graphic design practice composed of a constantly shifting network of collaborators. Together with graphic designer Stuart Bailey, he established Dexter Sinister, which is intended to model a just-in-time economy of print production, running counter to the contemporary assembly-line realities of large-scale publishing. Dexter Sinister published the semiannual arts magazine *Dot Dot Dot* from 2006 to 2011. Reinfurt recently launched a new umbrella project called The Serving Library with Stuart Bailey and Angie Keefer. Reinfurt was 2010 United States Artists Rockefeller Fellow in Architecture and Design and currently teaches at Princeton University.

Richard Renaldi, born in Chicago in 1968, received his BFA in photography from New York University. Exhibitions of his photographs have been mounted in galleries and museums throughout the United States, Asia, and Europe. His work can be found in numerous public and private collections. Renaldi has published three monographs: *Figure and Ground*, *Fall River Boys*, and *Touching Strangers*.

Xavier Ribas is a photographer and lecturer at the University of Brighton, UK, and visiting lecturer at the Polytechnic University of Valencia, Spain. He studied social anthropology at the University of Barcelona and documentary photography at Newport School of Art, Media, and Design. He has published four books: *Xavier Ribas*, *Sanctuary*, *Concrete Geographies [Nomads]*, and *Concrete Geographies [Ceuta and Melilla]*.

Shelley Rice teaches photographic history in the Department of Photography and Imaging and the department of art history at New York University.

A historian, critic, and curator, she has written for *Art in America*, the *Village Voice*, *Artforum*, *Aperture*, *Tate Papers*, and *Études Photographiques*, among other publications. Her books include *Parisian Views*, *Inverted Odysseys: Claude Cahun, Maya Deren, Cindy Sherman*, and *The Book of 101 Books*. A Guggenheim, Fulbright, and Hasselblad Fellow, she has been awarded the PEN/Jerard Award for Non-Fiction Essay. In 2010 she was named Chevalier in the Order of Arts and Letters in France.

Doug Rickard studied history and sociology at the University of California, San Diego, before moving to photography. His body of work *A New American Picture* was published in 2011. He is the founder of two websites, American Suburb X and These Americans.

Fred Ritchin is professor and associate chair of the Department of Photography and Imaging at New York University's Tisch School of the Arts, and codirects the Photography and Human Rights Program at NYU with the Magnum Foundation. He is also director and cofounder of PixelPress, which works with humanitarian groups to develop visual projects dealing with social-justice issues. Ritchin has written for *Aperture*, *Le Monde*, the *New York Times*, and the *Village Voice*, and authored several books, including *In Our Own Image: The Coming Revolution in Photography*, *After Photography*, and *Bending the Frame: Photojournalism, Documentary, and the Citizen*.

Will Rogan lives in Albany, California, with his family. Recent shows include solo shows at Objectif Exhibitions, curated by Chris Fitzpatrick, Antwerp; and *A Twice Lived Fragment of Time* at the University of California, Irvine. Recent group shows include *When Attitudes Became Form Become Attitudes* curated by Jens Hoffmann, California College of the Art Wattis Institute for Contemporary Arts, San Francisco; and the Shanghai Biennale. Rogan is also the coeditor and founder of the journal of editions, *Thing Quarterly*.

Thomas Roma's photographs are included in numerous collections and he has published twelve monographs. Twice the recipient of Guggenheim Fellowships and a New York State Council for the Arts Fellowship, Roma's work has appeared in exhibitions internationally, including one-person shows with accompanying catalogs at the Museum of Modern Art, New York, and International Center of Photography, New York. He is director of the photography program at Columbia University and has two recent books: *The Waters of Our Time*, with a text by his son Giancarlo T. Roma, and *In the Vale of Cashmere*, with a text by G. Winston James.

Stuart Rome began photographing in the 1970s during which time he began exhibiting works

in color, both landscapes and portraits, entitled *Modern Mythologies*. His first solo exhibition was presented at the International Museum of Photography at the George Eastman House in 1978. In 1985, Rome was hired to assist in the creation of a photography program at Drexel University in Philadelphia, where he continues to teach. Rome has exhibited extensively over the years in solo and group exhibitions in galleries and museums. Among his publications are *Maya, Treasures of an Ancient Civilization*, *Forest*, and *Signs and Wonders*.

Jon Rubin creates interventions into public life that reinvent social and political conditions and create new platforms for agency, participation, and exchange. His projects include starting a radio station in an abandoned steel town that only plays the sound of an extinct bird, running a barter-based nomadic art school, and operating a restaurant that produces a live talk show with its customers. He has exhibited at the San Francisco Museum of Modern Art; Shanghai Biennale; Museum of Contemporary Art, Denver; Museo Tamayo Arte Contemporáneo, Mexico; Rooseum Center for Contemporary Art, Sweden; Parkingallery, Tehran, Iran; as well as in backyards, living rooms, and on street corners.

Sasha Rudensky was raised in Russia before moving to the United States in 1990. Her work has been exhibited widely at Aperture Gallery, New York; Musée de l'Elysée, Lausanne, Switzerland; Macro Testaccio Museum and Galleria Gallerati, Rome; and FotoDepartament, St. Petersburg, Russia, among others. In 2010, Rudensky's work was included in *reGeneration 2: Tomorrow's Photographers Today*. She received her MFA from Yale University School of Art and BA from Wesleyan University. She was the recipient of the Ward Cheney Memorial Award from Yale University, Mortimer Hays-Brandeis Traveling Fellowship, Leica/Jim Marshall Award, Jessup Prize from Wesleyan University, and the Aaron Siskind Individual Fellowship grant. She is an assistant professor of art at Wesleyan University, where she is the head of the photography program.

Alessandra Sanguinetti was born in New York, 1968, and is based in San Francisco and Buenos Aires. She has been a recipient of numerous fellowships and awards, including the Guggenheim Fellowship, Hasselblad Foundation Grant, Robert Gardner Fellowship, and a Rencontres d'Arles Discovery Award. Her photographs are in various public and private collections, such as the Museum of Modern Art, New York; San Francisco Museum of Modern Art; Museum of Fine Arts, Houston; and Museum of Fine Arts, Boston. Her monographs are *On the Sixth Day*, *The Adventures of Guille and Belinda*, and *Sorry, Welcome*. She is a member of Magnum Photos.

Lynn Saville is a New York-based photographer specializing in night urban landscapes. Her work has been widely exhibited in the United States and abroad, and she has published two monographs: *Acquainted with the Night* and *Night/Shift*.

Asha Schechter grew up in Sebastopol, California (the longtime home of Charles Schulz). He lives and works in Los Angeles.

Jaap Scheeren is a photographer who lives and works in Amsterdam. He has made five publications: *The Black Hole*; *Oma Toos*; a Slovakian fairytale book called *3 Roses, 9 Ravens, 12 Months*; and, together with Hans Gremmen, a research project about printing called *Fake Flowers in Full Colour*. His most recent book—that was supposed to be a website, which it also became—is titled *Jaap Scheeren Cut Shaving*. He has worked on commissions for *Foam* magazine, KesselsKramer, *Libération*; *Wallpaper*; *ArtReview*; the *Guardian*; *Das Magazin*; *Apartamento*; and Hyères Fashion and Photography Festival, among others.

David Scheinbaum is former director/chair of the photography department at the Santa Fe University of Art and Design, and professor emeritus, College of Santa Fe. He worked with the preeminent photo historian Beaumont Newhall from 1978 until Newhall's death, and continues as coexecutor of his estate. With his wife, Janet Russek, he operates Scheinbaum & Russek Ltd., private fine art photography dealers and consultants in Santa Fe. His publications include: *Hip Hop: Portraits of An Urban Hymn*; *Miami Beach: Photographs of an American Dream*; *Stone: A Substantial Witness*; and, in collaboration with Janet Russek, *Ghost Ranch: Land of Light, Photographs by David Scheinbaum and Janet Russek*, and *Images in the Heavens, Patterns on the Earth: The I Ching*.

Paul Schiek was born in 1977 in Fond du Lac, Wisconsin. He received a BFA in photography from California College of Arts and Crafts, after which he started the publishing company TBW Books. Since then, Schiek's work has been shown both in the United States and internationally. His work has also been the subject of many books and publications. He currently lives and works in Oakland, California.

Ken Schles is a native New Yorker and photographer. He writes on the consequence of images. His books have appeared in surveys chronicling best examples in the history of the medium. He is a New York Foundation for the Arts Fellow whose work is represented in more than one hundred library and museum collections throughout the world. His monographs include *Invisible City* and *Night Walk*.

Michael Schmelling is the author of five photo books: *Shut Up Truth*, *The Week of No Computer*, *The Plan*, *Atlanta: Hip Hop and The South*, and *Land Line*. Schmelling's work from *The Plan* was included in the 2013 International Center of Photography Triennial, *A Different Kind of Order*.

Joachim Schmid is a Berlin-based artist who has been working with found photographs since the early 1980s. He has published over one hundred artist's books. His work has been exhibited internationally and is included in numerous collections. In 2007, a comprehensive monograph, *Joachim Schmid: Photoworks 1982–2007*, was published on the occasion of his first retrospective exhibition. In 2012, the book *Joachim Schmid e le fotografie degli altri* (Joachim Schmid and Other People's Photographs) was published on the occasion of an exhibition at Fondazione Museo di Fotografia Contemporanea in Cinisello Balsamo, Milan.

Gary Schneider was born in South Africa and lives and works in New York City. He has an MFA from Pratt Institute and is a faculty member at Mason Gross School of the Arts at Rutgers University. He is presently working on a Guggenheim Fellowship, making handprint portraits of South African artists. Schneider's early work in painting, performance, and film remain integral to his explorations of portraiture and identity.

Aaron Schuman is a photographer, writer, and curator. He is a senior lecturer in photography at the University of Brighton and the Arts University Bournemouth. Schuman is also the founder and editor of *SeeSaw* magazine, established in 2004, and *Photography Makes Sense*, established in 2014. He exhibits and publishes his photographic work internationally and writes for publications such as *Aperture*, *Foam*, *Time*, the *British Journal of Photography*, *Hotshoe*, and *Photoworks*. He has contributed essays to a number of books, including *Pieter Hugo: This Must Be the Place* and *Photographs Not Taken*, and has curated exhibitions for FotoFest International, the Houston Center for Photography, Kraków Photomonth, and more.

Barry Schwabsky, art critic for the *Nation* and coeditor of international reviews for *Artforum*, has taught at Yale University, New York University, and Goldsmiths College, among others. He has contributed to books and exhibition catalogs on artists such as Dana Schutz, Alec Soth, Jessica Stockholder, and Gillian Wearing. His most recent book is *Words for Art: Criticism, History, Theory, Practice*, and *Trembling Hand Equilibrium*, a collection of poetry, is forthcoming.

Mark Sealy, MBE, is director of Autograph ABP. He has initiated the production of many publications, exhibitions, and residency projects. He has commissioned photographers and filmmakers

worldwide, including the critically acclaimed film-work *The Unfinished Conversation* by John Akomfrah. In 2002, he was part of a team that jointly initiated and developed an £8 million capital building project, Rivington Place, which opened in 2007.

Nigel Shafran is a British photographer, born in London in 1964, who divides his work into self-motivated projects, commercial commissions, and teaching. Publications include *RuthBook*, *Dad's Office*, *Edited Photographs 1992–2000*, *Flowers for ___*, *Ruth on the Phone*, and *Teenage Precinct Shoppers*. His work has been shown at Tate Britain, London; Victoria and Albert Museum, London; the Photographers' Gallery, London; Taka Ishii Gallery, Japan; Galeria de Arte do Sesi, Brazil; and the Museum für Moderne Kunst, Germany, among others.

Christine Shank has a BFA from Miami University, Oxford, Ohio, and a MFA from Texas Woman's University. She has taught at the University of Connecticut, Washington University in St. Louis, Collin College, the Fort Worth Modern, Anchorage Museum, and the Visual Studies Workshop, Rochester, New York. She currently lives in Rochester where she is an assistant professor of photography and the codirector of the MFA in imaging arts, photography, and related media at Rochester Institute of Technology.

Leanne Shapton is a Canadian author and publisher based in New York City. She is the co-founder of J&L Books. Shapton has published five books: *Toronto*; *Was She Pretty?*; *Important Artifacts and Personal Property from the Collection of Lenore Doolan and Harold Morris, Including Books, Street Fashion, and Jewelry*; *The Native Trees of Canada*; and *Swimming Studies*, which won a 2012 National Book Critics Circle Award.

Tate Shaw is the director of the Visual Studies Workshop in Rochester, New York, and chair of the MFA in Visual Studies program in association with the College at Brockport, State University of New York. Shaw makes artist's books, writes essays, organizes symposia on books, and is copublisher of the small imprint Preacher's Biscuit Books.

Shimabuku was born in Kobe, Japan, in 1969. Since 2004, he has lived in Berlin. His performance and installation work proposes new ways of life and new methods of communication. Shimabuku's work has been exhibited internationally at the São Paulo Biennial in 2006, Venice Biennale 2003, Kunsthalle Bern 2014, and in group exhibitions at the Centre Pompidou in Paris and the Hayward Gallery in London.

Stephen Shore, at age fourteen, had his work purchased by Edward Steichen for the collection of the Museum of Modern Art, New York. At seventeen, Shore was a regular at Andy Warhol's Factory, producing an important photographic document of the scene, and in 1971, at the age of twenty-three, he became the first living photographer since Steichen forty years prior to have a one-man show at the Metropolitan Museum of Art, New York. Among his numerous other one-man shows, Shore has exhibited at the Museum of Modern Art, New York; Art Institute of Chicago; and Kunsthalle Düsseldorf. He has received two National Endowment for the Arts Grants and a Guggenheim Foundation Grant, and was appointed the director of the photography program at Bard College in Annandale-on-Hudson, New York, in 1982, where he is currently the Susan Weber Soros Professor in the Arts.

Aaron Siskind (1903–1991) was a photographer that was closely involved with the Abstract Expressionist movement. His photography is often focused on the details and surfaces of nature and architecture, presenting his subjects in abstract and compelling ways. He was originally an English grade school teacher, and later began his photographic career in the 1930s as a social documentary photographer with the New York Photo League. Throughout his career, he taught alongside Harry Callahan at IIT Institute of Design in Chicago and the Rhode Island School of Design. He was also one of the founding photographers whose archives established the Center for Creative Photography in 1975.

Mike Slack lives and works in Los Angeles. He is a cofounder of The Ice Plant, and author of *OK OK OK*, *Scorpio*, and *Pyramids*.

Gerald Slota is an artist and photographer who has been widely exhibited internationally. He has had solo shows at the George Eastman House International Museum of Photography and Film, Rochester, New York, and Langhans Galerie in Prague. His work has also been shown at Les Rencontres D'Arles, France. Slota's images have appeared in numerous publications, including the *New York Times Magazine*, the *New Yorker*, *New York* magazine, *Discover*, *BOMB*, *Blindspot*, *Art in America*, and *Aperture*. He currently teaches at the School of Visual Arts in New York. Slota has garnered many awards, including a Polaroid 20 x 24 Grant, a MacDowell Artist Residency, and Mid Atlantic Fellowship Grants.

Aline Smithson is currently represented by galleries in the United States and Europe and has published throughout the world, after previously having a career as a New York fashion editor. Smithson founded the blogzine *LENSCRATCH*, has been the gallery editor for *Light Leaks* magazine, and a contributing writer for numerous publications. She reviews and teaches workshops at photography

festivals across the United States, is a juror for various organizations, and has been teaching at the Los Angeles Center of Photography since 2001. In 2012, she received the Rising Star Award from the Griffin Museum of Photography for her contributions to the photographic community.

Tabitha Soren left a career in television in the late 1990s to start another as a photographer. She received a BA in journalism and politics at New York University and later studied photography at Stanford University and at California College of the Arts. Her work is in the collections of the Oakland Museum of Art, Cleveland's Transformer Station, Indianapolis Museum of Contemporary Art, New Orleans Museum of Art, and Ogden Museum of Southern Art, New Orleans.

Alec Soth is a photographer born and based in Minneapolis. His photographs have been featured in numerous solo and group exhibitions, including the 2004 Whitney and São Paulo Biennials. In 2008, a large survey exhibition of Soth's work was exhibited at Jeu de Paume in Paris and Fotomuseum Winterthur in Switzerland. In 2010, the Walker Art Center produced a survey exhibition of his work entitled *From Here to There*. Soth's first monograph, *Sleeping by the Mississippi*, was published in 2004 to critical acclaim. Since then, Soth has published *NIAGARA, Fashion Magazine, Dog Days, Bogotá, The Last Days of W*, and *Broken Manual*. He has been the recipient of numerous fellowships and awards, including the Guggenheim Fellowship in 2013. In 2008, he started his own publishing company, Little Brown Mushroom. Soth is a member of Magnum Photos.

Jem Southam was born in 1950 in Bristol, England. He studied photography at the London College of Printing and has since lived in southwest England, where he makes most of his work and where he has taught for over thirty years. He is currently a professor of photography at Plymouth University. His published books include *The Red River, The Raft of Carrots, Rockfalls, Rivermouths and Ponds, Landscape Stories*, and the *river/Winter*.

Doug and **Mike Starn**, artists and identical twins, have been working conceptually with photography for over two decades, yet they defy categorization—often combining traditionally separate disciplines such as photography, sculpture, and architecture. Their work has been the subject of museum exhibitions worldwide. Their installation *Big Bambú: You Can't, You Don't and You Won't Stop*, on the roof of the Metropolitan Museum of Art, was the ninth most attended exhibition in the museum's history. Their work has been the subject of several books, including *Gravity of Light, Attracted to Light*, and *Doug and Mike Starn*. Their pieces are represented in important collections internationally. They were artists-in-residence at NASA in the mid-'90s and have received two National Endowment for the Arts Grants and the International Center of Photography's Infinity Award.

Will Steacy is an American photographer and writer. He comes from five generations of newspapermen and worked as a union laborer before becoming a photographer. His work has been featured in the *New Yorker, Esquire, Harper's, Mother Jones*, the *Paris Review, Forbes, Colors, Time, Wired*, the *Guardian, Foam*, HBO and CNN, and he has been a guest on NPR, BBC, and PBS. His critically acclaimed books *Photographs Not Taken* and *Down These Mean Streets* were published in 2012. He lives in New York.

Mark Steinmetz is a photographer who resides in Athens, Georgia. He has published numerous books, including *Greater Atlanta, Summertime, Paris in My Time*, and *Philip and Micheline*, among others and two limited-edition books, *Idyll* (with Raymond Meeks) and *Pastoral*. His work is in the collections of the Museum of Modern Art, New York; Whitney Museum of American Art, New York; Metropolitan Museum of Art, New York; Art Institute of Chicago; San Francisco Museum of Modern Art, and others. He has taught photography at Harvard University, Yale University, Sarah Lawrence College, Emory University, and the University of Hartford. Steinmetz is a recipient of the Guggenheim Fellowship.

Brian Storm is founder and executive producer of the award-winning multimedia production studio MediaStorm, based in Brooklyn. MediaStorm's principal aim is to usher in the next generation of multimedia storytelling by publishing social documentary projects incorporating photojournalism, interactivity, animation, audio, and video for distribution across multiple media. Prior to launching MediaStorm in 2005, Storm spent two years as vice president of news, multimedia and assignment services for Corbis. From 1995 to 2002 he was director of multimedia at MSNBC. com. Storm received his master's degree in photojournalism from the University of Missouri. He lives in New York City.

Katja Stuke and **Oliver Sieber** both live and work in Düsseldorf. They both work independently on their own photographic projects. Under the label BöhmKobayashi, they also cover an extensive range of personas: photographers and artists, curators and exhibition organizers (ANT!FOTO), designers, artbook editors, and publishers. Regardless, in their works and activities as artists and art facilitators, they have become moderators of a very specific photographic culture. Recently, they have exhibited

at Kunsthalle Bremen, Germany; Museum für Photographie, Braunschweig, Germany; Museum of Contemporary Photography, Chicago; Fondation d'entreprise Hermès, Bern, Switzerland; FotoMuseum, Antwerp; Florence Loewy, Paris; and Museum Folkwang, Essen, Germany.

Jock Sturges is known for his nudes and extended portraits of families in Northern California counterculture communities, Ireland, and French naturist beaches. His large-format images borrow from classical periods in both photography and painting. His work is also found in the collections of many museums, including the Museum of Modern Art and Metropolitan Museum of Art, New York; Bibliothèque Nationale, Paris; and Frankfurt Museum of Modern Art. Recent books are *LIFE~TIME*, *Misty Dawn*, *Mit Jock Sturges Familiär*, and a new monograph, *Fanny*.

Josef Sudek (1896–1976) was a Czech photographer who had a career that spanned nearly seven decades. He is one of the masters of twentieth-century photography and devoted himself to creating a portrait of his native city, Prague, with mystical panoramic views of its streets and buildings, poetic still life images taken from his studio window, and atmospheric depictions of his garden. His fascination with light and mood permeated his life's work.

Bill Sullivan is an artist who lives and works in New York City. He worked for more than a decade on a conceptual body of artwork entitled Das Blaue Auto, which chronicled the evolution of a fictional lost European art movement. He took up photography with a focus on street photography in 2002, culminating in the project 3 Situations, completed in 2007. Since 2007 he has created several bodies of work that form such series as Self Portraits with Mirrors, Landscapes, People I Know, Courts, Things Change, Touch Screen, Forest Hills, and Pure Country.

Kelly Sultan was born and raised in the San Francisco Bay Area, and is a graduate of Mills College, Oakland, California. She is a visual artist with a history in both education and interior design. She is currently preparing for a retrospective of the work of her late husband, Larry Sultan opening at Los Angeles County Museum of Art, November 2014, and lives in their home of twenty-five years just north of San Francisco. Their two sons, Max and Will, are both in school in New York and San Francisco.

Larry Sultan (1946–2009) was an internationally recognized artist and educator with numerous solo and group shows worldwide, and the recipient of multiple awards and grants, including the Guggenheim Fellowship and several National Endowment for the Arts grants. From 1978 to 1988, he was a professor at the San Francisco Art Institute, and a distinguished professor in both the undergraduate photography program and the graduate program in fine arts at the California College of the Arts, from 1988 to 2009.

Peter Sutherland came to New York City from Colorado in 1998 and has been working and living there with his wife, Maia. When not working on art projects or assignments, he enjoys snowboarding and playing soccer. His favorite movies are *Gimme Shelter* and *Casino*.

Eva Sutton is a photographer and programmer whose work explores the boundaries between images, image archives, and time-based media. Her work has been featured at venues, including Aperture Gallery; SF Camerawork; Exit Art, New York; Tang Museum, Saratoga Springs, New York; and National Center of Photography, Paris. She has lectured at Princeton University, New York University, Cooper Union, American Museum of Natural History, Hong Kong Arts Centre, and the Ludwig Foundation in Havana, among others. Sutton is professor of photography at the Rhode Island School of Design. She lives and works in New York City.

Triin Tamm lives and works in Paide, Estonia. She produces books, objects, collections, and confusion—outside of a linear progression and without succumbing to the constraining expectations of the art system. At times working self-reflexively, Tamm comments on or renders transparent the processes of making her works or exhibitions. And she works a-temporally, producing documentation of potential works or retroactively producing those works from their documentation, collecting future titles, etc. Tamm works in response to the dwindling space for artistic freedom and widens it a bit.

Robyn Taylor works as an editorial assistant for the Aperture books program. Hailing from Bristol, England, she holds a BA in documentary photography from the University of Wales, Newport.

Rein Jelle Terpstra is an artist based in Amsterdam. Since a residency at the Rijksakademie van Beeldende Kunsten, Amsterdam, he has been devoted to photography and to art in public spaces. His photo projects, slideshow installations, and books investigate the relationships between perception and memory. In 2002, he published *Nabeelden* (Afterimages), on the photograph not taken, and in 2013, *Retracing*, on remembering images in the wake of blindness. The installation version of *Nabeelden* is permanently on show at Nederlands Fotomuseum, Rotterdam. He irregularly publishes from his large collection of vernacular photography. He teaches visual art and photography at Minerva Art Academy, Groningen, Netherlands.

Sara Terry made a mid-career transition into documentary photography and filmmaking after nearly two decades of work as an award-winning print and public radio reporter. As a photographer, she has focused on post-conflict issues. Her long-term project about the aftermath of Bosnia's war, *Aftermath: Bosnia's Long Road to Peace*, led her to found The Aftermath Project, a non-profit which supports photographers covering the aftermath of conflict, publishes an annual book, and creates curriculum on post-conflict and visual literacy issues. She was named a 2012 Guggenheim Fellow in photography for her current long-term project, *Forgiveness and Conflict: Lessons from Africa.*

Bob Thall has taught photography at Columbia College Chicago since 1978, serving as chair of the photography department from 1998 to 2011. He received his MFA from the University of Illinois at Chicago, where he studied with Joseph Jachna and Peter Hales, among others. Bob Thall's primary photographic subject has been the Chicago landscape, and that work has been published in four monographs: *The Perfect City, The New American Village, City Spaces,* and *At City's Edge.* Thall was the recipient of a John Simon Guggenheim Memorial Fellowship in 1998. He is currently working on an extended project on American cities.

Hank Willis Thomas is a photo-conceptual artist working primarily with themes related to identity, history, and popular culture. He received a BFA in photography and Africana studies from New York University, and his MFA/MA in photography and visual criticism from the California College of Arts. His work is featured in the collections of the Museum of Modern Art, New York; Guggenheim Museum, New York; and Oakland Museum of California. He has exhibited at the Smithsonian National Museum of American History, Washington, D.C., and the High Museum of Art, Atlanta, among others.

Elisabeth Tonnard is an artist and poet working in artist's books, photography, and literature. She has published thirty books, which are included in numerous public and private collections. The book-works range in scale and method, from a book that is completely invisible to a book containing a short story that swallowed a novel, to a book that is a swimming pool. The work has won several awards and is being exhibited widely. In 2013, a new edition of *In this Dark Wood* was published. Tonnard lives in the Netherlands.

Charles H. Traub is the founder and chair of the MFA Photography, Video and Related Media program at the School of Visual Arts, and president of the Aaron Siskind Foundation. He is a former chair of the photography department at Columbia College Chicago, a former director of the Light Gallery in New York, and cofounder of *Here Is New York: A Democracy of Photographs*, which received the International Center of Photography Cornell Capa Infinity Award, among many others. His latest book, *Dolce Via*, is set to be published in 2014.

Anne Wilkes Tucker received a BA from Randolph-Macon Woman's College and Rochester Institute of Technology, and a MA from the Visual Studies Workshop at the State University of New York. She joined the Museum of Fine Arts, Houston, in 1976, where she founded the museum's photography department and is currently the Gus and Lyndall Wortham Curator. She has curated over forty exhibitions and has lectured throughout the United States, Europe, Asia, and Latin America. She been awarded fellowships by the National Endowment for the Arts, John Simon Guggenheim Memorial Foundation, Getty Center, Harry Ransom Center, and Dora Maar House. *Time* magazine honored her as "America's Best Curator." She was the first recipient of the Focus Lifetime Achievement Award from the Griffin Museum of Photography and she received an honorary doctorate from the College at Brockport, State University of New York.

Anne Turyn is a fine art photographer and educator, currently on the faculty at Bard High School Early College Queens and Pratt Institute, Brooklyn. Her work has been included in exhibitions at the Museum of Modern Art, New York; Metropolitan Museum of Art, New York; Walker Art Center, Minneapolis; Contemporary Arts Museum, Houston; and Denver Art Museum, among others. Turyn published *Missives,* a book of color photographs, and founded and edited the chapbook series *Top Stories.*

Brian Ulrich is a Richmond, Virginia-based photographer and holds an MFA in photography from Columbia College Chicago. He has had solo exhibitions at the Museum of Contemporary Art, Chicago, and the Museum of Contemporary Art San Diego. His work has been published in the monograph *Is This Place Great or What?*, and in several publications. In 2009, he was the recipient of a John Simon Guggenheim Fellowship. He is an assistant professor at Virginia Commonwealth University in the photography and film department.

Penelope Umbrico is a photo-based artist whose work explores the production and consumption of photographs. She has exhibited widely and her work is in the permanent collections of the Guggenheim Museum, New York; Metropolitan Museum of Art, New York; Museum of Modern Art, New York; Museum of Contemporary Photography, Chicago; and San Francisco Museum of Modern Art, among others. She is the recipient of numerous awards, including

a Guggenheim Fellowship. She has held numerous visiting artist and teaching positions, including at the Rhode Island School of Design, Parsons The New School for Design, Harvard University, and Cooper Union. She was chair of MFA Photography at Bard College from 2004 to 2010, and is currently core faculty at the School of Visual Arts, MFA Photography, Video and Related Media program in New York City. Aperture published her first monograph, *Penelope Umbrico (photographs)*.

Carlo Van de Roer was born in Wellington, New Zealand, in 1975. He received a BFA from Victoria University before working and exhibiting internationally in the United States, New Zealand, United Kingdom, and France. Van de Roer has received the ADC Young Guns Award, and the APA Award for Fine Art, been named a Top 50 Photographer by Photolucida, and received the Honorable Mention for the BMW Paris Photo Prize. His work has drawn notice from the *New York Times*, the *New Yorker*, *Interview* magazine, *Vogue*, *Wired* magazine, and NPR. Van de Roer currently lives and works in Brooklyn.

Bertien van Manen is a photographer who has worked on several book projects, including *A Hundred Summers, A Hundred Winters*, photographs taken in the ex-Soviet Union, *East Wind West Wind* made in China, and *Give Me Your Image*, photographed in Europe and shown in *New Photography* at the Museum of Modern Art, New York, 2005. Her recent books include *Let's Sit Down Before We Go* and *Easter and Oak Trees*, which shows intimate, black-and-white images of van Manen's family in the 1970s. These projects resulted in photo-albums and exhibitions all over the world. She lives in Amsterdam.

Paolo Ventura was born in Milan in 1968. His work has been exhibited in museums and private galleries worldwide, including the Italian Pavilion of the 2011 Venice Biennale. His work is held in various collections, including the Boston Museum of Fine Arts, the Library of Congress in Washington, D.C., MACRO Museum of Contemporary Art in Rome, and the Maison Européenne de la Photographie in Paris.

Chris Verene has been photographing three generations of his family and their small Midwestern Illinois community since 1984. Verene has been called a natural storyteller, focusing on the whole intimate truth of human narratives. This work has been published in two monographs, *Chris Verene* and *Family*, as well as other catalogs. Verene's work is in numerous major museum collections, including at the Whitney Museum of American Art, New York; Metropolitan Museum of Art, New York; and Walker Art Center, Minneapolis. Verene lives and

works in New York City. He is the photography program coordinator for the College of Staten Island at the City University of New York.

Sipke Visser grew up in northern Netherlands, lived in Amsterdam for a while, and then moved to London in 2005. The running theme in his work is the people around him. He aims to photograph those intimate moments when people are immersed in themselves or with each other. Often he finds ways to get strangers to participate with or comment on his photography, notably in *Return to Sender*, a project for which he sent his photographs to random strangers, asking them to reply in one way or another.

Massimo Vitali studied photography at the London College of Printing. In the early 1960s, he started working as a photojournalist, collaborating with many magazines and agencies throughout Europe. In the early 1980s, a growing mistrust in the belief that photography had an absolute capacity to reproduce the subtleties of reality led to a change in his career path, and he began working as a cinematographer for television and cinema. His series of Italian beach panoramas began in 1995 in the wake of drastic political changes in Italy. Massimo started to observe his fellow countrymen very carefully. He lives and work in Lucca, Italy, and Berlin.

Tim Walker is a London-based photographer whose work has entranced the readers of *Vogue* for over a decade. Extravagant staging and romantic motifs characterize his unmistakable style. Walker began his career working as an assistant to Richard Avedon and at the age of twenty-five he shot his first fashion story for *Vogue*. His work has been exhibited in solo shows at the Design Museum and at Somerset House, London, coinciding with the publication of his monographs *Pictures* and *Story Teller*. Walker's first short film, *The Lost Explorer*, premiered at Locarno Film Festival in Switzerland and went on to win best short film at the Chicago United Film Festival.

WassinkLundgren is a collaboration between Dutch photographers Thijs groot Wassink and Ruben Lundgren, who live and work, respectively, in London and Beijing. They work on photography and film projects that shift mundane, often unnoticeable, everyday occurrences into visually compelling and gently amusing observations of the world around us. WassinkLundgren has exhibited in museums worldwide, including Foam, Amsterdam; Suzhou Jinji Lake Art Museum, China; National Media Museum, Bradford, UK; Fotomuseum Winterthur, Switzerland; and Stedelijk Museum, Amsterdam. Among others, their publications include *Tokyo Tokyo, Lu Xiaoben, Don't Smile Now . . . Save It for Later!*, and *Empty Bottles*, which was awarded the prestigious Prix du Livre at Les Rencontres d'Arles 2007.

Alex Webb is best known for his vibrant and complex color photography, often made in Latin America and the Caribbean. He has published eleven books, including *Violet Isle: A Duet of Photographs from Cuba* (with Rebecca Norris Webb) and *The Suffering of Light*, a collection of thirty years of his color work. Webb became a full member of Magnum Photos in 1979. His work has been shown widely, including at the Metropolitan Museum of Art and Whitney Museum of American Art, New York, and at the High Museum of Art, Atlanta. He's received numerous awards, including a Guggenheim Fellowship.

Rebecca Norris Webb, originally a poet, has published three photography books that explore the complicated relationship between people and the natural world: *The Glass Between Us*, *Violet Isle: A Duet of Photographs from Cuba* (with Alex Webb), and *My Dakota*. Her fourth book, *Memory City* (with Alex Webb), is a meditation on film, time, and the city of Rochester, New York, in what may be the last days of film as we know it. Her work has been exhibited internationally, including at the Museum of Fine Arts, Boston, and George Eastman House International Museum of Photography and Film, Rochester, among others.

Donald Weber worked as an architect in Rotterdam with urban theorist Rem Koolhaas's Office for Metropolitan Architecture before becoming a photographer. He is the recipient of a Guggenheim Fellowship, two World Press Photo Awards, and the Lange-Taylor Documentary Prize, among others. He has published two monographs, *Bastard Eden, Our Chernobyl* and *Interrogations*.

Weegee (1899–1968) was the pseudonym of Arthur Fellig. He made a significant contribution to the history of photography in the twentieth century as a photographer and photojournalist known for his black-and-white street photography. He worked in Manhattan's Lower East Side as a press photographer in the 1930s and '40s, and much of his work depicted very realistic scenes that often confront urban life, death, and crime. In 1945, he published *Naked City*, his first book of photographs. The entire Weegee archive belongs to the International Center of Photography in New York.

Shen Wei is currently based in New York City. His photographs have been widely exhibited, at venues, including the Griffin Museum of Photography, Winchester, Massachusetts; Center of Contemporary Art, Seattle; and Kunst Licht Gallery, Shanghai. He holds an MFA from the School of Visual Arts, New York, and a BFA in photography from Minneapolis College of Art and Design.

Hannah Whitaker is an artist based in New York. She holds a BA from Yale University and an MFA from International Center of Photography-Bard. In 2012, she was nominated for the Rencontres d'Arles Discovery Prize. She is a contributing editor for *Triple Canopy*.

Charlie White is a Los Angeles-based artist and associate professor at the Roski School of Fine Arts at the University of Southern California. White's work spans photography, film, animation, writing, and experimental pop music. He has exhibited internationally, including shows at the Los Angeles County Museum of Art; MoMA PS1, New York; and Institute of Contemporary Art, Philadelphia. White was selected for the 2011 Singapore Biennale, and his films have been featured at the Sundance Film Festival and Directors' Fortnight at Cannes. White's most recent monographs include *American Minor* and *Such Appetite*.

Lindsey White is an artist and educator based in San Francisco. Through video, photography, and sculpture, White models a type of site-gag index, working with the language of magic and comedy to present the unexpected and impossible in everyday life. She is a part of the collaborative project Will Brown, based in a storefront space in San Francisco. Will Brown's main objective is to manipulate the structures of exhibition-making as a critical practice. Her projects have been shown both nationally and internationally. She currently teaches at San Francisco Art Institute and California College of the Arts.

Grant Willing lives and works in New York City. He has exhibited his work in North America and Europe and is currently working on a series of artist books concerning landscape architecture, design, and interpretation.

Julie Winokur is a writer, documentary filmmaker, and founding director of Talking Eyes Media. Her work has appeared on PBS, MSNBC, and Discovery online, as well as in the *New York Times Magazine*, *National Geographic*, *Time*, and the *Washington Post*. Her latest project, *Bring It to the Table*, tackles divisive politics in America, and has been featured on NPR and MSNBC.

Neil Winokur's work has been exhibited widely following its inclusion in *Lichtbildnisse: Das Portrat in der Fotografie*. Other notable exhibitions include *Pleasures and Terrors of Domestic Comfort*, the Museum of Modern Art, New York, and *The Photography of Invention*, Smithsonian American Art Museum, Washington, D.C. Winokur's photographs are included in the collections of the Museum of Modern Art, New York; Metropolitan Museum of Art, New York; Museum of Fine Arts, Houston; Los Angeles County Museum of Art; Denver Art Museum; Philadelphia Museum of Art; and others.

Frederick Wiseman is an independent filmmaker who has made forty-one films. He has

directed plays for La Comédie-Française in Paris and the Theatre for a New Audience in New York. He is a MacArthur Fellow, the recipient of a Guggenheim Fellowship, and an Honorary Member of the American Academy of Arts and Letters. He has won numerous awards, including four Emmys, career achievement awards from the Los Angeles Film Society and the New York Film Critics, the George Polk Career Award, and the American Society of Cinematographers Distinguished Achievement Award, among others. Wiseman films are available at Zipporah Films: zipporah.com.

Silvio Wolf, born in Milan, received a higher diploma in advanced photography at the London College of Printing. Over time, he has moved away from the pure two-dimensional format of photography, creating multimedia projects and sound installations. His works appear in galleries, museums, and public spaces in Belgium, Canada, England, France, Germany, Italy, Korea, Luxembourg, Spain, Switzerland, and the United States. He teaches photography at the European Institute of Design in Milan and is a visiting professor at the School of Visual Arts in New York.

Denise Wolff is a senior editor at Aperture, specializing in photography books. Prior to Aperture, she was the commissioning editor for photography at Phaidon Press in London. Throughout her career, she has had the opportunity to work on many different types of books, including monographs with such established photographers as Roger Ballen, Mary Ellen Mark, Martin Parr, and Stephen Shore, as well as first books, retrospectives, and large survey anthologies on a variety of subjects—from portraiture to road trips.

Antonio M. Xoubanova studied photography at Escuela de Arte 10 in Madrid. Upon finishing his studies in 2003, he set up Blank Paper alongside other photographers with shared interests. He is the recipient of several awards and grants. Since 2005, he has conducted workshops and lessons at the Blank Paper school of photography while working on his personal projects, M30 and Casa de Campo. He is currently working on Un Universo Pequeño, the final project in a trilogy that uses Madrid as a muse. In 2013, he published *Casa de Campo* and cofounded the photographer's management platform AMPARO, alongside Óscar Monzón, Aleix Plademunt, and Ricardo Cases.

This guide will help direct you to assignments and ideas of similar topic, approach, and/or concept. For example, "classroom" lists those assignments that discuss the classroom, as well as those that could be done with a class.

Subject Guide

A

Abstract, 6, 76, 92, 103, 148, 156, 179, 186, 206, 207, 296, 309, 310, 378

Absurdity, 8, 14, 15, 35, 41, 45, 49, 56, 61, 72, 81, 91, 92, 126, 136, 147, 233, 235, 296, 301, 315, 370

Access, 131, 144, 356, 367, 376

Advice, 18, 20, 21, 23, 27, 30, 31, 35, 39, 40, 50, 55, 59, 60, 67, 70, 84, 87, 88, 98, 103, 105, 108, 116, 118, 123, 124, 125, 126, 129, 130, 137, 139, 144, 146, 169, 170, 175, 178, 180, 185, 186, 212, 217, 221, 227, 228, 239, 247, 251, 258, 267, 271, 272, 273, 282, 295, 302, 304, 306, 311, 312, 317, 318, 322, 323, 327, 328, 331, 334, 339, 344, 357, 364, 367, 368, 376, 377, 379, 381, 384

Aerial, 63

Alter ego, 16, 33, 111, 176, 200, 368

Alternative process, 93, 100, 129, 179, 347

Ambiguity, 126, 177, 218, 281, 349, 355, 365

Analysis, 31, 40, 63, 100, 148, 158, 171, 176, 210, 211, 215, 242, 268, 289, 325, 333

Animals, 35, 48, 89, 126, 255, 316, 327

Architecture, 22, 164, 230, 285, 318, 366

Archive, 47, 57, 124, 146, 171, 209, 218, 224, 261, 268, 290, 352

Art, 66, 131, 142, 175, 180, 224, 259, 292, 310, 318, 327, 330

Art history, 310, 348

Articulation, 104, 148, 215, 218, 340, 348

Atmosphere, 107, 358

Audience, 25, 26, 43, 97, 105, 131, 153, 161, 176, 214, 255, 292, 295, 355, 371

Audio, 14, 23, 86, 112, 163, 329, 335, 336

Aura, 7, 100, 206, 259

Authorship, 8, 30, 83, 111, 112, 116, 152, 165, 169, 172, 224, 232, 256, 264, 287, 292, 305, 338, 344

B

Beach, 35

Beauty, 66, 76, 81, 85, 113

Beginner, 43, 59, 76, 98, 129, 173, 228, 245, 282, 299, 308, 322, 343, 358

Beginnings, 52, 73, 228, 239, 264

Body, 41, 95, 140, 156, 369

Books, 43, 80, 112, 124, 151, 153, 217, 233, 249, 257, 265, 281, 285, 311, 330, 334, 338

Boredom, 52, 108, 124, 198, 298, 339

Brainstorming, 64, 124, 136, 141, 148, 150, 242, 370

C

Captions, 83, 174, 218, 232, 270, 324

Chance, 24, 31, 35, 41, 45, 56, 140, 149, 183, 186, 207, 221, 250, 251, 272, 281, 283, 312, 320, 327, 352, 356, 362, 370, 372, 377, 381, 384

Children, 99, 112, 132, 167, 223, 245, 293, 299, 331

Cinema, 48, 80, 193, 262, 335, 336, 374

Classroom, 77, 87, 88, 174, 175, 186, 229, 233, 242, 247, 300, 313, 321, 339, 349, 370

Cliché, 11, 59, 117, 141, 293, 306

Collaboration, 16, 17, 25, 41, 43, 45, 49, 64, 83, 95, 111, 112, 114, 116, 120, 131, 140, 143, 165, 167, 174, 191, 192, 195, 226, 276, 287, 295, 316, 329, 331, 335, 349, 351, 356, 358, 361, 370

Collecting, 45, 60, 72, 73, 86, 146, 171, 211, 237, 341

Collection, 57, 60, 146, 171, 352

Color, 7, 72, 89, 93, 267, 274, 294, 330, 341

Comfort zone, 21, 33, 41, 48, 49, 51, 61, 64, 67, 75, 88, 92, 111, 137, 153, 156, 191, 215, 235, 283, 287, 295, 301, 304, 307, 328, 335, 356, 361, 376

Community, 31, 43, 61, 77, 88, 112, 116, 121, 131, 143, 171, 176, 214, 226, 269, 276, 356, 366

Acknowledgments

We would like to thank Aperture Foundation for their support of this effort, and, in particular, Denise Wolff for her invaluable insight, editing skills, and sense of humor, as well as Robyn Taylor for her devotion, feedback, and herculean organizational abilities. This book would never have come together without them, and is much richer from their contributions.

We would also like to thank Chris Boot for initiating this collaboration; Natalie Ivis for wrangling the bios and subject guide; Madeline Coleman, Susan Ciccotti, Matt Harvey, and Kaitlyn Battista, working behind the scenes at Aperture; and Tamara Shopsin for the enchiladas.

Thanks to Therese Mulligan and the School of Photographic Arts and Sciences at the Rochester Institute of Technology for their support of this project in its earliest stages.

A special thanks to the teachers and mentors whose "assignments" have helped us over the years, namely Miles Boyd, Jay Freer, Jim Goldberg, Todd Hido, Chris Killip, David Kucera, Larry Sultan, Anne Turyn, Carol Wilson, and Jack Woody.

Thanks to Mike Slack for using up his last batch of Polaroid film to make the dreamy alphabet that flows through the book.

And finally, a huge thanks to all of the contributors who agreed to be a part of this book.

—Jason Fulford and Gregory Halpern

The Photographer's Playbook
307 Assignments and Ideas
Edited by Jason Fulford and Gregory Halpern
Photographs by Mike Slack
Cover photograms by Jason Fulford

Editor: Denise Wolff
Editorial Assistant: Robyn Taylor
Designer: Jason Fulford
Production: Matthew Harvey
Production Assistant: Luke Chase
Senior Text Editor: Susan Ciccotti
Copy Editor: Sara Terry
Proofreader: Madeline Coleman
Work Scholars: Caitlin Clingman, Natalie Ivis,
Jessica Lancaster

Additional staff of the Aperture book program
includes: Chris Boot, Executive Director; Lesley A.
Martin, Creative Director; Taia Kwinter, Publishing
Manager; Emily Patten, Publishing Assistant; Elena
Goukassian, Proofreader/Copy Editor; Samantha
Marlow, Associate Editor; Lanah Swindle, Editorial
Assistant; True Sims, Senior Production Manager;
Andrea Chlad, Production Manager; Brian Berding,
Designer; Kellie McLaughlin, Director of Sales and
Marketing; Richard Gregg, Sales Director, Books

First edition, 2014
Printed in China
15 14 13 12 11 10

Library of Congress Control Number: 2014931007
ISBN 978-1-59711-247-5

To order Aperture books, or inquire about gift or
group orders, contact:
+1 212.946.7154
orders@aperture.org

For information about Aperture trade distribution
worldwide, visit:
aperture.org/distribution

aperture

Aperture Foundation
548 West 28th Street, 4th Floor
New York, NY 10001
aperture.org

Aperture, a not-for-profit foundation, connects the
photo community and its audiences with the most
inspiring work, the sharpest ideas, and with each
other—in print, in person, and online.